IMAGES
of America

BELLEVUE

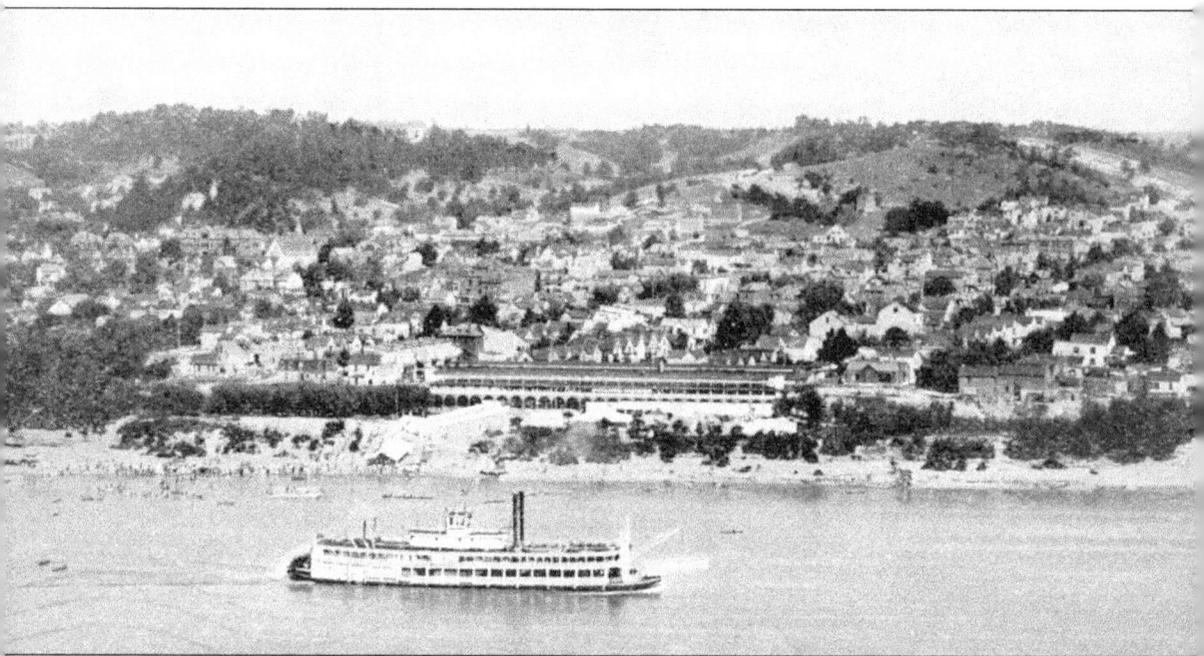

As the *Island Queen* passes Queen City Beach, Bellevue and the surrounding hills are visible. Bellevue's strategic location on a small rise above the Ohio River made it less susceptible to flooding. The small rise made the location a desirable residential community, and the sloping waterfront made it the ideal location for Cincinnati's premier bathing beach.

IMAGES
of America

BELLEVUE

City of Bellevue

ARCADIA
PUBLISHING

Published by Arcadia Publishing
Charleston, South Carolina

Library of Congress Catalog Card Number: 2005925967

For all general information contact Arcadia Publishing at:
Telephone 843-853-2070
Fax 843-853-0044
E-mail sales@arcadiapublishing.com
For customer service and orders:
Toll-Free 1-888-313-2665

Visit us on the Internet at www.arcadiapublishing.com

This city logo, adopted by Bellevue in the 1990s, is now used on stationary and official documents. The logo was inspired by the historic flavor of Bellevue and particularly by one of Bellevue's most notable landmarks, Sacred Heart Church.

CONTENTS

ACKNOWLEDGMENTS

This book was compiled and written through a collaboration between the City of Bellevue and its citizens. With the support of Mayor John Meyer, City Administrator Donald Martin, Police Chief William Cole, and City Attorney Frank Warnock, this publication was completed in less than one year between 2004 and 2005.

Project management for this publication was provided by Michele Brozek, downtown coordinator and historic preservation administrator with the City of Bellevue, and Chief William Cole. Project support was also provided by Margo Warminski of the Cincinnati Preservation Association, Skye Connerly of the Campbell County Library, and David Schroeder of the Kenton County Library.

Images of historic Bellevue were generously donated by the following individuals: Kathy Barrett, Zachary Jordan, Mary Jo Harrington, Tom Rechtin Sr., Clarence and Shirley Pritchard, Robert Rothfuss, Edna Hanerkamp, Rose Schweitzer, Bernie Rechtin, Carol Schoulthies, Mary Bickers, Jennifer Hazeres, Edith Kirchhoff, Sandy Leopold, Edward Ulsas, Mrs. William Reeves, Victor Camm, Charles Tharp, Dolores Morehead, Donald Johns, Diane Witte, Rev. Keith Haithcock, Chief William Cole, and others that may have been forgotten. This book could not have been written without the research and writing skills of the following people: Virgil and Dottie Webb, Tom Wiethorn, Diane Witte, Julie Fischer, Rick Blevins, Joe and Cathy Hurley, Bernie Rechtin, and Okey Spaulding.

Major text research and writing was completed by Chief William Cole. Born in Washington, D.C., Chief Cole was raised in Hamilton, Ohio, where he graduated from Hamilton High School. After graduation, Cole served in the U.S. Marine Corps and attended the University of Cincinnati while still in the Marine Reserves. Cole began his career as a Bellevue police officer in 1986 and rose through the ranks to the position of chief in 2002.

Additional text research and writing was completed by John W. Rodrigues, a student of the University of Cincinnati. Raised in Nashville, Tennessee, Rodrigues received his bachelor's degree from Union College in Schenectady, New York, a master of community planning from the University of Cincinnati, and is currently pursuing a master of business administration from the University of Cincinnati.

INTRODUCTION

Bellevue is located in the extreme northern part of Kentucky, bordering Cincinnati, Ohio. Bellevue is a part of Campbell County and is bordered to the west by Newport, to the east by Dayton, and to the south by Fort Thomas. The Ohio River flows along Bellevue's northern border, dividing Bellevue from Cincinnati.

Even though Bellevue is situated in a largely urban area, at one square mile and a population of less than 7,000 people, Bellevue could hardly be considered anything but a small town. However, because of its proximity to Cincinnati, Newport, and Covington, Bellevue also has the feel of a larger city. Looking across the Ohio River to Cincinnati provides a breathtaking view, helping Bellevue live up to the French meaning of its name, "beautiful view."

Much of the Ohio River Valley area, known in the mid-18th century as the Ohio Country, was owned by our country's greatest citizen, George Washington. Some maps of this territory show the land that would become Bellevue as George Washington's property. Other maps from that time shown ownership by James Taylor I, or as property of the French or British crown. No matter who claimed ownership, the land at that time was inhabited only by Native Americans, who used it for hunting, fishing, and warfare.

Tribes such as the Illini, Miami, Shawnee, Cherokee, and Tuscarora often clashed in the Ohio valley area. In 1745, the Shawnee tribe migrated to the banks of the Ohio River to hunt and fish. There they were met by Cherokee and Miami Indians in a battle lasting three days and costing many lives.

In 1755, when Kentucky was still an unsettled land, Mary Ingles and Eliza Draper were captured by the Shawnee during a bloody raid of the settlement known as Draper's Meadows in what is now West Virginia. During the long trek that followed the Ohio River into the land that would later become Bellevue and then several miles south to an area known as Big Bone Lick, Mary Ingles remained a captive of the Shawnee. The travel was a violent and bloody one, and Mary Ingles witnessed many murders and much bloodshed during Shawnee skirmishes. Seizing an opportunity in the Big Bone Lick region, Mary Ingles escaped and made her way home.

Mary's son, Thomas, had also been captured by Native Americans. In 1768, after learning that their son was still alive, Mary and William Ingles were able to pay a ransom and have their son returned to them. Thomas had adopted the customs and lifestyle of the Shawnee Native Americans by the time he was returned to his parents. Mary and William sent him to be educated by Dr. Thomas Walker, who was also the guardian of Thomas Jefferson. Thomas Ingles grew to become a prosperous man. Mary Ingles lived to the age of 84, when she died in 1815.

Mary Ingles's story carries such influence through West Virginia and Kentucky that she is still considered a hero to this day. State Route 8, which winds along the Ohio River through Kentucky (roughly the route taken by Mary Ingles as a Shawnee captive) is named Mary Ingles Highway in her honor. That same state route is the main roadway through Bellevue.

After the Revolutionary War, many settlers moved into the Ohio Valley area from the eastern states and from Europe. The area continued to be settled, and Kentucky was admitted to the Union in 1792 as the 15th state. Ohio followed in 1803 as the 17th state.

In 1861, the predictions of George Washington came to be, and war broke out between the states. (Washington, however, believed that the split in the Union would be East and West, not North and South. His prediction was about 80 years before the Civil War.) Kentucky's role in this struggle was an important one. Jefferson Davis, a Kentucky native, was named president of the Confederate States. Lincoln, who was born in Kentucky, considered Kentucky so important to the struggle that he is reputed to have said, "I hope to have God on our side, but we need Kentucky."

Less than one mile west of the land that would become Bellevue, the Roebling Suspension Bridge was under construction in Covington, Kentucky, during the Civil War. The war slowed the bridge construction, and a pontoon bridge built east of the Roebling Bridge site was used for the duration of the war to move troops from the North to the South. The Roebling Bridge, named for John A. Roebling, was later used as a model for the Brooklyn Bridge in New York. John Roebling designed both bridges.

Officially Kentucky was a neutral state in the war. However, with 100,000 Kentuckians fighting for the Union and 40,000 Kentuckians wearing the uniform of the Confederates, it can truly be said that in Kentucky, more than any other state, the Civil War was a war of brother against brother. Ironically the Great Seal of Kentucky bears a design showing two men facing each other and shaking hands and bears the motto "United We Stand, Divided We Fall." This seal was adopted in 1792, 69 years before the Civil War began.

The war ended in 1865, five years before the incorporation of Bellevue, but the Bellevue area was already being settled at that time and was developing a strong sense of community. In 1903, 33 years after Bellevue's incorporation as a city, a group of men and women who had fought in the war came together for a photograph in front of Bellevue High School. Among those in the photograph are the Maunders brothers. During the war, one brother fought for the Union, and the other fought for the Confederacy. Another pair of brothers from the Bellevue area also fought on opposite sides of the war and then lived together after the war. The Seiter brothers were known to walk through the city together after the war, each wearing his uniform from the war. One brother had lost a leg in war, and the other had lost an arm. Another man in the photograph, Benjamin Perry, lived to be 93 years old. When he died in his home at 330 Foote Avenue, he was the last surviving Civil War veteran from Bellevue.

After the close of the war, the community that had formed in the land between Newport and the towns of Brooklyn and Jamestown (later merged to become Dayton) petitioned the Kentucky Legislature for a charter as an incorporated community.

The act was approved and was signed by Gov. John White Stevenson on March 15, 1870. Governor Stevenson was a fellow Northern Kentuckian from Covington who later was elected to the U.S. Senate.

The charter, signed by Governor Stevenson, reads in part as follows:

Be it enacted by the General Assembly of the Commonwealth of Kentucky:

Section 1: That the town of Bellview, in the County of Campbell, be, and is hereby incorporated; and the town limits shall embrace the recorded maps of said town and additions as laid out by A. (Albert) S. Berry, and the additions of Henry C. Timberlake, and of so much of the Williamson Estate as laid off in town lots; and it shall be the duty of the trustees hereinafter appointed to cause a complete map of said town to be made cut and recorded in the County Court Clerk's Office of Campbell County, embracing the above described property. . . .

Section 5: That the land inclosed by the following boundary shall constitute a separate voting precinct, via; beginning at the east line of Newport, on the Ohio River, thence up river to the east line of Mrs. Harris' land; thence south to the line of the Highland District, thence to the Newport line; thence to the Ohio River, and place of beginning.

Note that the city's name in the original charter was misspelled as "Bellview," not Bellevue, as was intended by the settlers of this area.

The land where Bellevue is located was originally granted to Col. John Campbell for his services during the French and Indian War. Campbell County was named for Colonel Campbell. Before the War of 1812, the area was settled by Gen. James Taylor, who served in the War of 1812, and a large group who came with him from Virginia. General Taylor's farm included land in both Newport and Bellevue.

An article published in *History of Kentucky* by Lewis Collins in 1847 had this to say about Bellevue:

> General James Taylor, one of the pioneers of Kentucky, resides in Newport. He has attained his seventy-eighth year, and is remarkably active and sprightly for a man of his age. His venerable consort, to whom he has been united for upwards of half a century, and who came to Kentucky in the midst of Indian troubles, still retains much of the vigor of her youth, and attends strictly to her household affairs. The mansion of these venerable pioneers, "Belleview," one of the most beautiful and costly in Kentucky, has long been distinguished for elegant hospitality.

Bellevue received its name from the Virginia plantation that was owned by General Taylor's father, Col. James Taylor. The plantation had been named for a nearby creek, which had received its name from Colonel Taylor's family.

General Taylor named many of the early streets in Bellevue as the city was being settled and built. Coming through the city, east from Berry Avenue, General Taylor chose these street names: Lafayette Avenue, named for the Marquis de Lafayette, a French nobleman and close friend and ally of Gen. George Washington during the Revolutionary War; Taylor Avenue, named for General Taylor's family; Washington Avenue, named in honor of George Washington; Foote Avenue, Ward Avenue, Van Voast Avenue, and O'Fallon Avenue, all of which, legend states, were named for relatives of the Taylor family.

In 1894, Bellevue's officials worked to bring more settlers to the city. In their first brochure, they said:

> Fairfield Avenue, running east and west through the entire town, is the principal business thoroughfare, and the business houses are kept well stocked with the latest and best of everything in all branches of trade.
>
> Bellevue is built on a gentle slope running from the Ohio River to the Kentucky Highlands region. . . .
>
> Bellevue is the only town south of the Ohio that is entirely above high water. The 71-foot, ¾-inch state of the flood of 1884 barely touched the skirt of the town, while surrounding cities were partly submerged.

There was more than just boasting to these claims of being above the high-water mark. Bellevue is topographically higher than surrounding towns. As the Ohio River would rise and fall each year, homes and land in the neighboring towns of Newport and Dayton would flood. Bellevue did not. This resulted in higher property values in Bellevue as it was settled, which contributed to Bellevue's prosperity.

Bellevue had other famous sons through its history as well. One of those was John F. Siple, a handwriting specialist who worked from 1909 to 1939. John Siple was the handwriting examiner during the investigation and trial of Bruno Hauptmann, who was convicted of kidnapping and killing the son of famed pilot Charles Lindberg.

Into the 1950s, 1960s, and 1970s, Northern Kentucky became known as a part of the country that was heavily controlled by organized crime, primarily Newport and Covington, where gambling, prostitution, and other forms of illegal conduct were commonplace. During this same period, a nightclub existed in Bellevue was named the Avenue Nightclub. The Avenue was known for good food and as the only gambling establishment in Northern Kentucky that was not controlled by organized crime. On March 23, 1963, the Avenue Nightclub was engulfed in flames, killing two people.

Bellevue had several other attractions throughout its history. Into the early 20th century, Bellevue was well known for its beautiful, white-sand beaches along the Ohio River. There was

a very large beach house and a half mile of beautiful beach line. These beaches existed until the Ohio River was fitted with damns and locks to assist with barge travel on the river. At this point, the white sand was submerged permanently beneath the waters of the Ohio River.

As Bellevue's development continued, it was much like many other Midwestern cities in our country. There were great events, sad events, and normal, everyday events. Today Bellevue is going through a redevelopment in targeted parts of the city. Multi-million-dollar construction projects are taking place in these areas. Both residential units and commercial construction is underway.

In addition, Bellevue is embracing its history by revitalizing and preserving its historic structures in town. Bellevue now has two historic districts and a strong drive toward the preservation of its beautiful buildings.

Bellevue recognizes the importance of preserving its past while preparing for its future. So much so, in fact, that the phrase on Bellevue's logo is "Preserving the Past, Preparing for the Future."

William D. Cole
Chief of Police
Bellevue, Kentucky
September 2005

One

THE PEOPLE AND PLACES OF BELLEVUE

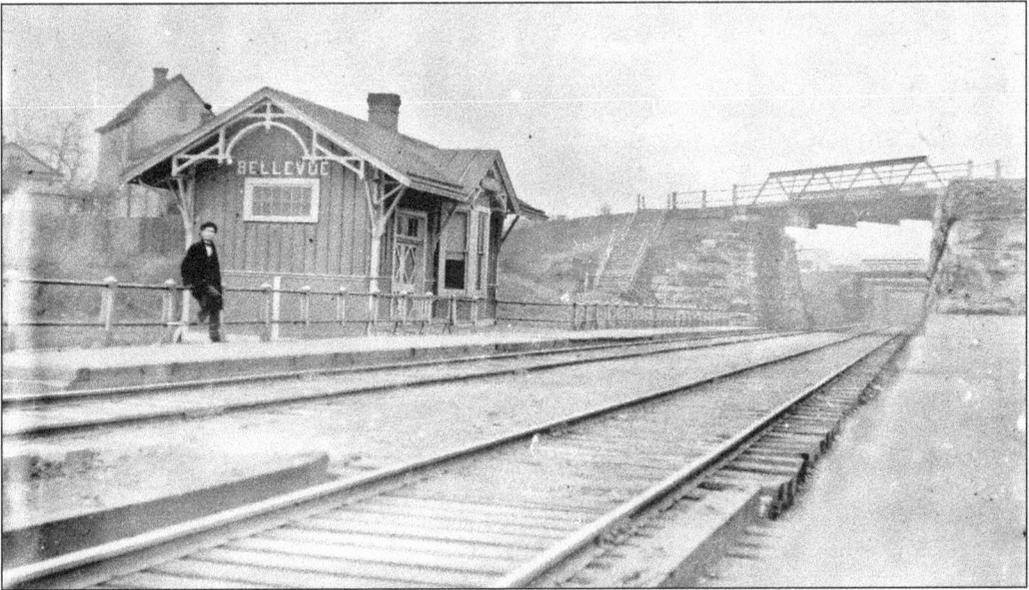

The iron horse first galloped through Bellevue in the 1880s, when the Chesapeake and Ohio Railroad was constructed through the city. In 1892, a combination freight and passenger station with 24-hour telegraph service was built trackside at 329 Retreat Street. Like those in neighboring Newport and Dayton, it was a one-story frame structure in the stick style sheathed in board-and-batten siding. The overpasses in the background carry the streets of Washington, Foote, Center, and Ward over the new rails. Passenger service was discontinued in the 1950s, and the building was eventually demolished. One set of tracks was removed in the 1980s. The remaining set still carries both freight trains and a daily passenger train.

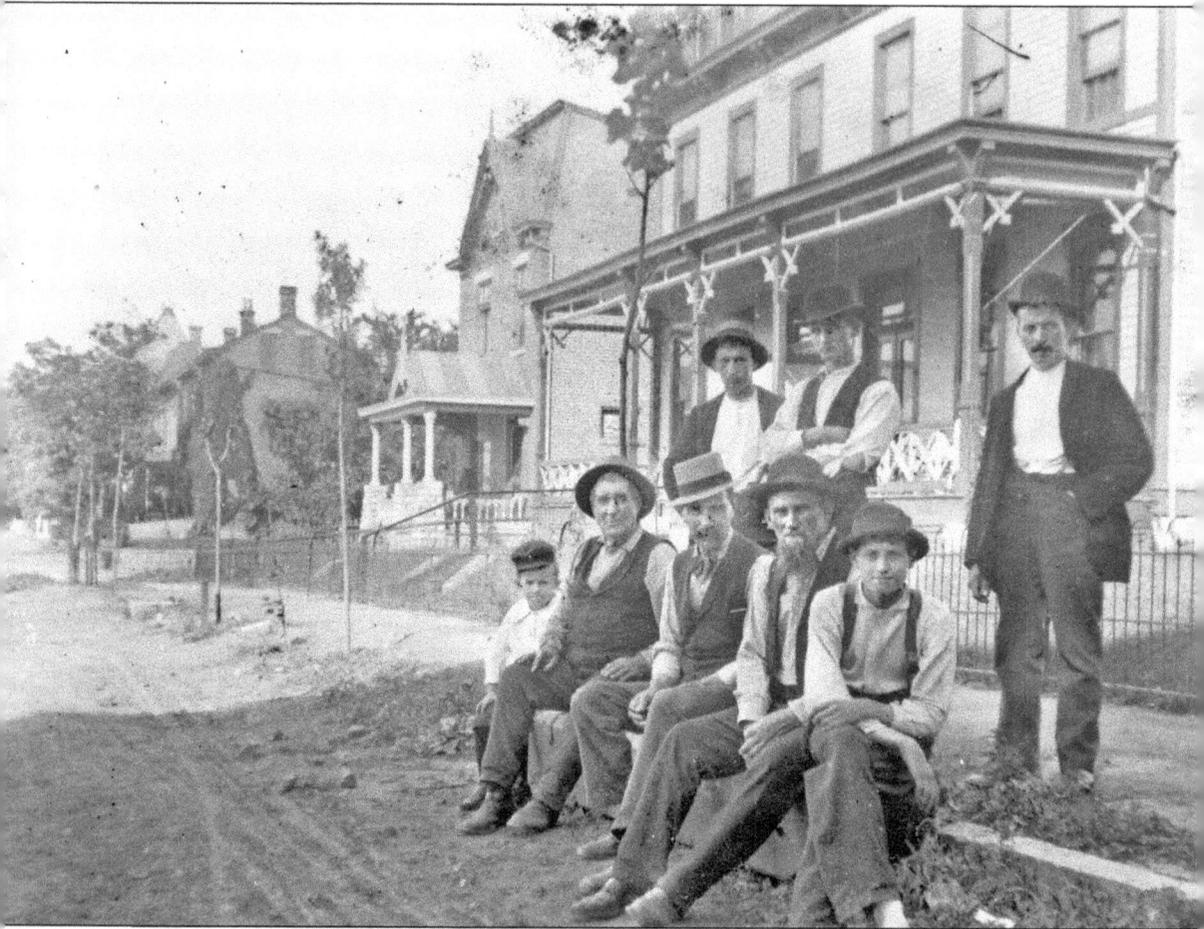

A group of men stand proudly in front of one of their favorite houses along Prospect Street. Prospect was developed as a popular residential street in the late 19th and early 20th centuries.

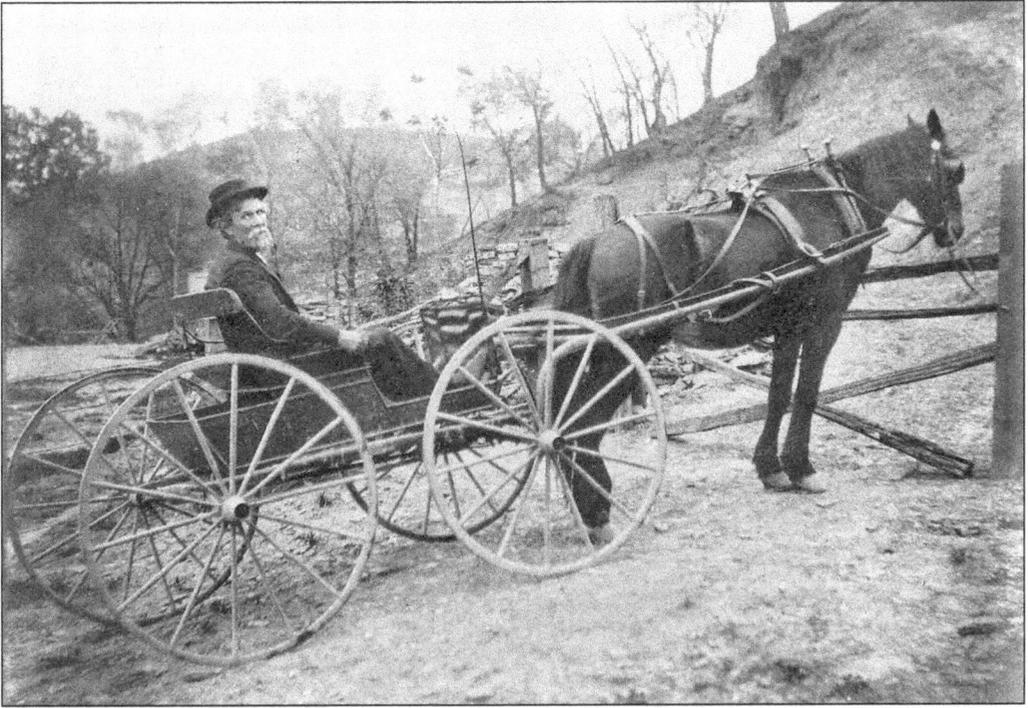

Outside of the developed portions of Bellevue, this man enjoys a ride through the farmland south of the city in the late 1890s.

Bought by Campbell County in 1923, the Covert Run toll road became the final toll road in Northern Kentucky to open up to public use. The road started at this toll gate in Bellevue and meandered up the hills into Fort Thomas to the south. A once-profitable venture, the toll road ceased to be necessary when faster transportation made it easier to take alternative routes. This photograph was taken near the time that the road went toll-free.

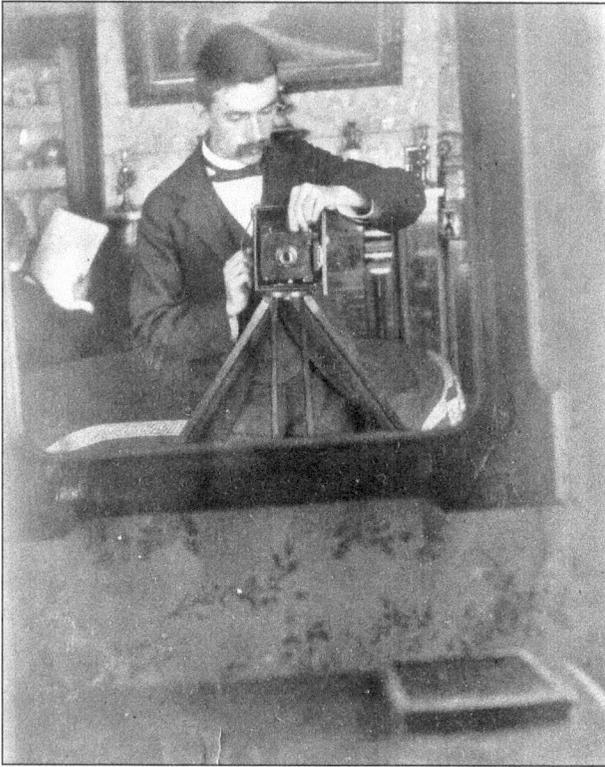

William A. Wall, a locally famous Bellevue photographer, prepares to take a self-portrait in his shop.

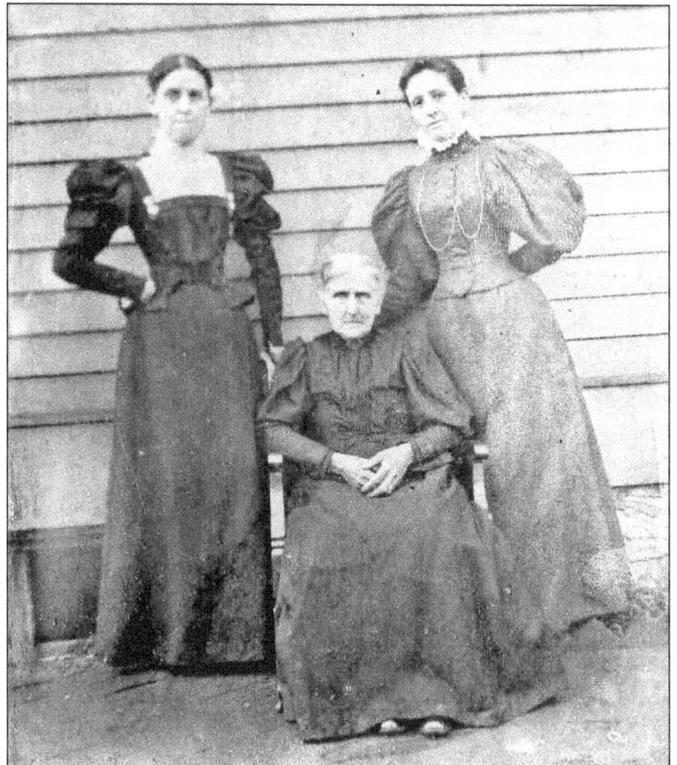

These ladies of Bellevue, Mrs. Whittington and her daughters, take a moment from their day in December 1896 to pose for this picture at their house on Front Street.

Here stands William A. Wall, a locally famous photographer from Bellevue in the late 19th and early 20th centuries. Wall traveled throughout the Greater Northern Kentucky and Cincinnati area photographing buildings, places, and impromptu portraits of people. This photograph is a self-portrait.

Mrs. Edith Fisher stands in the back yard of her Bellevue house in 1896.

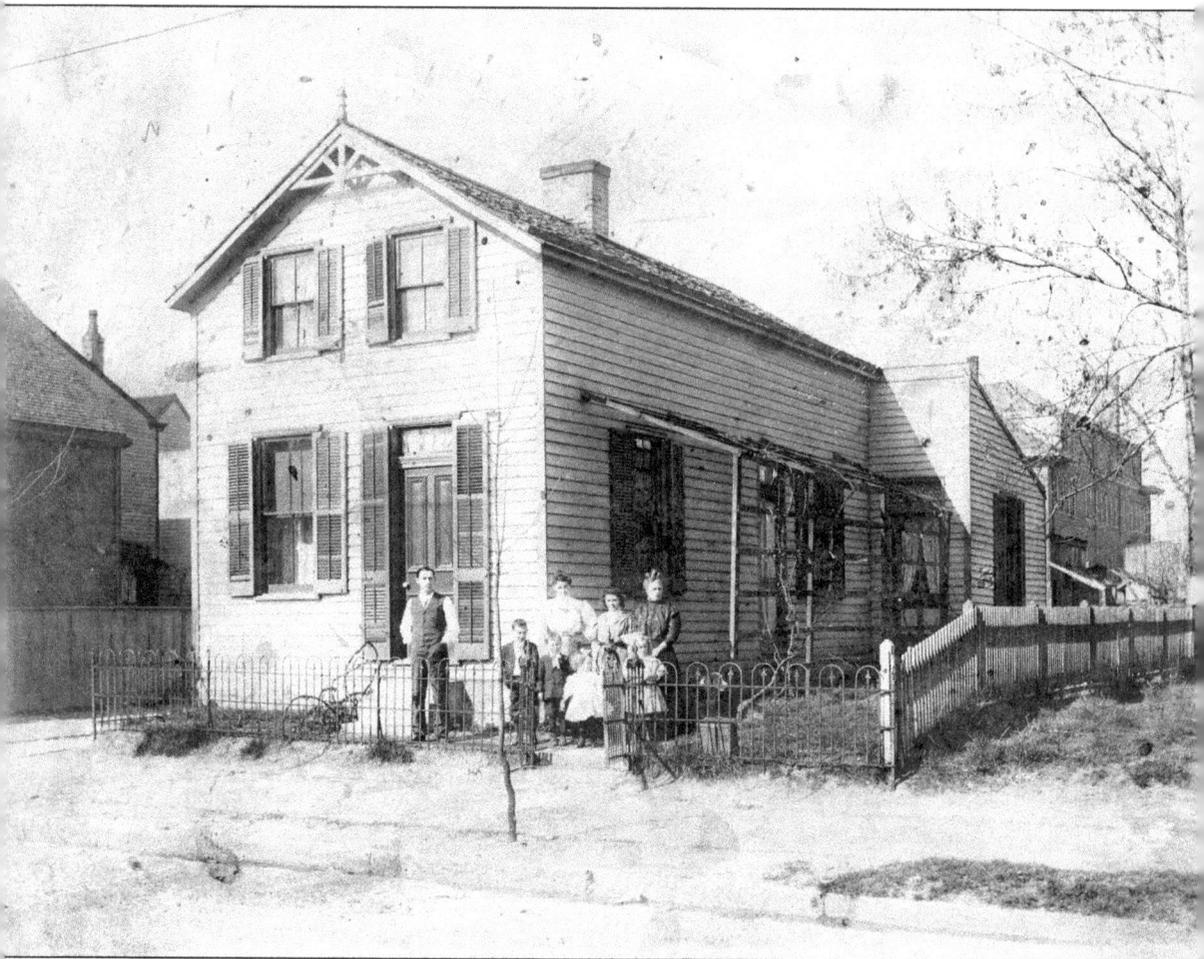

This 1905 home to the Rothfuss family at 409 Taylor Avenue typifies early 20th-century vernacular Victorian architecture. From left to right, Frederick, Fred William, George, Nora, Mildred, and three unidentified friends line up in their front yard. Notice the working shutters on the windows and doors to protect the home during storms.

Mrs. Anne Fisher smiles for a
Christmas portrait in December 1896.

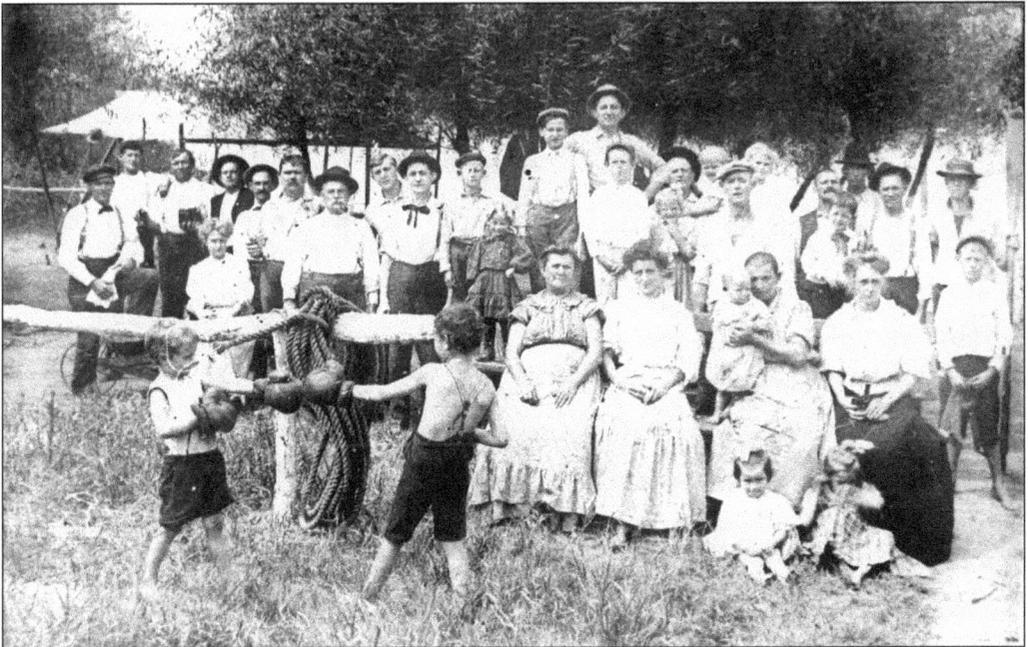

Today parents take their children to Tae Kwon Do classes; at the turn of the 20th century, it was
boxing. Here a couple of young boys keep their guard up while their families pose with them for
this photograph along Bellevue's riverfront.

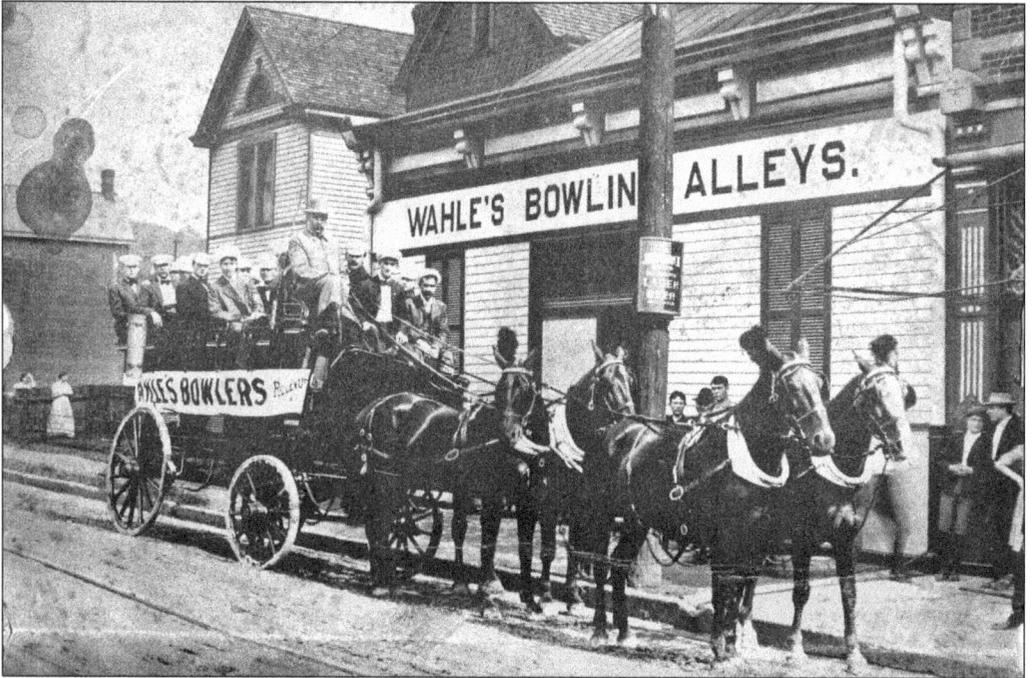

Sports have played a major role in building Bellevue's community, and in the early 20th century, Wahle's Bowling Alleys was at the center. Men and women alike flocked to the lanes on Fairfield Avenue for weekly tournaments that drew competitors from across Northern Kentucky.

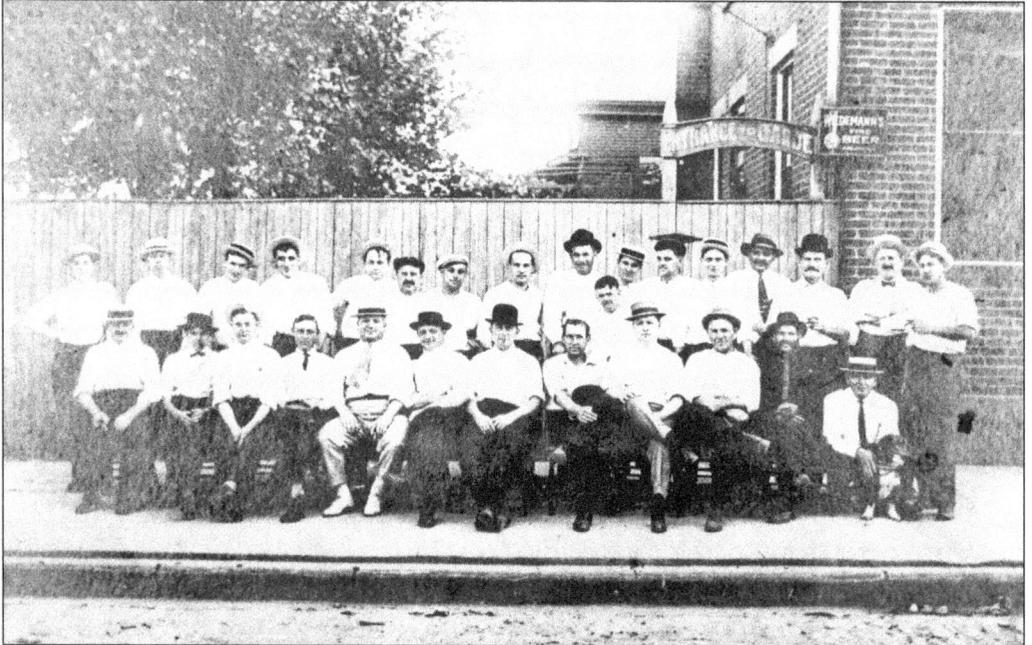

Patrons of a tavern (later named the WE Tavern) on the corner of Taylor and Walnut Streets gather for a photograph just outside the entrance to the beer garden one summer afternoon. The region's German and Irish heritage was often celebrated by consuming locally brewed beers at beer gardens or pubs like this throughout the area.

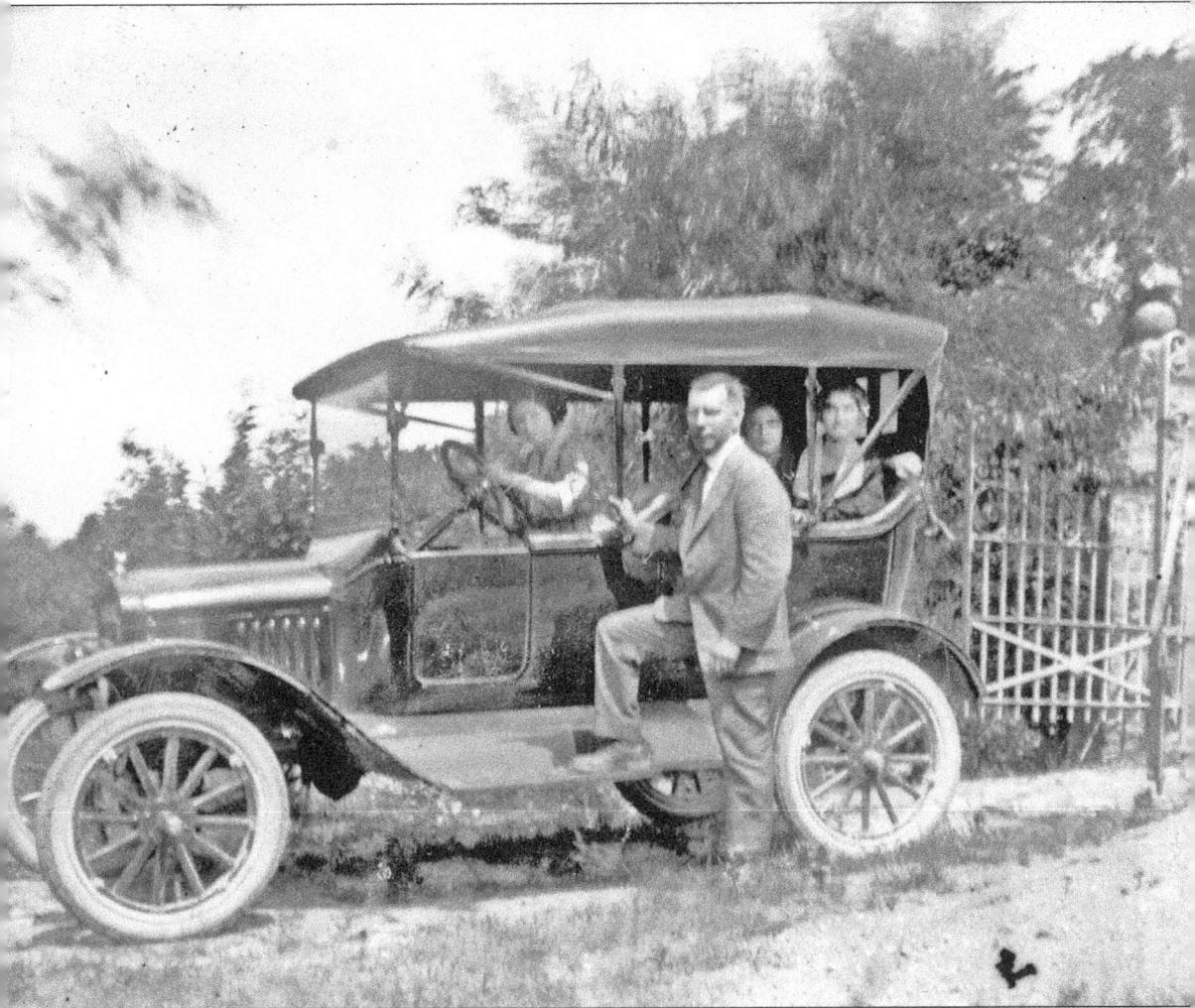

This is the car that put Bellevue, as well as the rest of the country, on wheels. It is the legendary Ford Model T. Henry Ford was notoriously resistant to change, so this basic touring-car design was virtually identical from 1917 to 1921. However there are a few clues that narrow it down to either a 1919 or 1920 model year. Oil-burning cowl lamps were standard on Model Ts until 1919. Beginning in 1919, they were still standard, but only on non-starter cars. Their absence in this photo indicates the owner selected a car with an electric starter—a wise decision. The demountable rims shown were not available on open cars until 1919 and then only as an option. The vertical seam in the rear of the body just above the rear fender and the style of rear top latch were both last used in the 1920 model.

Parked across Taylor Avenue, Pat (center) and Joe (left) Heekin and Al Schwartz, show off their newly customized hot rod in 1913. This highly modified speedster is difficult to positively identify. It could be a 1910–1913 Hudson. The shape of the radiator was used by Hudson as well as at least two dozen other companies. If it is a Hudson, the Hudson radiator emblem (a triangle) has been removed. The body appears to be custom built, and the electric lights were

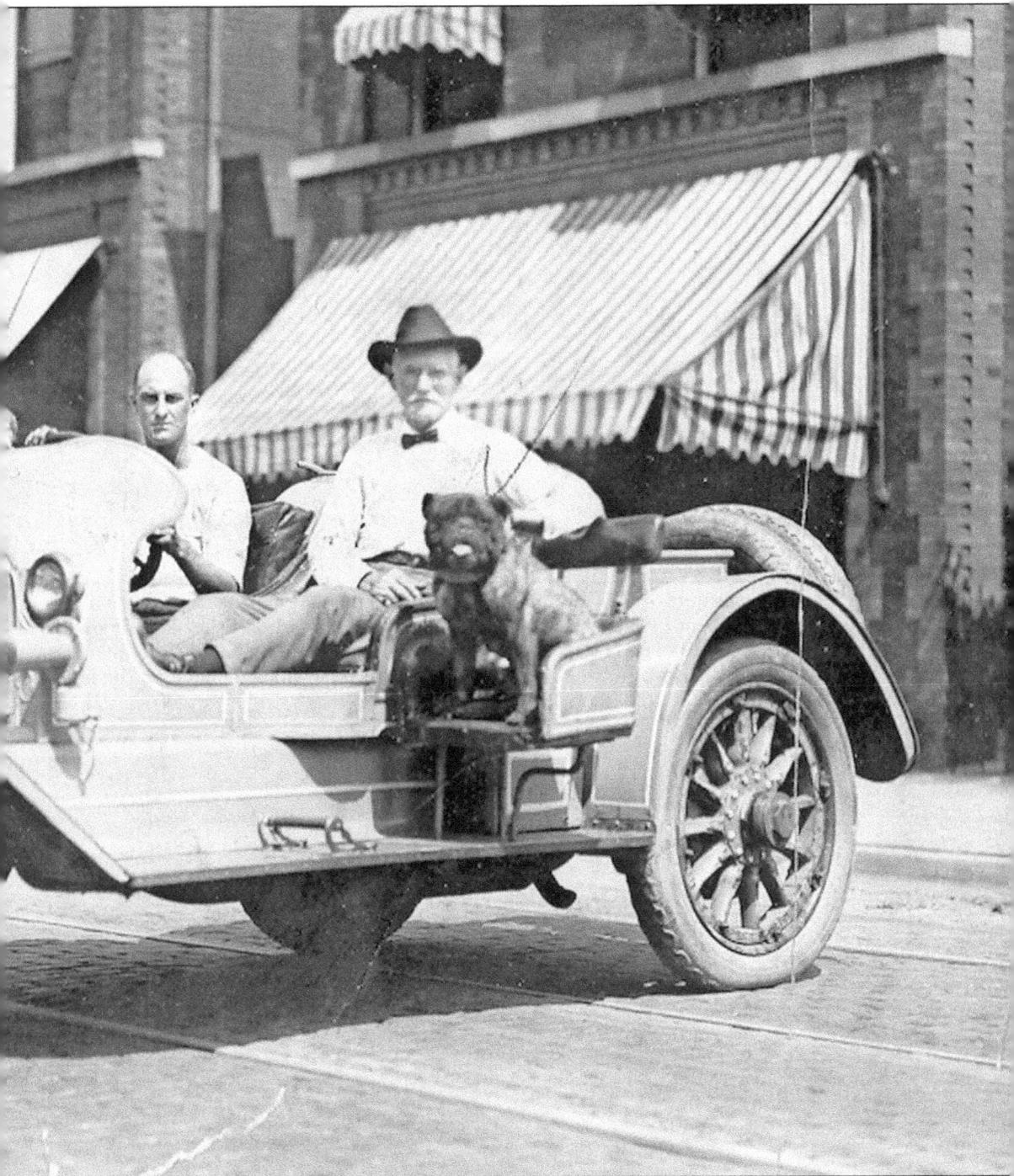

most likely installed by the owner. The bumper and rear-view mirrors are also owner additions. Notice that the vehicle was a right-hand-drive model. In the early years of the automobile, many things were not standardized, including the seating position of the driver. The bulldog in the added side-seat is an interesting choice for an early anti-theft system.

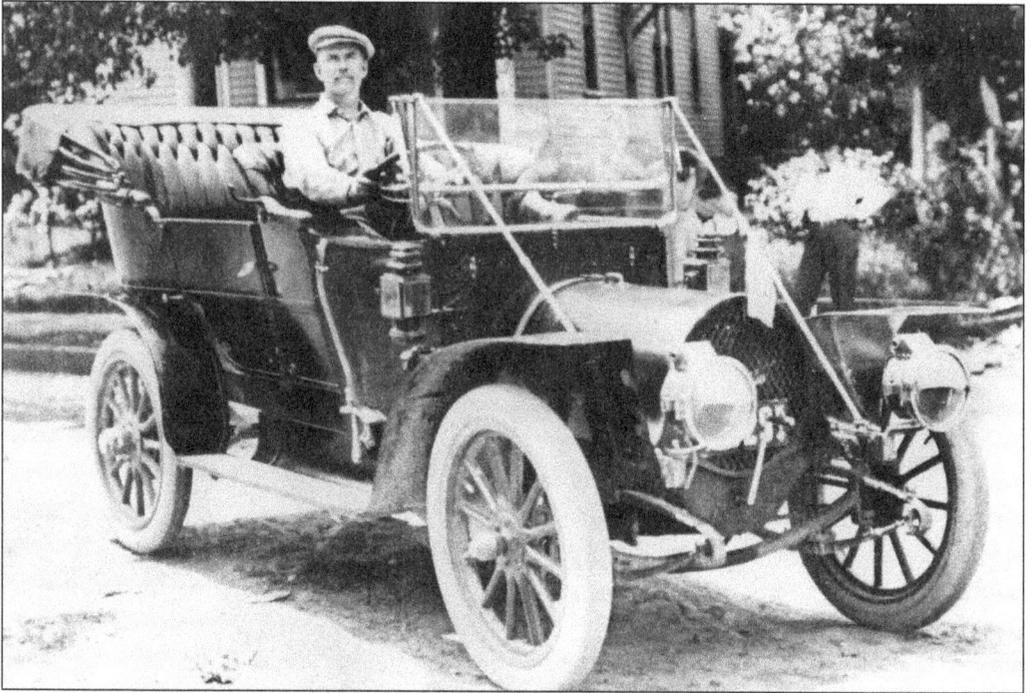

This gentleman poses in his 1909 Franklin. Franklin built America's most successful line of air-cooled cars from 1902 until 1934. This model was made from 1905 to 1911. After 1934, Franklin built aircraft engines, although one more car was powered by a Franklin engine: the infamous 1948 Tucker. Kentucky began to issue license plates in 1910. The white diamond on the lower right indicates this plate was issued in 1914.

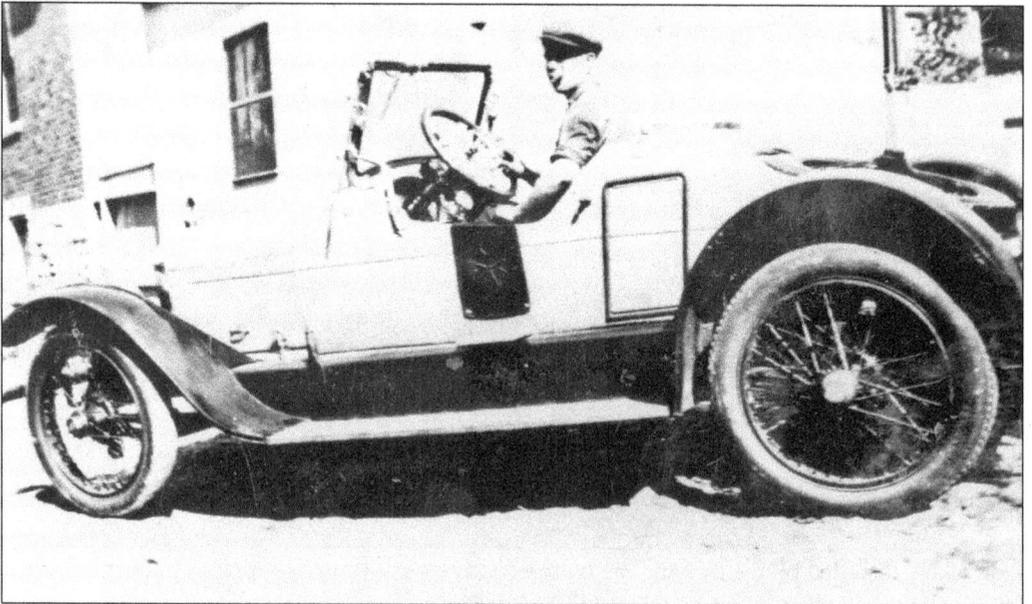

A young Bellevue man poses in his car in an alley off of Berry Avenue. The car is likely a 1920s Stutz Model H Bearcat. Notice the rectangular door in the bodywork just in front of the rear fender. The door opened to a space that was ideal for storing a set of golf clubs.

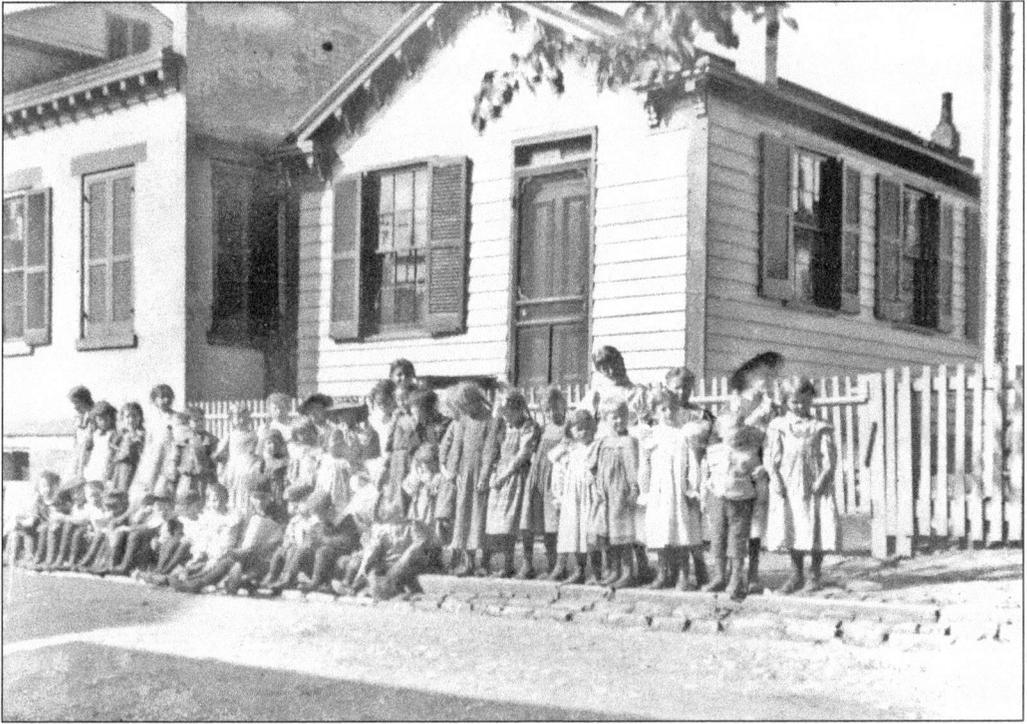

A group of children line up along the street for this quick portrait. Note the Italianate–style shotgun cottages that were common in Bellevue.

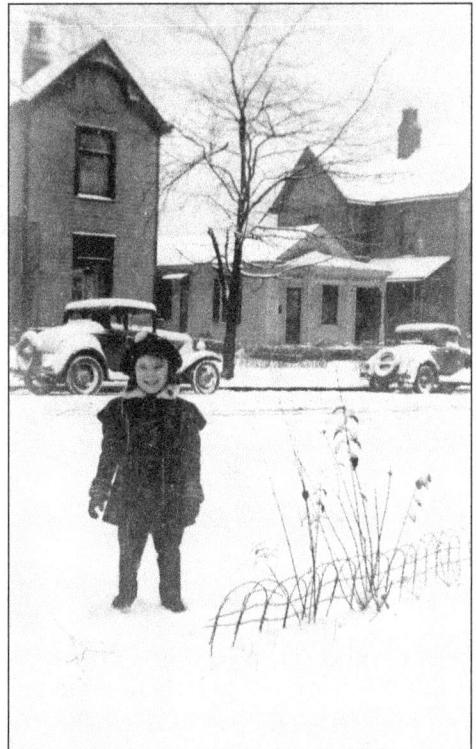

Little Patricia plays in the snow on Foote Avenue. The two-and-a-half-story Queen Anne residence on the left of the Italianate cottage in the background were common in Bellevue.

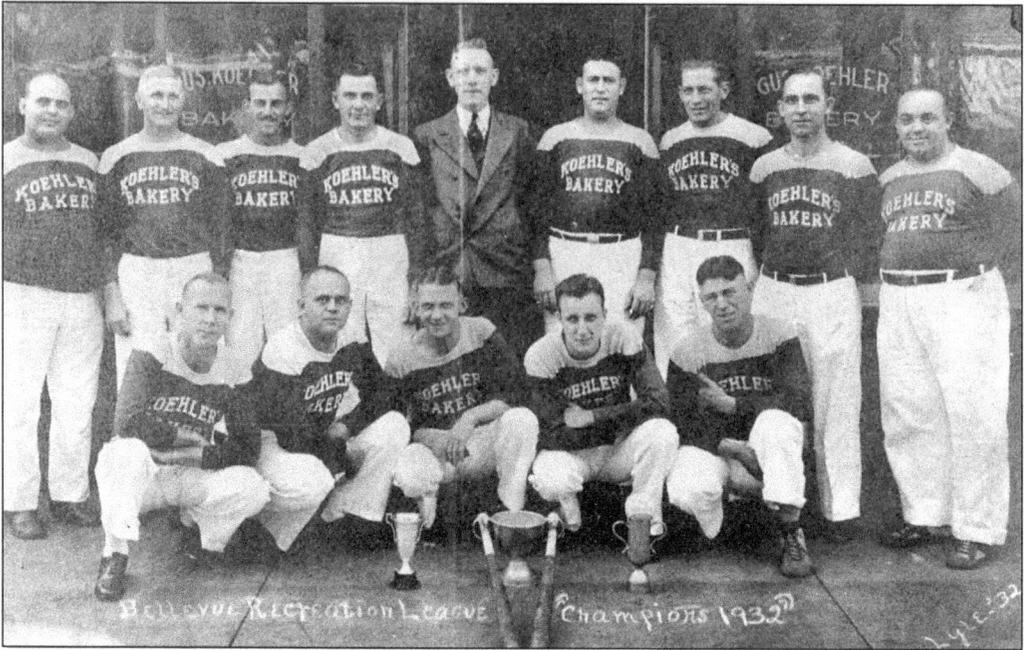

Amateur baseball was a big part of Bellevue summers. Locally famous for the baseball talent in its community, Bellevue always had a proud history of championship-winning teams. The Koehler's Bakery team, sponsored by Gus Koehler's Bakery, won the local recreation-league championship in 1932.

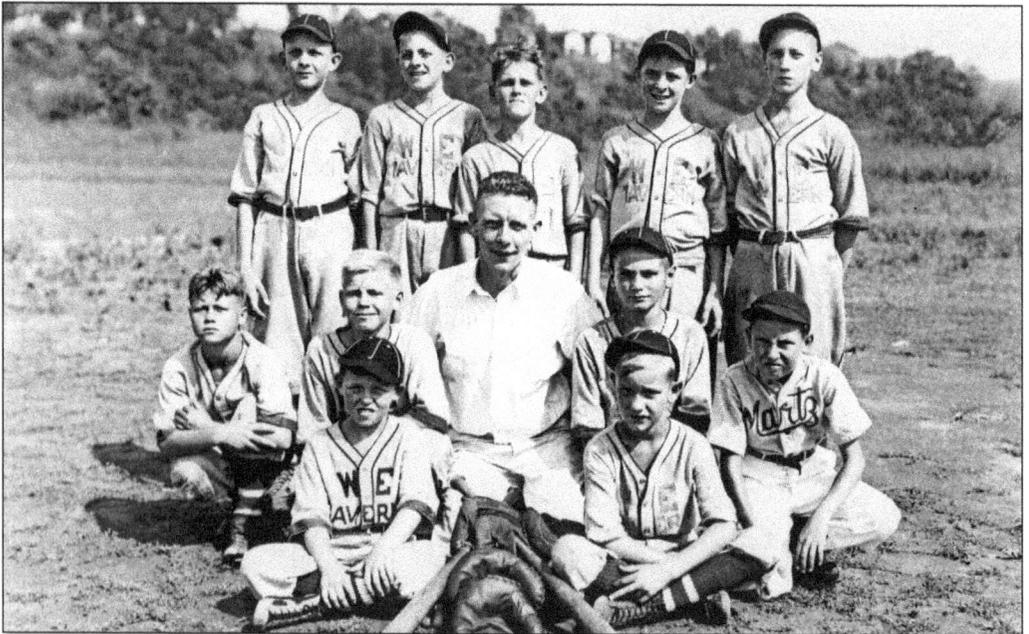

Baseball caught on at a young age in Bellevue. The boys on this little-league team look to mimic the successes of other amateur teams in the city. The Cincinnati area has been baseball crazy for over a century, and the early residents of Bellevue were no different. This team was sponsored by the WE Tavern, located at Walnut Street and Taylor Avenue.

This 1930s photograph showcases the latest in "modern" football gear. The helmets were mostly made of heavy leather, and the limited padding existed mostly on the trousers. On the left in this photograph stands young Adolph Perry, who would go on to serve Bellevue as its police chief from 1948 to 1967. After his retirement from police service, Chief Perry continued to serve as a crossing guard for the school system until the late 1980s.

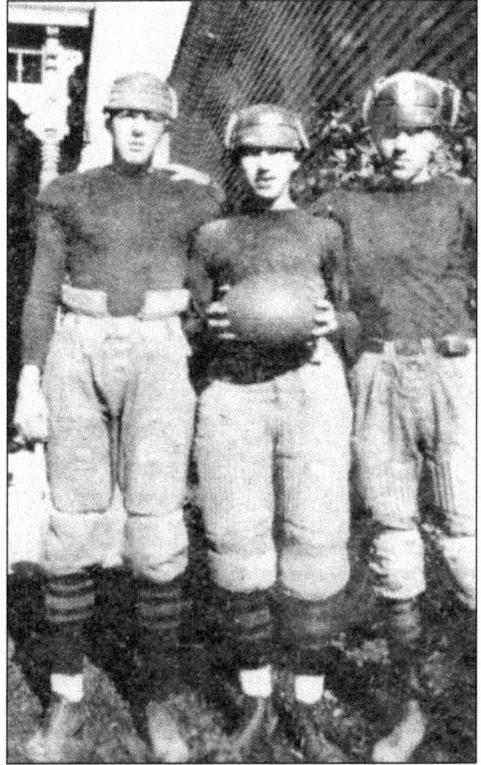

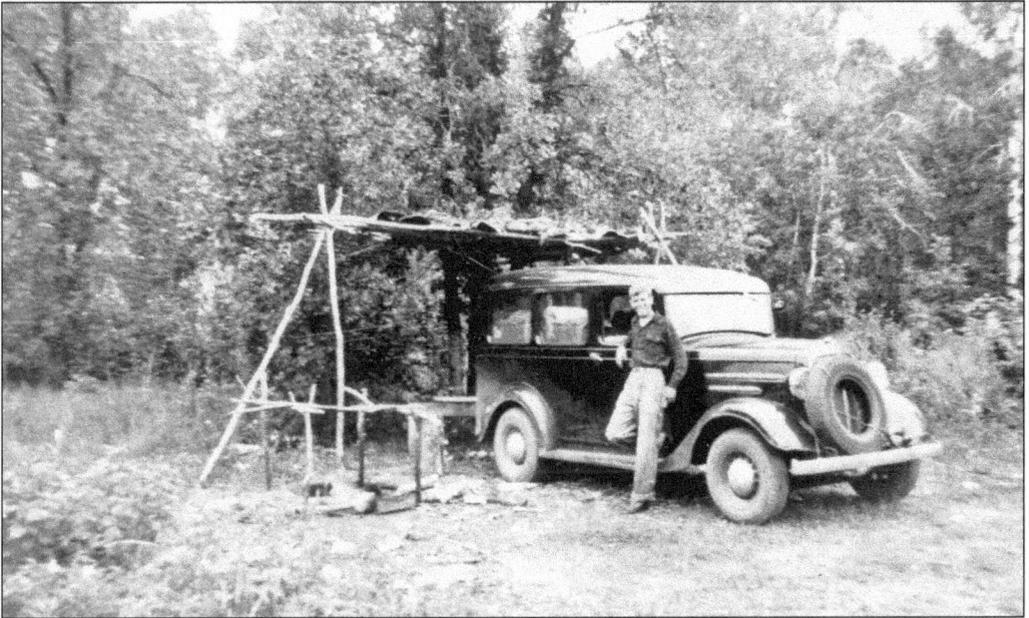

Chevrolet's huge Suburban is now considered the bane of the ecology by some environmentalists. It was not so controversial in its second year of production. The owner of this 1936 version, then known as the Carryall Suburban, appears to be enjoying a peaceful coexistence with nature during a little camping trip on the outskirts of town. Chevrolet's trademark bow tie is missing from the hood.

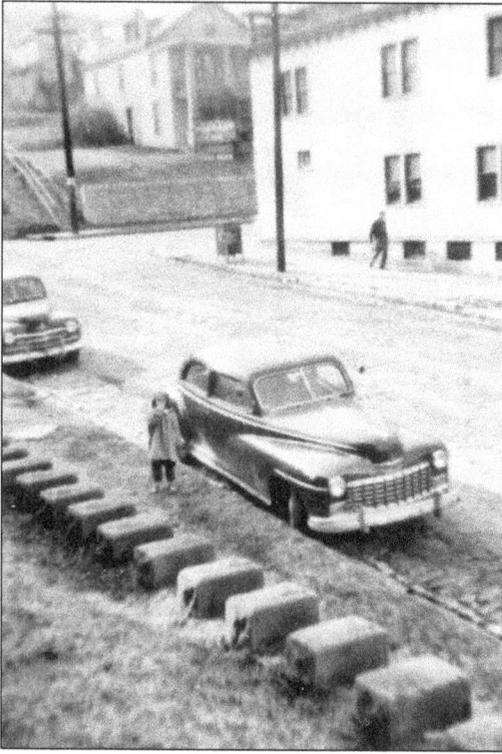

During World War II, automotive production gave way to the production of war materials. When the war ended, car manufacturers began producing essentially the same models that had been sold prior to the war. Here stands a young man wishing he could take his father's Dodge for a spin around the block. It could be a 1946, 1947, or 1948 model, as they were virtually identical. Many of Bellevue's streets at that time were still primarily cobblestone or brick.

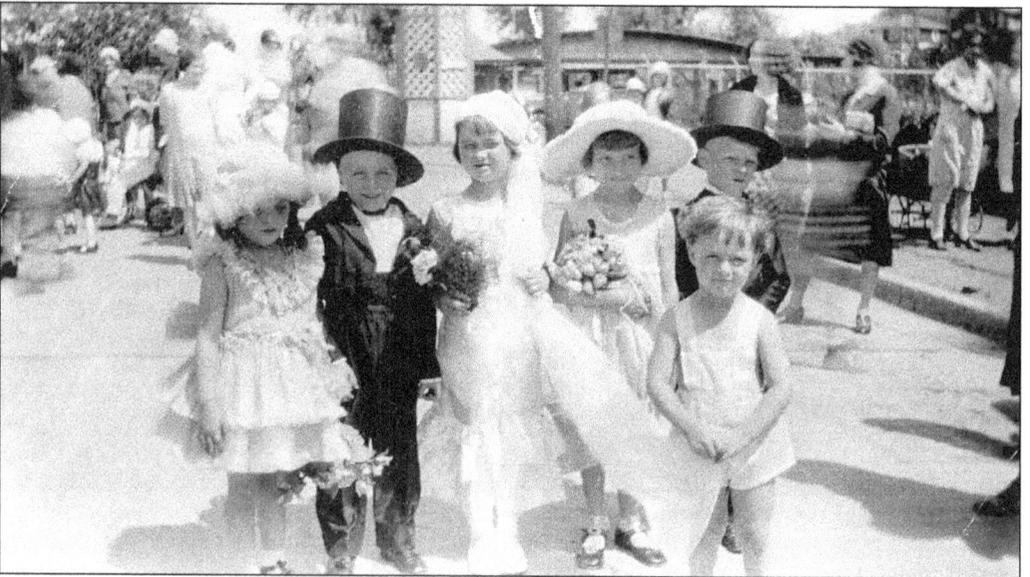

Five young Bellevue residents have fun playing dress-up in a mock wedding on one warm summer afternoon.

Dressed for a cold winter day, Carole Swope and her brother, Tom, stop on the sidewalk of their Ward Avenue home before heading out to enjoy their free time. Carole continued the Swope family's history of service to Bellevue as the first female member of the Bellevue City Council.

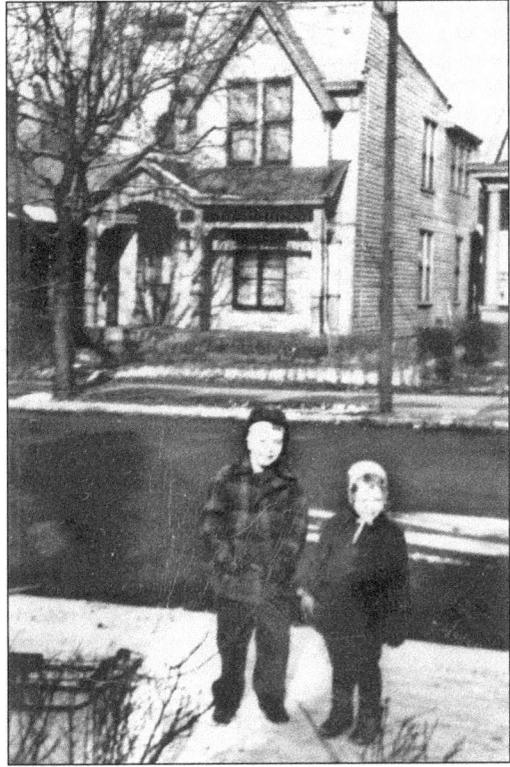

A young Tom Swope, dressed for church, stands near his family's house at 328 Ward Avenue. Built between 1895 and 1896, this home was a two-and-a-half-story Victorian residence.

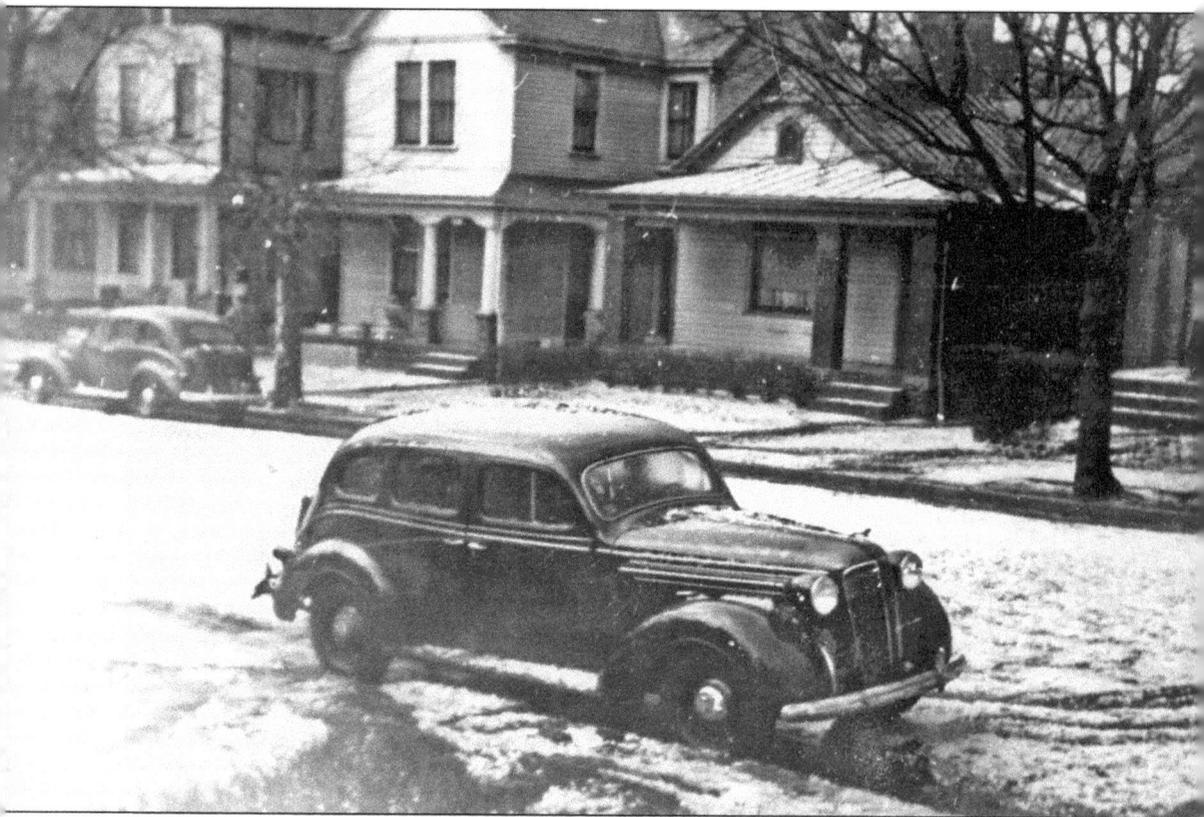

Pop Krebs's car is parked along a Bellevue street in March 1936. Notice the old "suicide" doors at the back of the car.

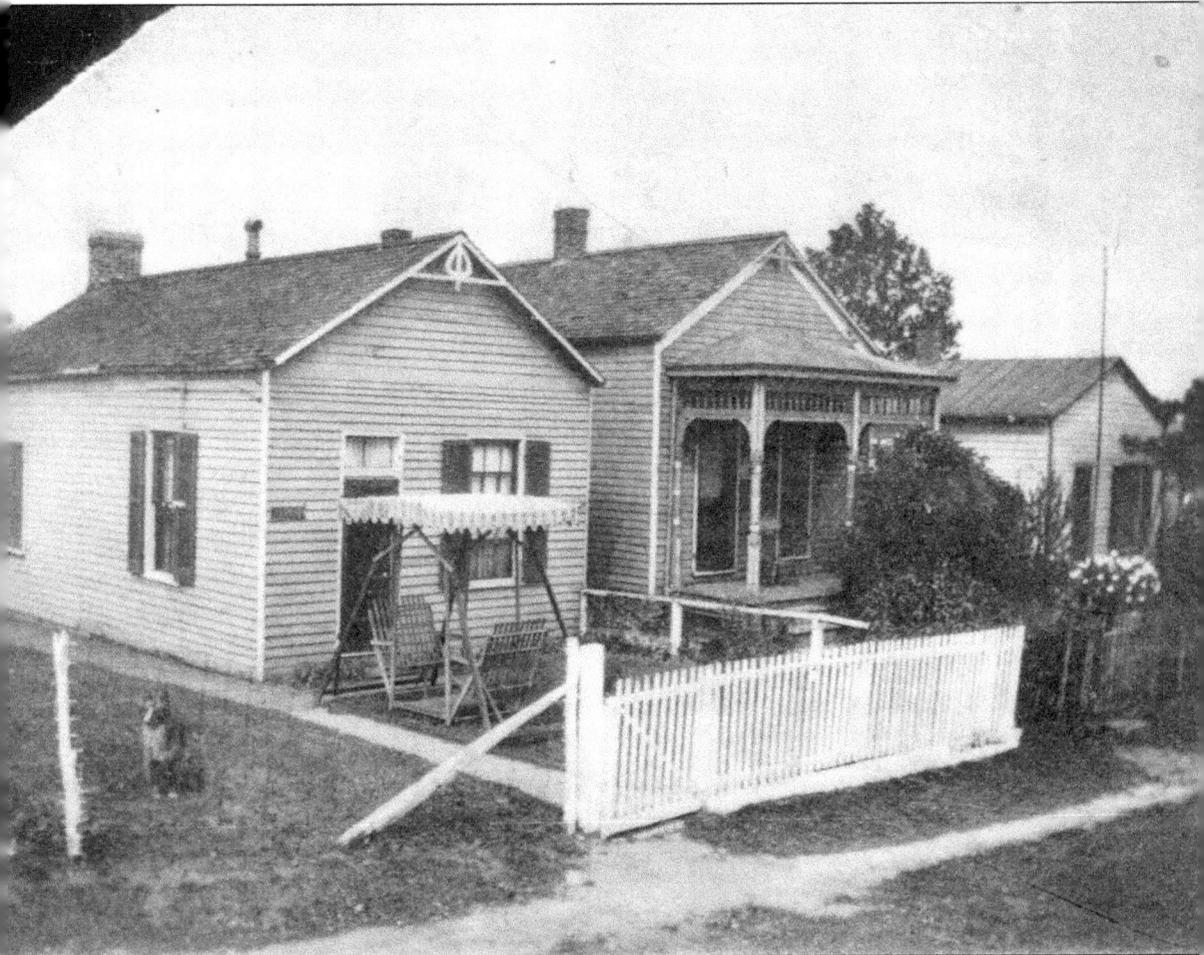

These small shotgun-style cottages on Bellevue's periphery were typical of the some of the houses built on smaller lots scattered throughout the city.

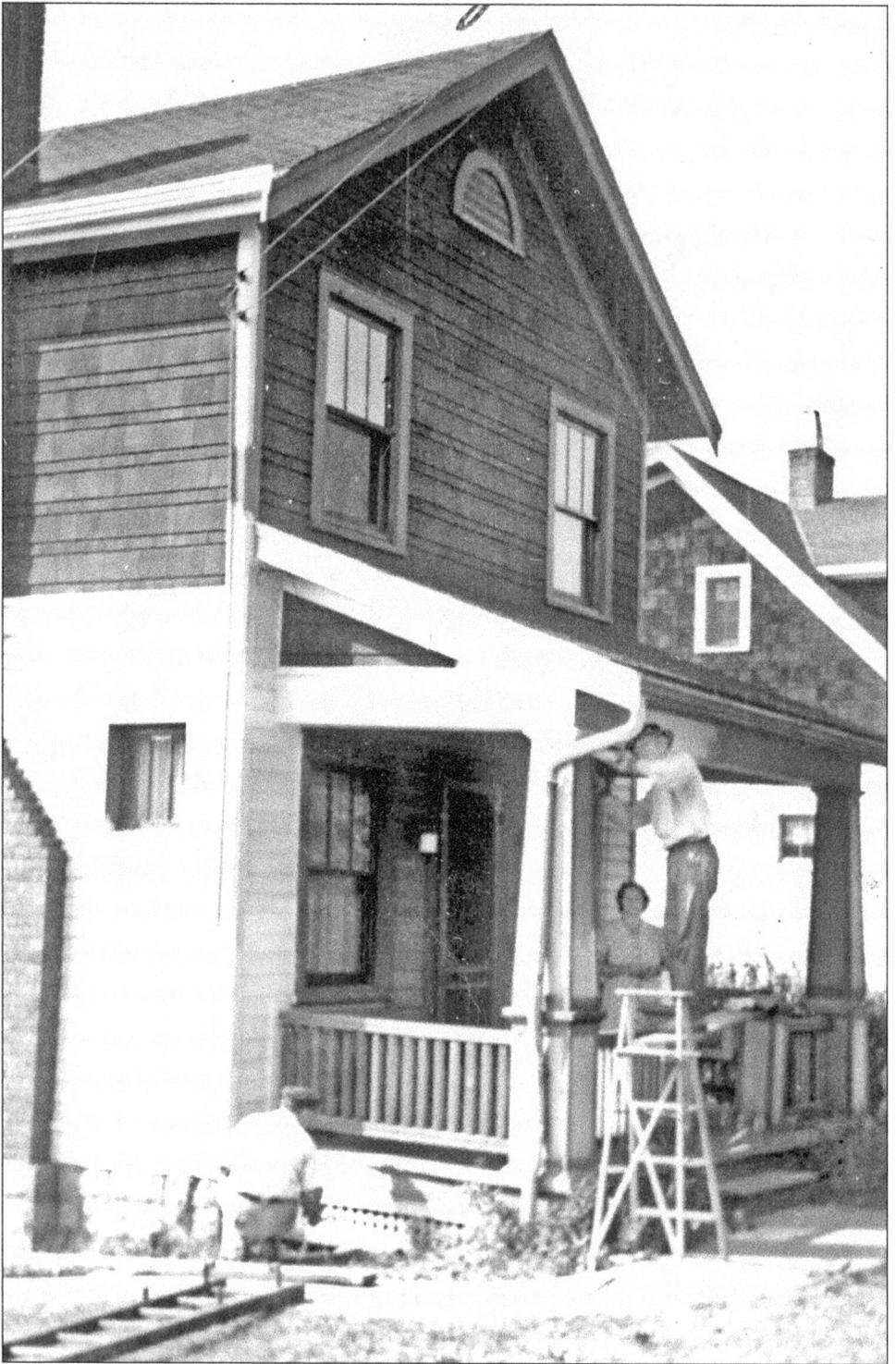

Mrs. Swope supervises the completion of various home-repair projects from the front porch of her home at 326 Ward Avenue. This home was built in the early 1890s.

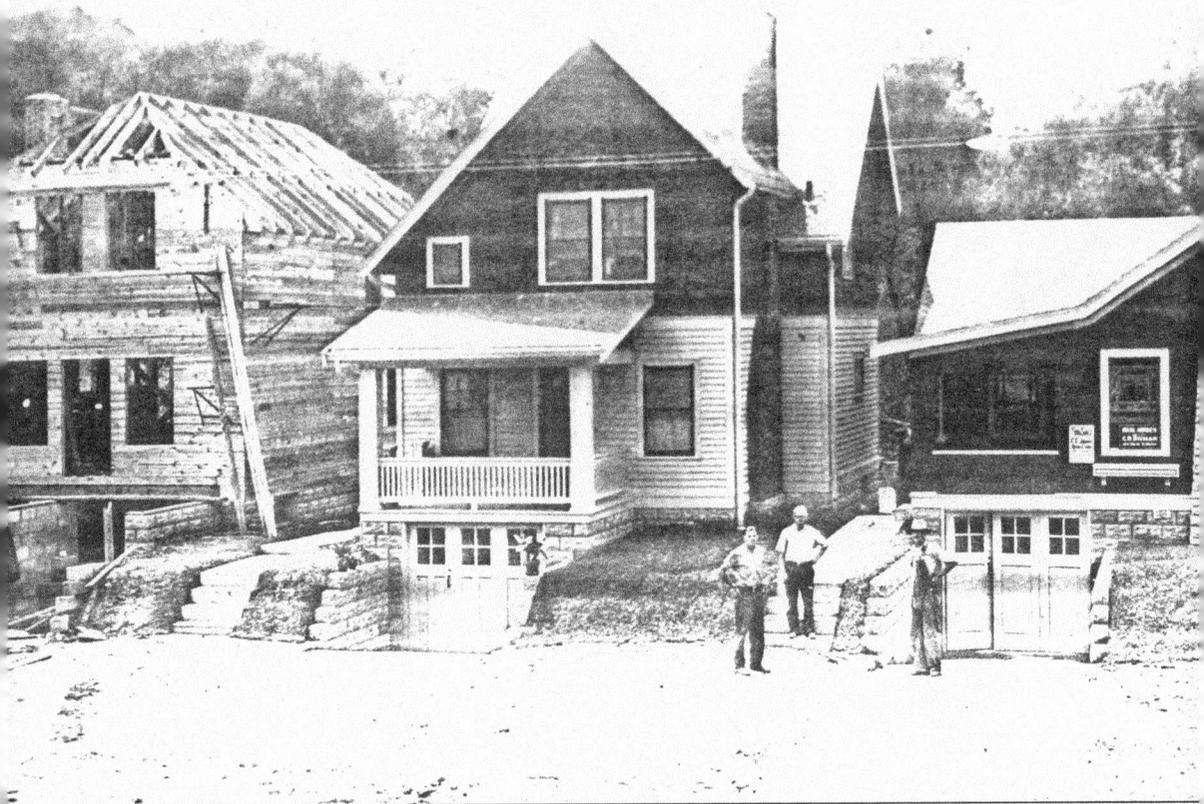

There was a bungalow building boom on Covert Run Pike in the 1920s. "Scores of neat homes" were built for middle-class families along the picturesque roadway that follows the creek of the same name. Pictured are the homes of John E. Kaiser, Mrs. Mary E. Seeger, and James E. Schaub. The Covert Run Pike, which connects Bellevue and present-day Fort Thomas, was built as a toll road in the early 19th century. Tolls were removed around 1920, and the road was paved with asphalt in 1926.

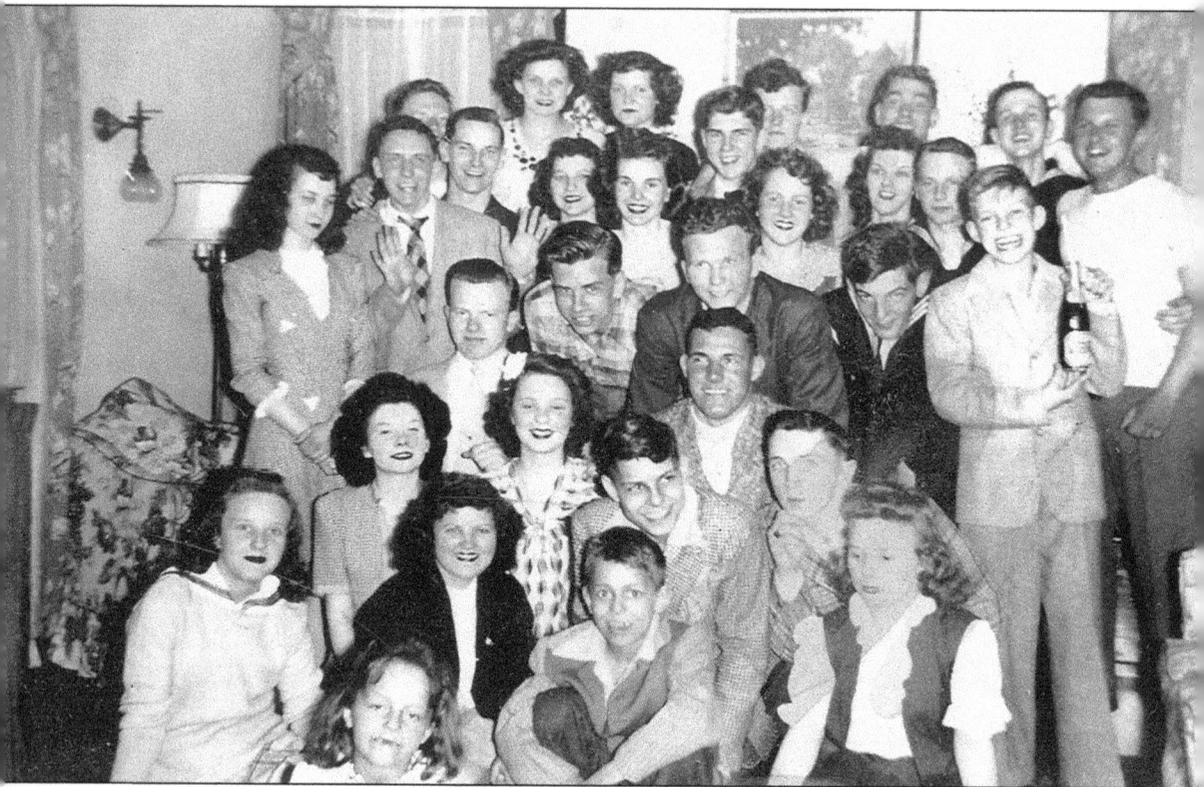

A group of young people gathers at the Rechtin House at 411 Van Voast Avenue in 1945.

These young ladies are standing in front of a rare 1942 Plymouth convertible. Automotive manufacturing was halted on January 31, 1942, to retool for war production. The bright trim on this car indicates it was made early in the shortened run. All cars built from mid-December 1941 to the end of January 1942 were "black out" models. The bumpers, hubcaps, and trim were painted instead of chrome plated. The mineral chromite, used in chrome plating, was desperately needed in the war effort.

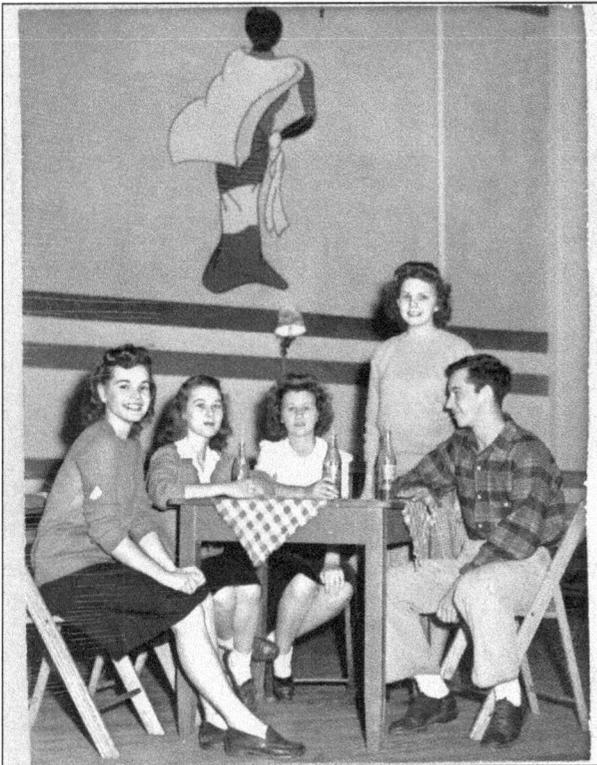

Bellevue teens gather for a soda while at a dance at Horseshoe Gardens in the 1950s. Long after the beaches on the riverfront closed, the clubhouse remained open as a location for dances and other social gatherings. Teen mixers, held regularly, gave the teens an opportunity to socialize outside of the school environment.

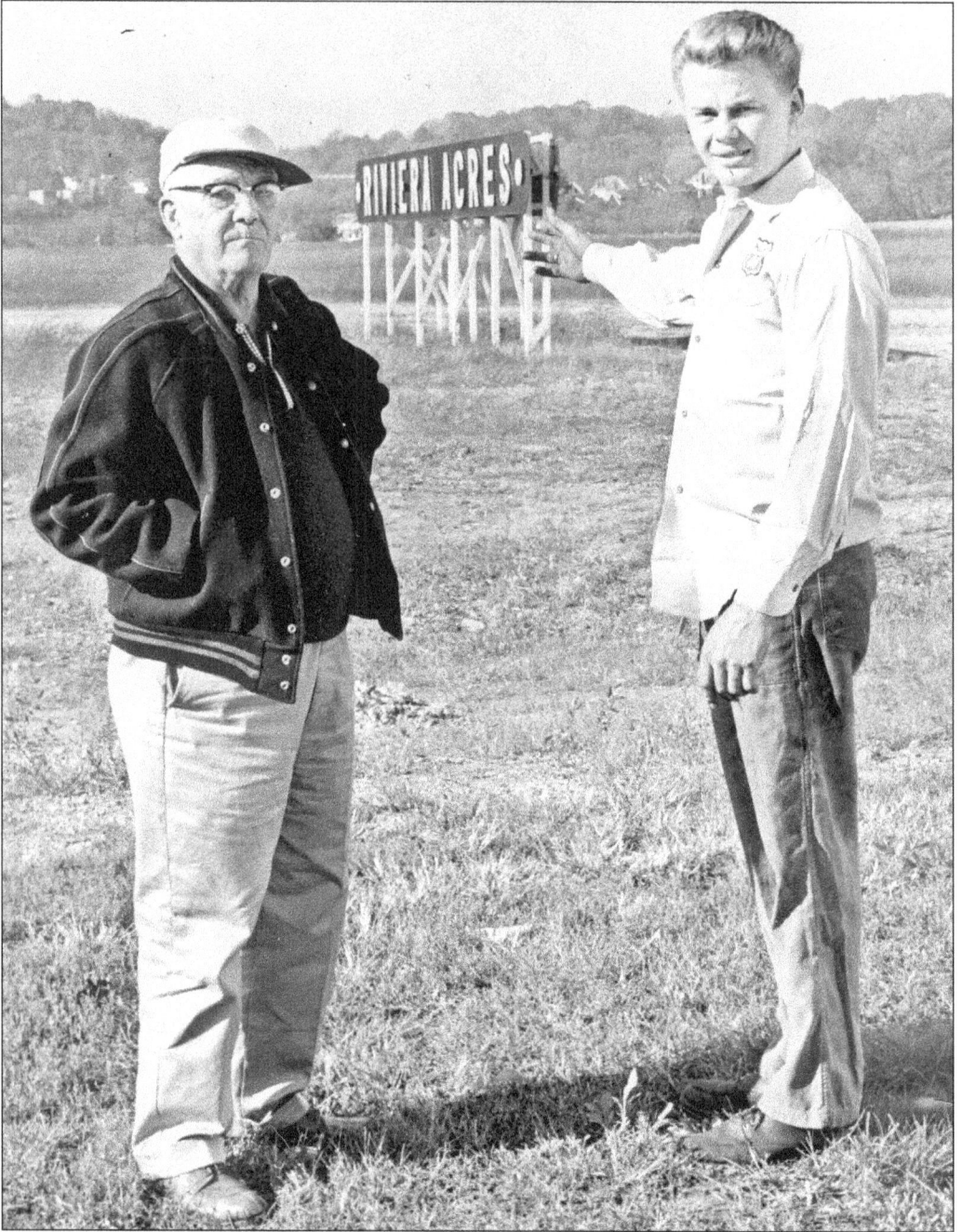

George Mogge (left) and Earl Stevens pose here in front of "The Fill" in October 1965. A site for potential development along Sixth Avenue (now Donnermeyer Drive), The Fill sat vacant for years. The Riviera Acres sign behind the men had long marked The Fill as the location for a planned development. The Riviera Acres plans were never completed, but the land was later developed into a retail district for Bellevue. The roadway to the west of this property is now named Riviera Drive.

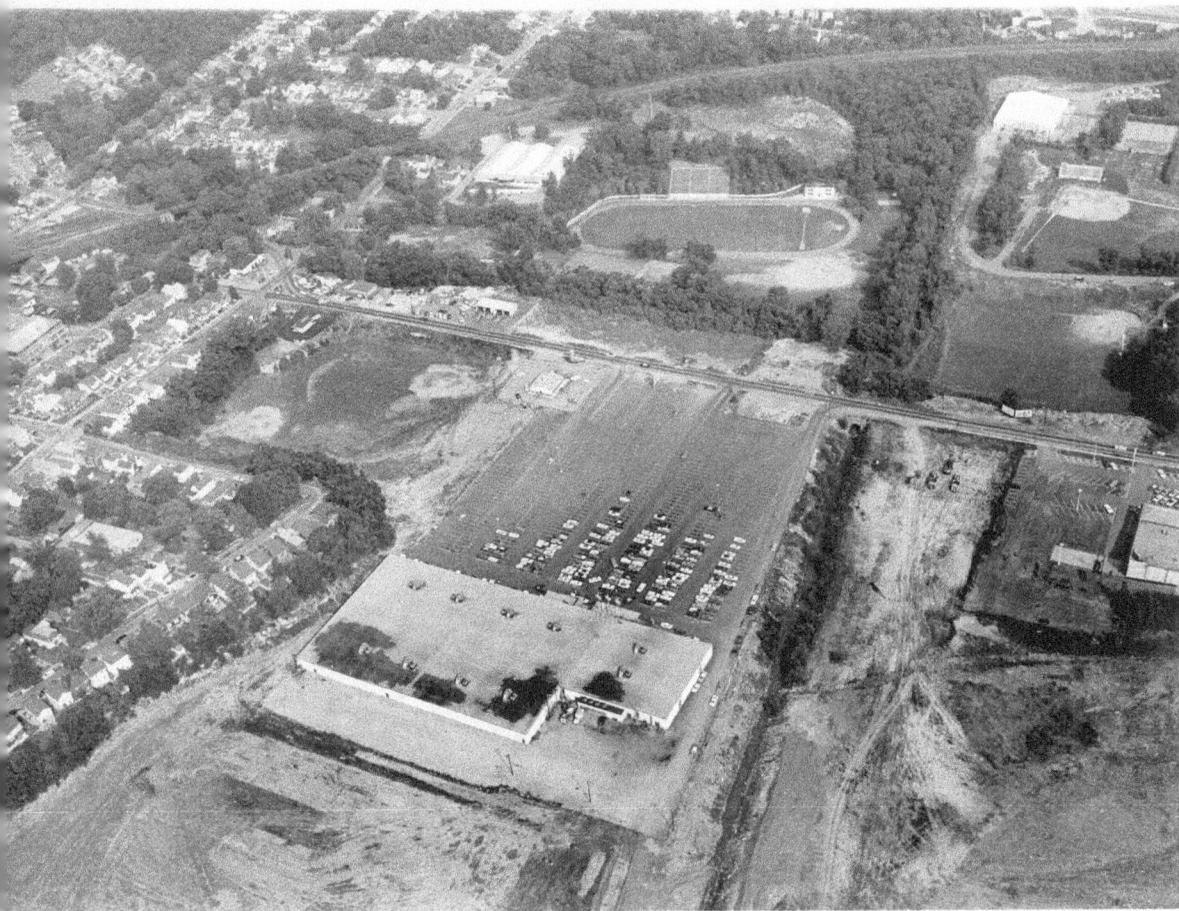

This aerial view shows the beginnings of Bellevue's retail shopping center. Known for years as The Fill because it had been a landfill, the property was considered for several kinds of developments before finally becoming Bellevue's retail district. The building seen here has housed grocery stores, a Rinks department store, and several other businesses. In the years to follow, surrounding property included restaurants, gas stations, and other stores.

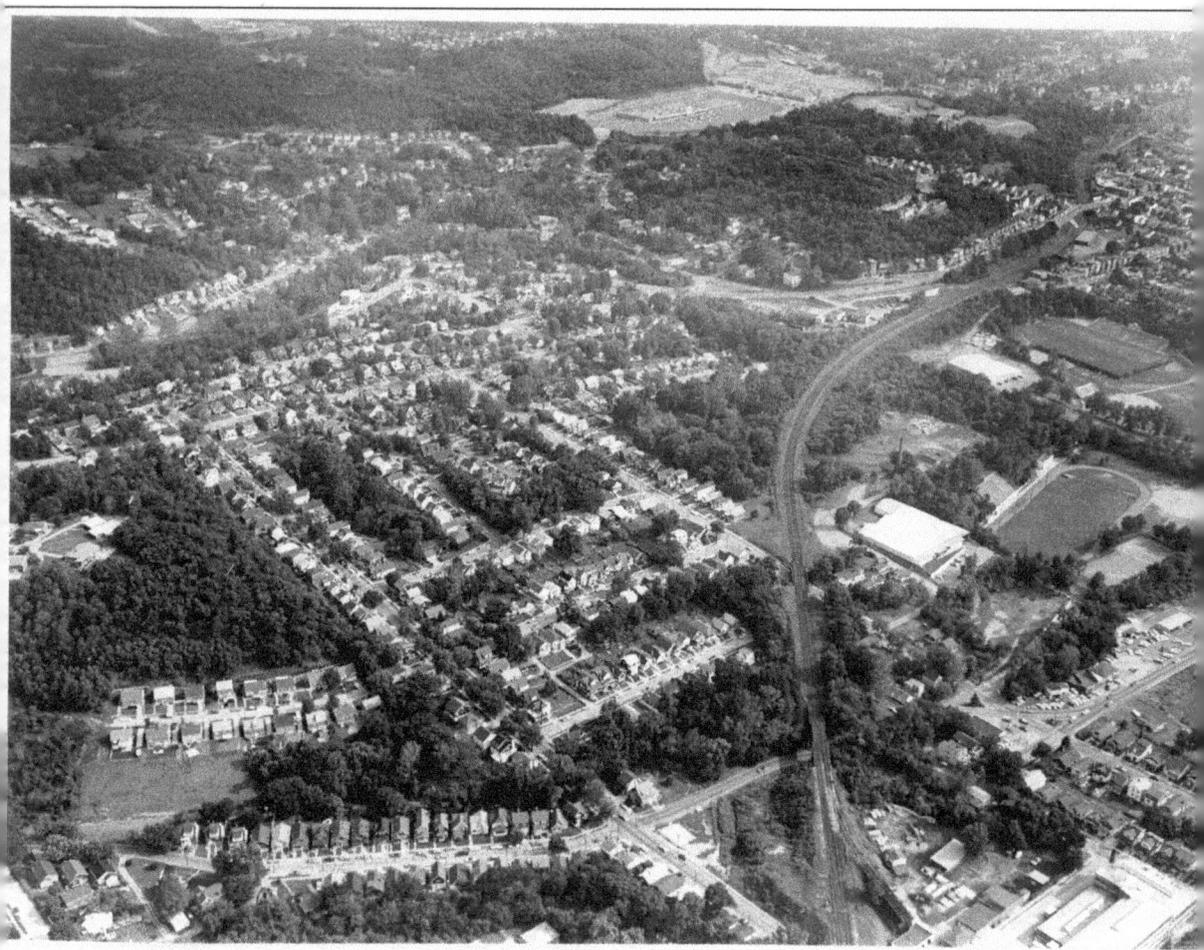

This aerial view shows the southern section of Bellevue. By the time of this photograph, much of Bellevue had been developed, primarily with housing in the southern section. At center-right is Gilligan Stadium. Kent Manufacturing Company is at the lower right. Kent was a maker of fine bathroom cabinets and vanities, as well as other items. Kent employed many people from Bellevue and Dayton.

Two

LIFE ON THE RIVER

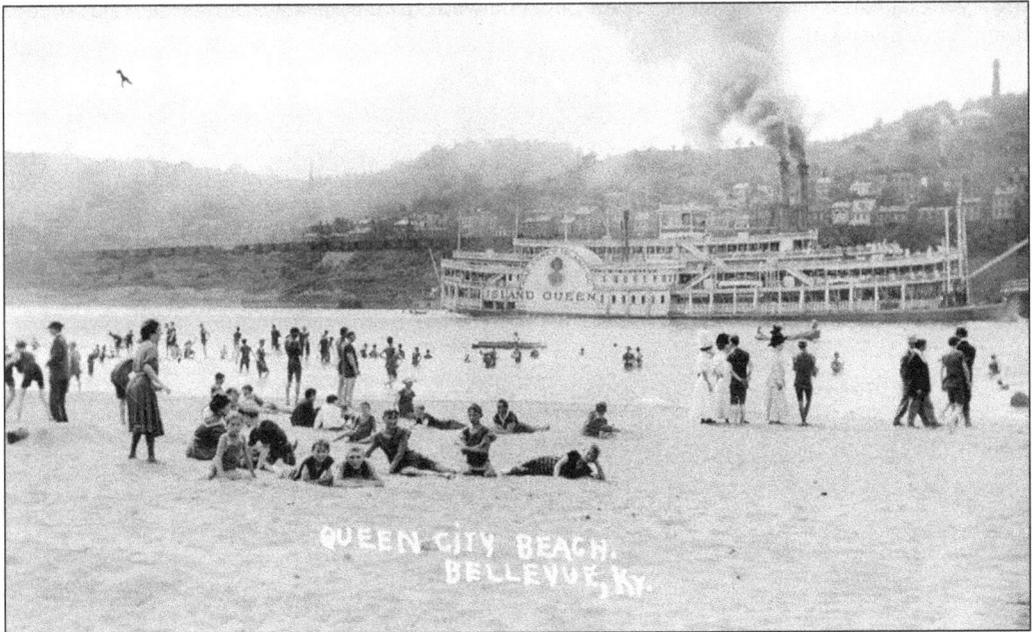

Beach goers watch the *Island Queen* steam up the river on its way to Coney Island. A regular scene during the summer, beach goers looked forward to its passing but also, for safety's sake, had to make sure they were out of its way when the boat passed.

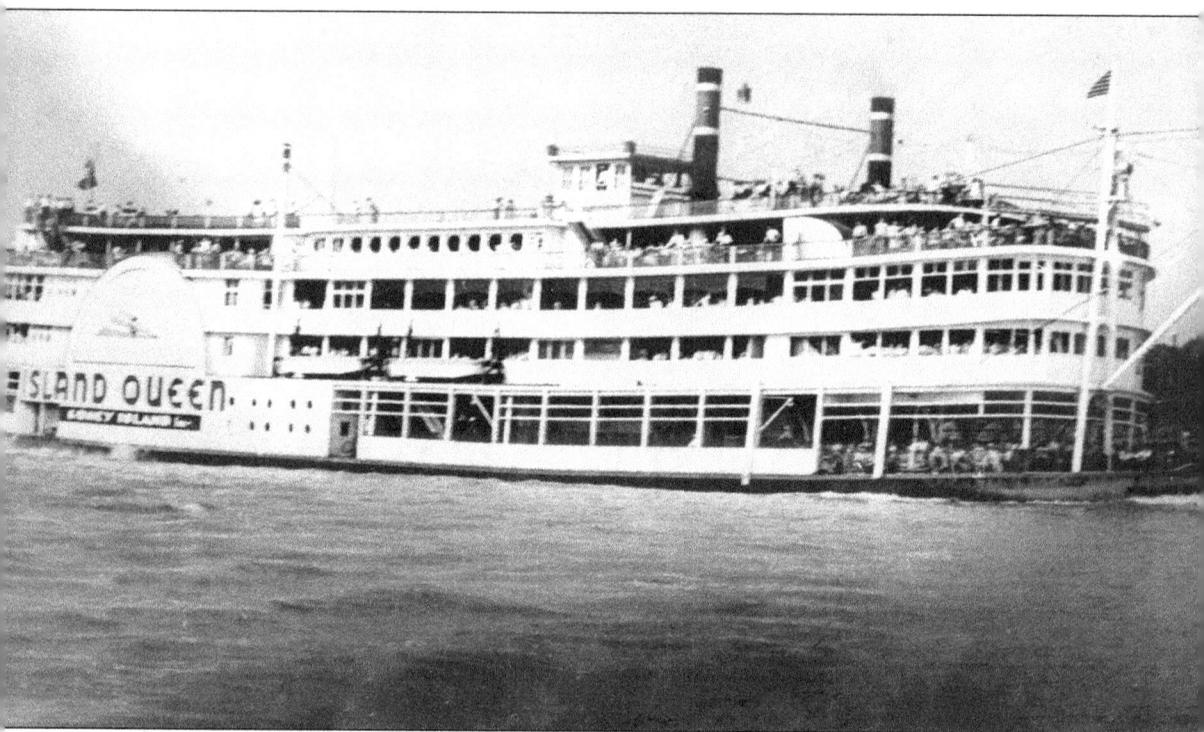

As it passes, the passengers of the *Island Queen* wave to the people on the Queen City Beach in Bellevue. The *Island Queen* served as the main mode of transportation between Cincinnati and its world-famous amusement park, Coney Island. During the summer months, the riverboat was a common sight at the Bellevue waterfront as it made numerous trips to and from Cincinnati daily.

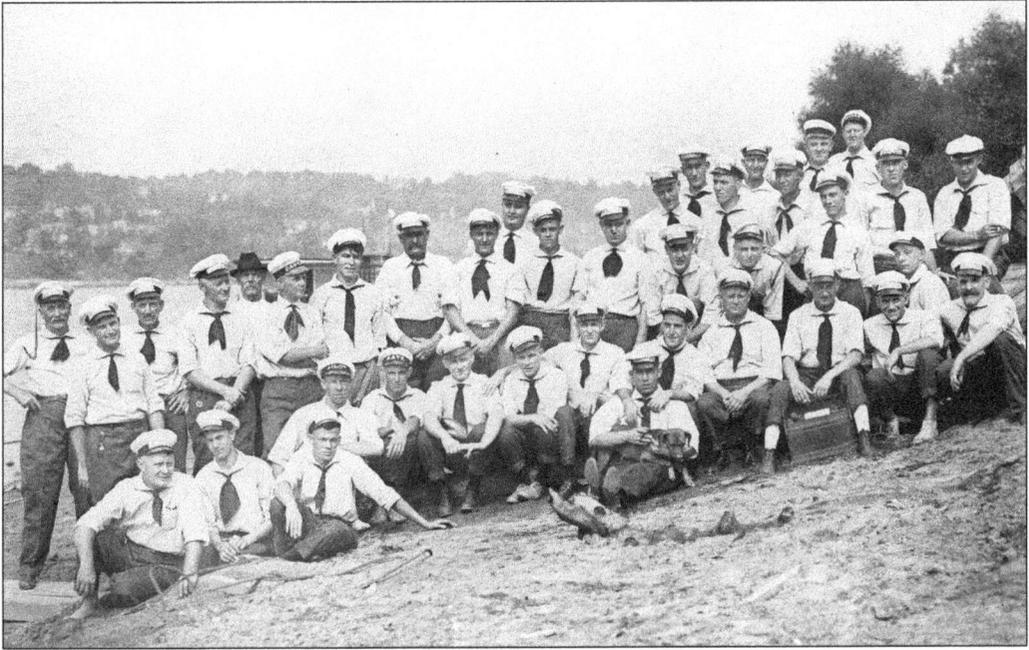

Unlike the other cities in the Cincinnati area, Bellevue never depended on the river for its existence. As a result, the waterfront and the river became sources of recreation and relaxation. Two of the most popular activities were boating and swimming. The Bellevue Yacht Club took advantage of the river as a source of recreation, and people took their boats out as often as possible. When they were not out on their boats, they were at their club rehashing the local news.

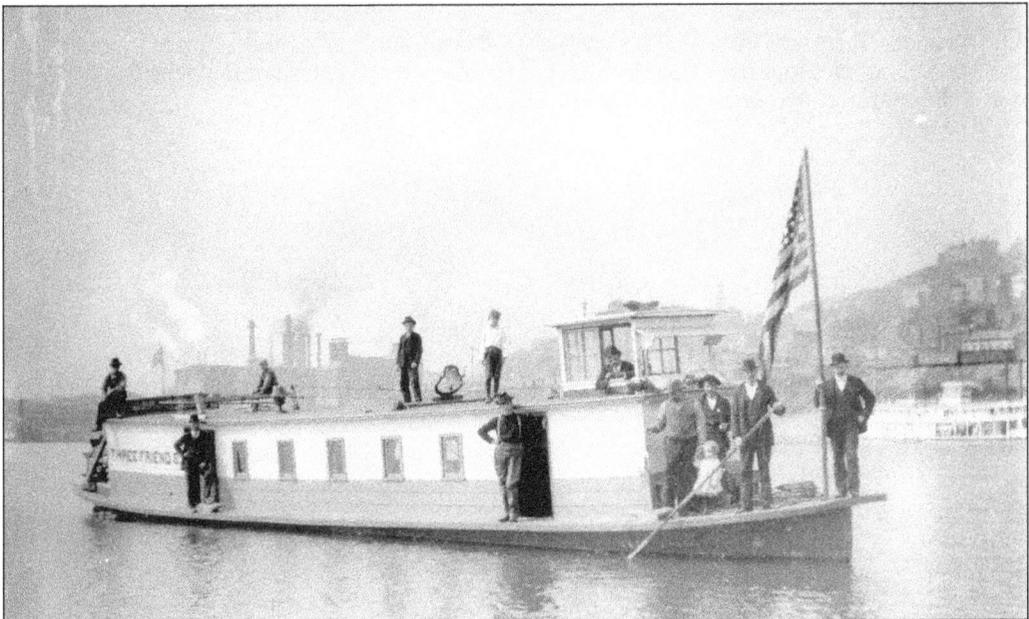

The crew and passengers of the *Three Friends* riverboat gather for photographs being taken from the Bellevue shore. Cincinnati is visible in the background. In the 1890s, small boats similar to this one ferried passengers up and down the Ohio River, taking them to local destinations.

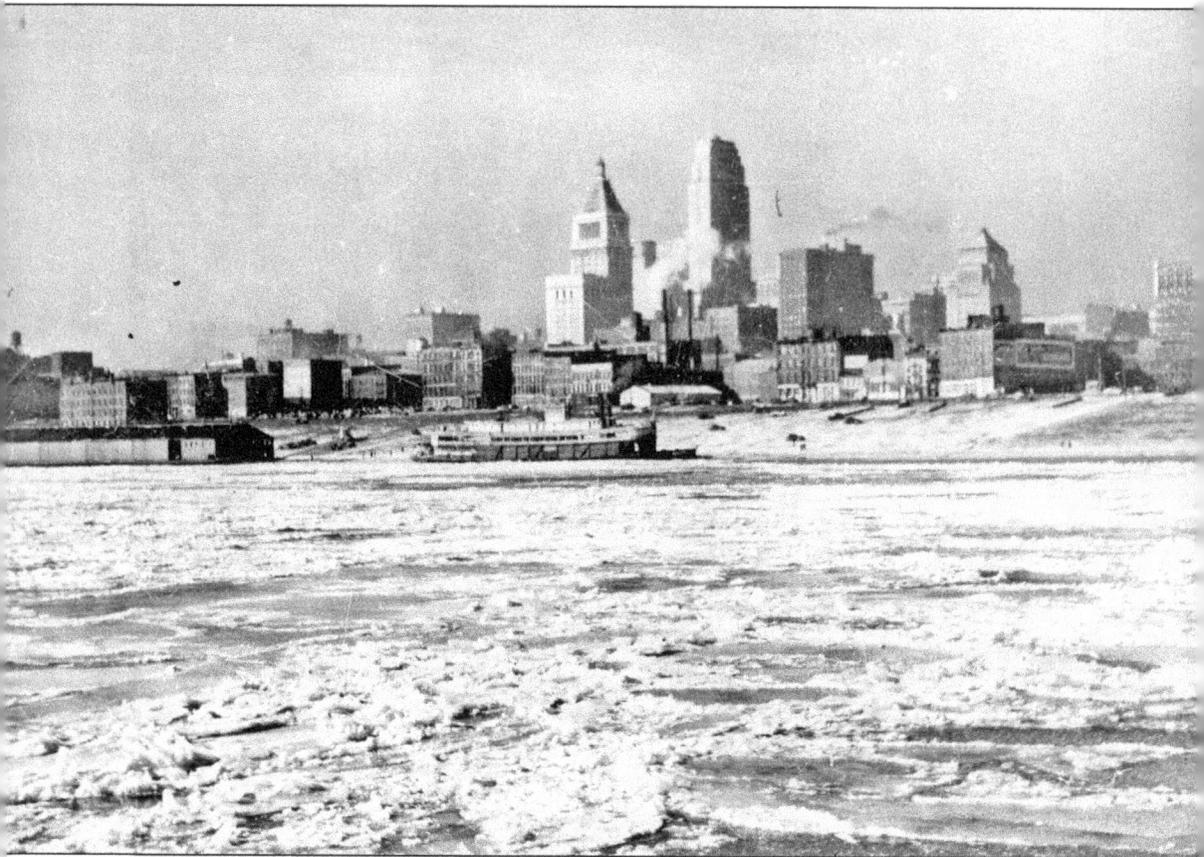

The view of Cincinnati from Bellevue has always been impressive, and a frozen river adds to the effect. The few times the Ohio River froze over allowed the people of Bellevue to partake in nontraditional river activities, such as ice skating.

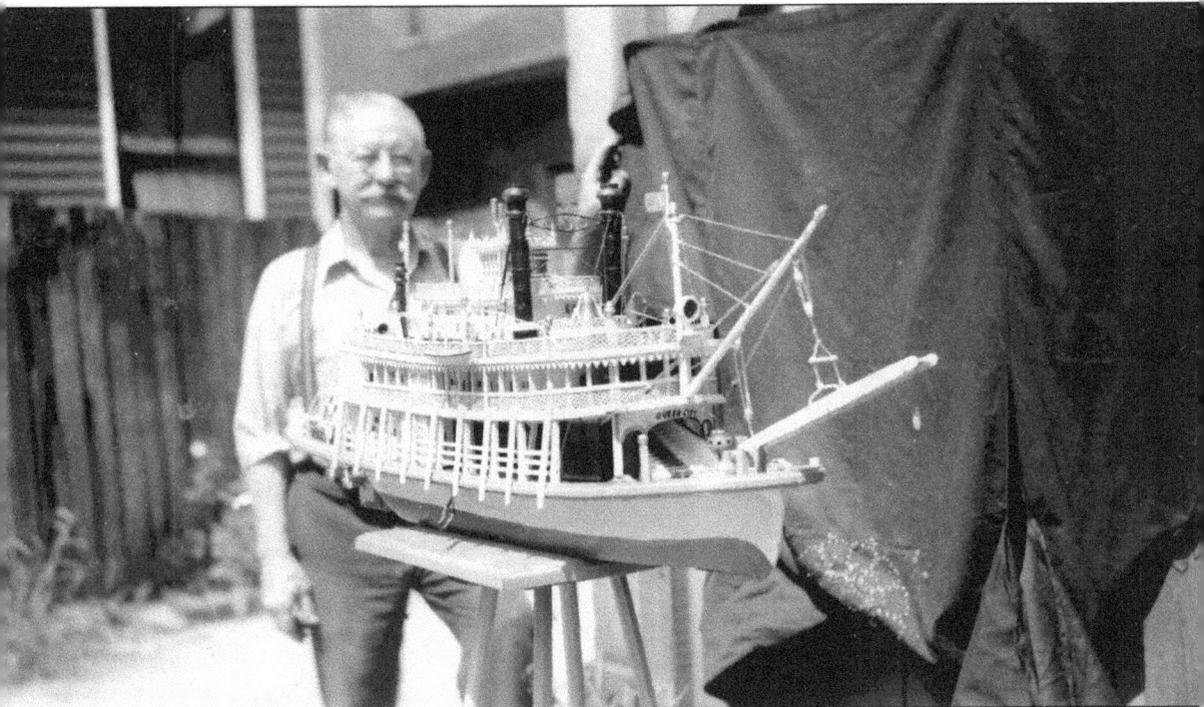

Jim Hafer stands with his recently completed model of a riverboat.

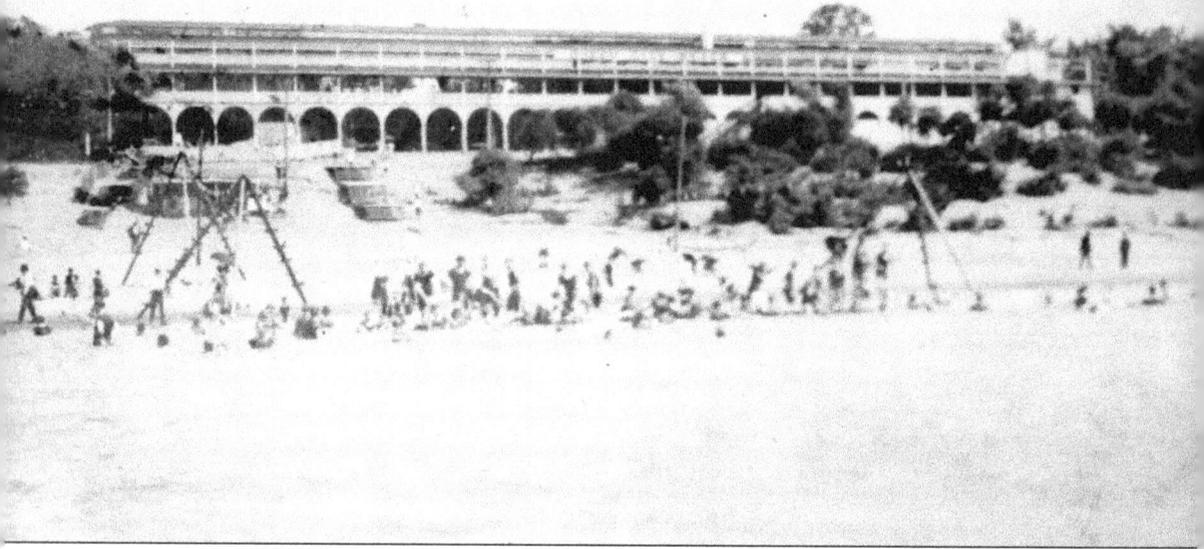

By 1900, Bellevue's prime location on the Ohio River began drawing many Cincinnatians to its shores on hot summer days. As a result, in the summer of 1902, the city opened the Queen City Bathing Beach. The beach's 1,500 feet of shoreline covered with beautiful white sand turned Bellevue into one of the most popular leisure resorts in the country. Swimming and canoeing were two of the most popular activities at the beach. Beach-goers also had the opportunity to take swimming lessons during the day and attend dances at the clubhouse in the evening.

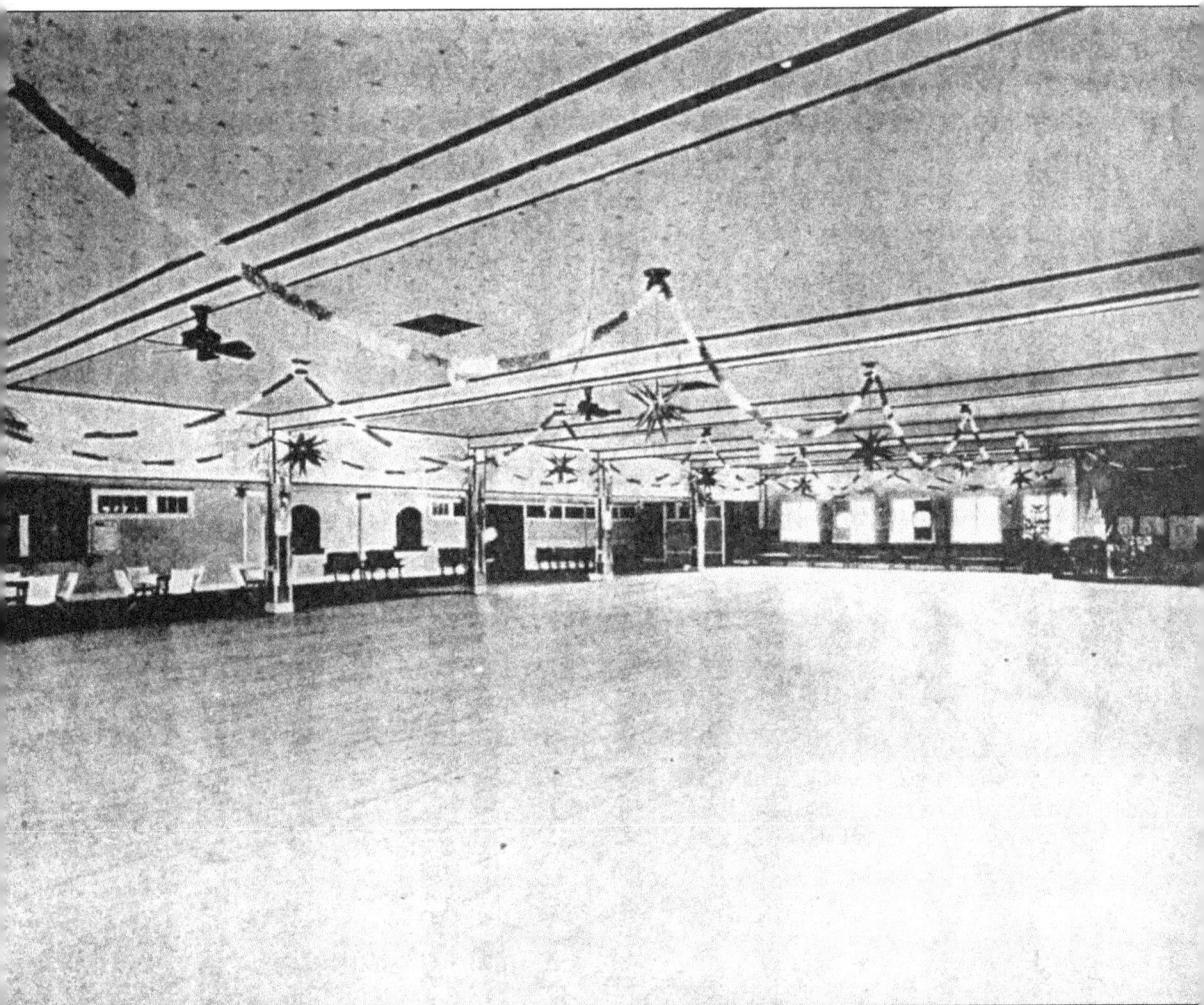

Serving as the clubhouse, the Horseshoe Gardens was one of the social centers of Bellevue. The ballroom was home to numerous celebrations and dances for any number of occasions. Even after the closing of the beaches, Horseshoe Gardens remained a social hub for the city.

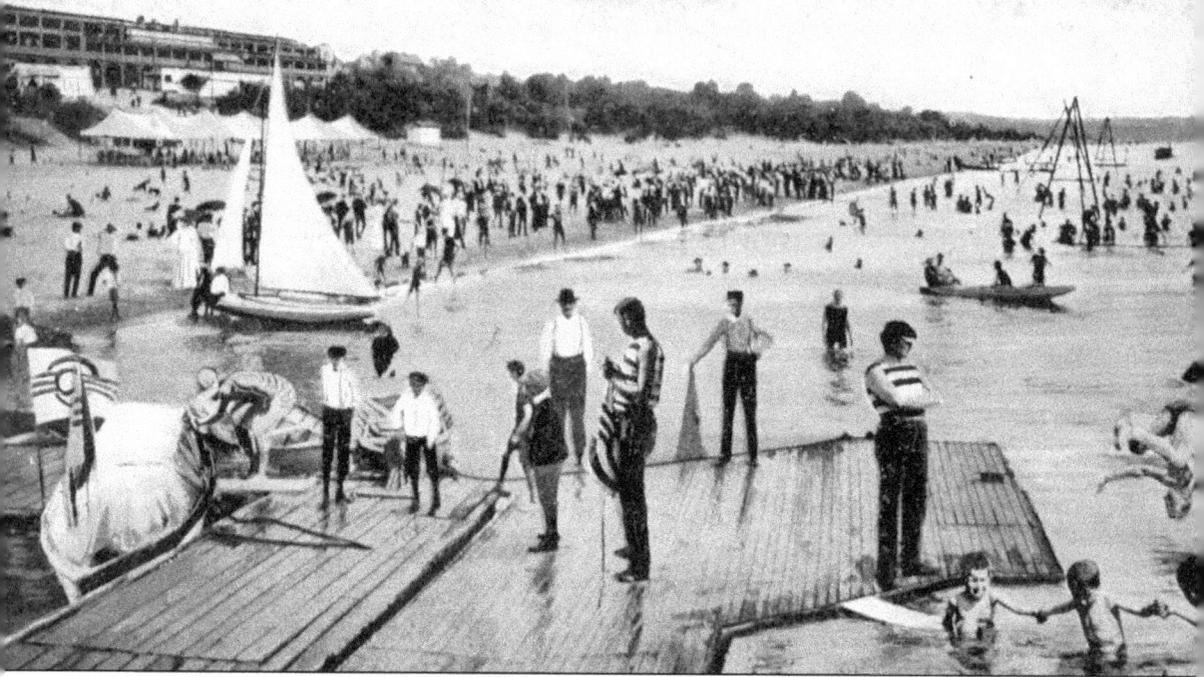

When the crowds flocked to Bellevue every summer to take advantage of the expansive beaches, little room remained for much else. Whether strolling on the beach, swimming in or boating on the river, or diving off the dock, one was sure to have lots of company from other folks enjoying the summer.

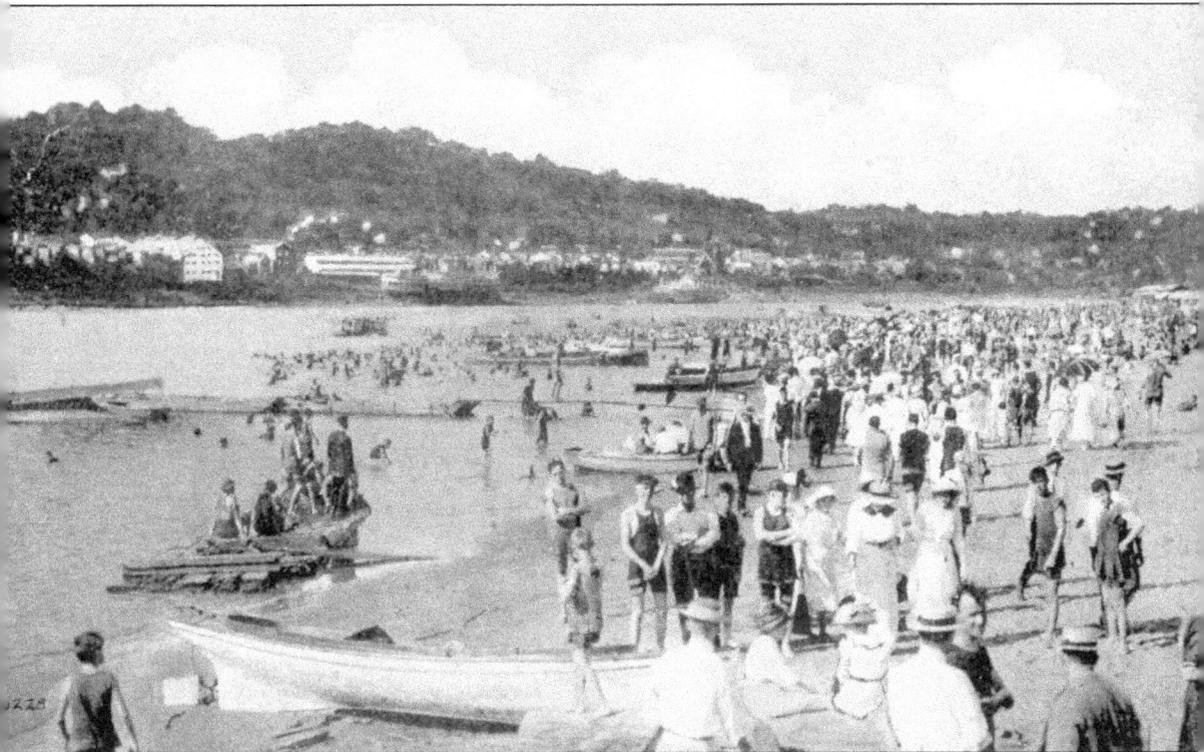

This post card shows both the popularity of Bellevue's riverfront beaches and the diversity of the riverfront's use. Bellevue's riverfront was not used for shipping, so it was not cluttered with docks like the riverfronts of many cities during the turn of the century. This meant that Bellevue's beautiful white-sand beaches could be used for many recreational activities. Across the river, the eastern-most section of Cincinnati can be seen.

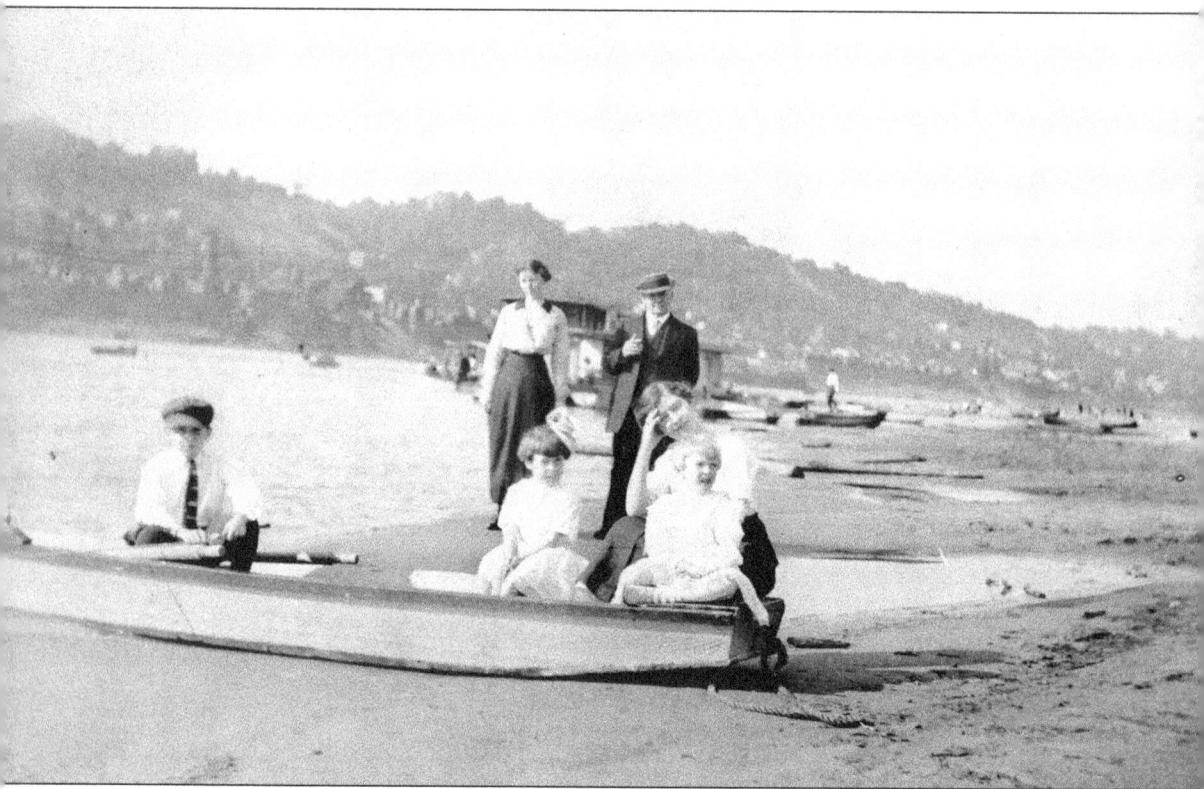

The Elmes family enjoys a quiet day at the Bellevue beaches. George, Ida, Essie, Hazel, and Lola are included here taking advantage of the beach before the crowds descend looking to escape from the heat.

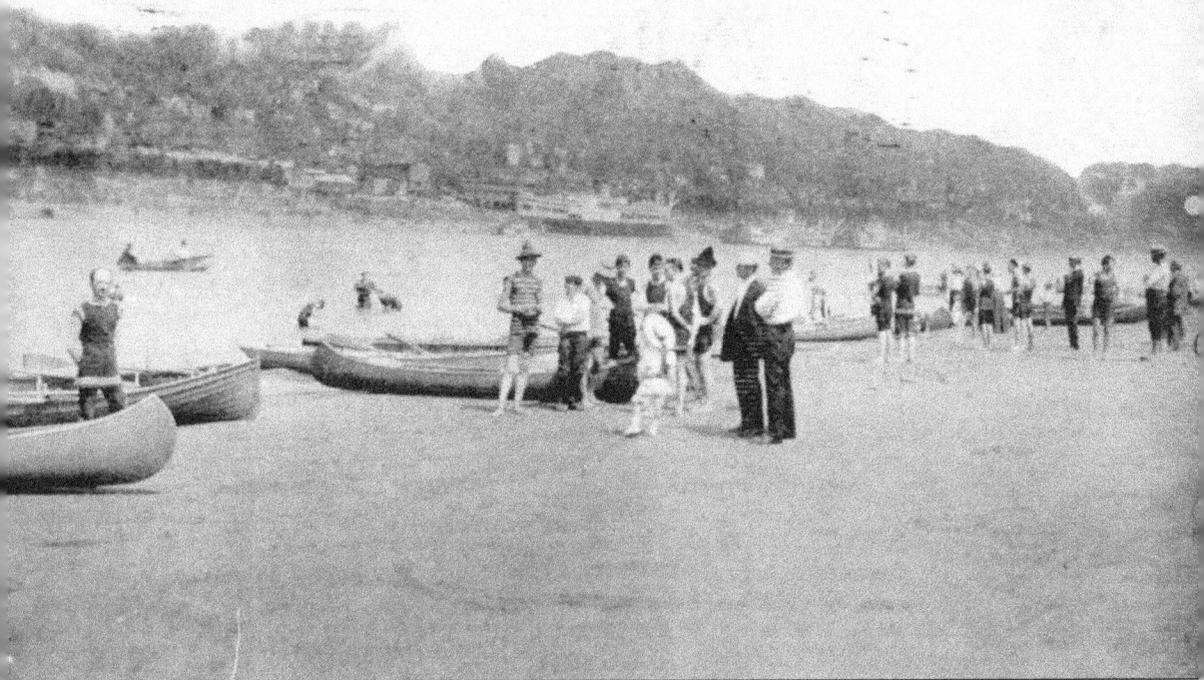

Bathing Beach, opposite Cincinnati, O.

Canoeing, a popular activity on the Ohio River, became one of the most popular activities at the Queen City Beach. Besides canoes, beach-goers could select from row boats and paddle boats for their nautical enjoyment.

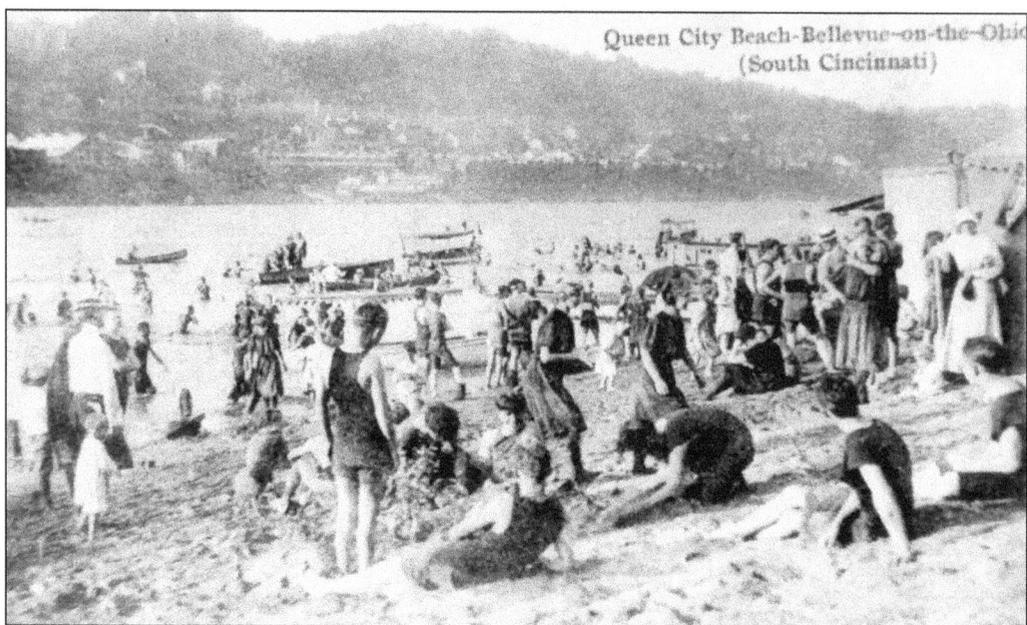

The crowds at Bellevue's beaches steadily grew each year, and at the peak of popularity, seas of people flooded the beaches trying to cool off during the summer heat. Bathers were drawn by the various activities available on the beaches and in the clubhouse.

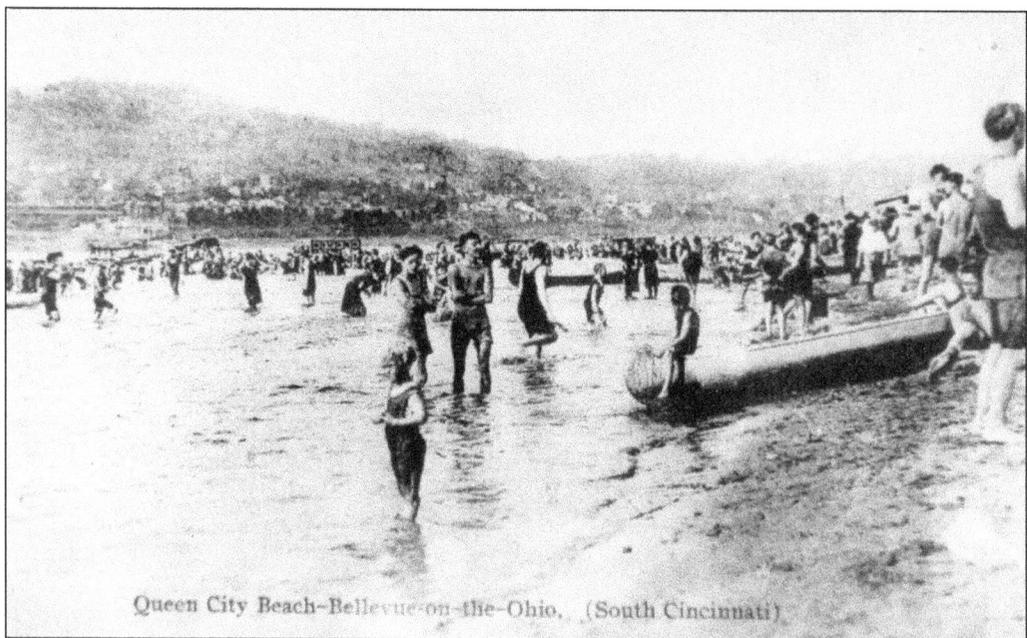

Beach photographs were commonly used for early 20th century postcards. Both photographs on this page are early examples.

Three

EDUCATION

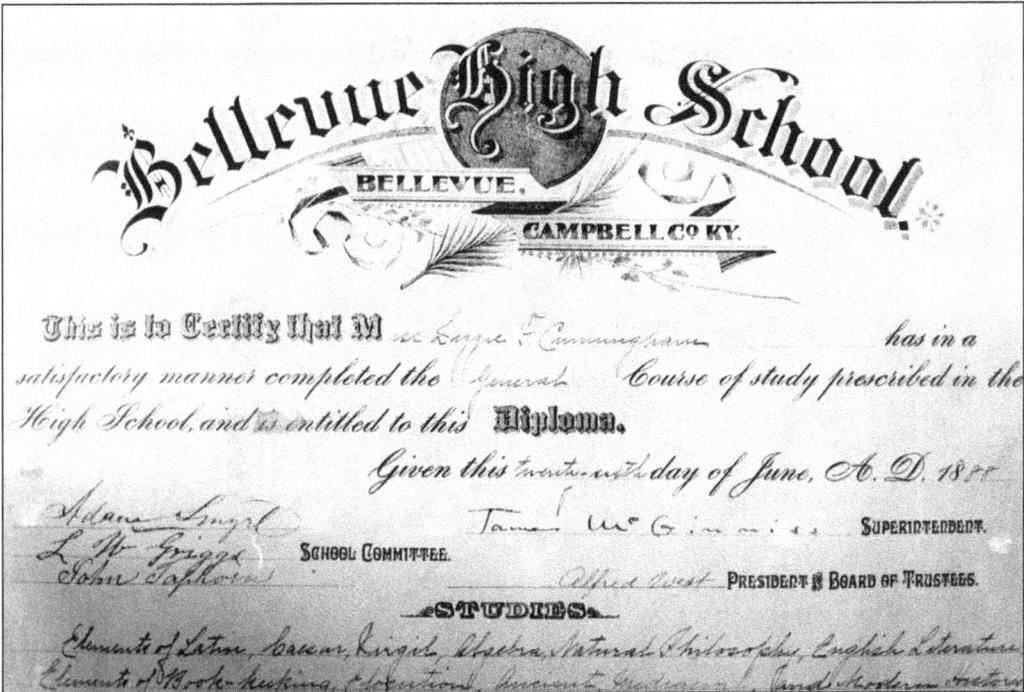

This diploma for Lizzie Cunningham shows some of the subjects that had to be mastered prior to graduating: Latin, algebra, philosophy, English literature, bookkeeping, and history, among others. During the next 17 years, Bellevue's population growth created the necessity for a building dedicated only to high-school students.

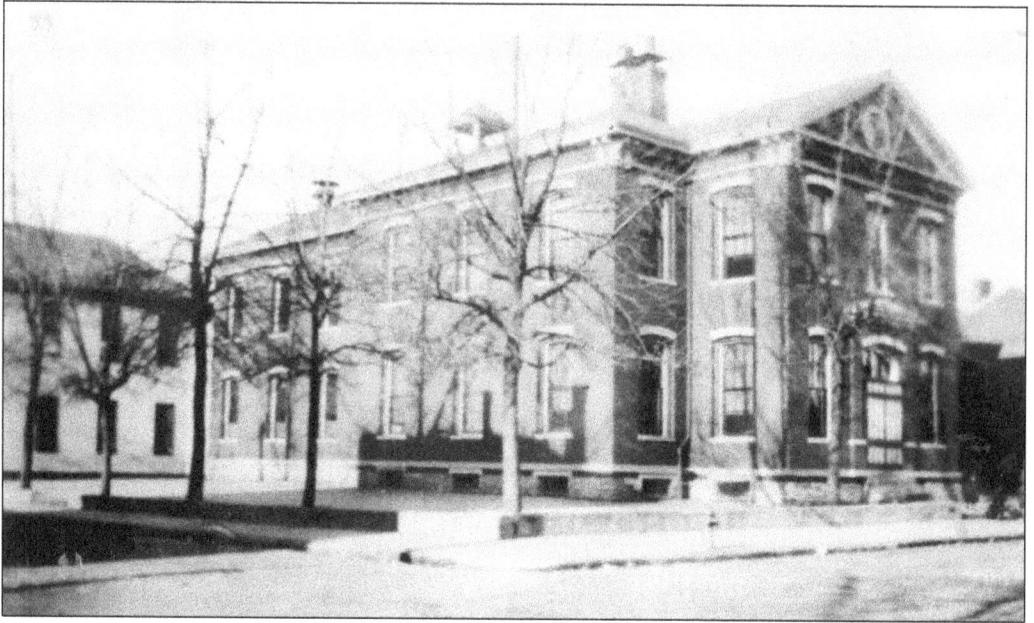

Public secondary schools were built across Kentucky in the late 19th century following a new state law that mandated a high school in every city. Bellevue's first school was located at Center and Lafayette Streets. It was a handsome building in minimal Italianate style built on the Latin-cross plan. The design was highlighted by gently arched windows, a bracketed cornice, and a closed pediment with an oculus, or eye. A firehouse occupied the rear of the lot. The building became a grade (elementary) school in 1902, following construction of a new building at Washington and Center Streets. The original school building was demolished in 1931 to make way for the present high school.

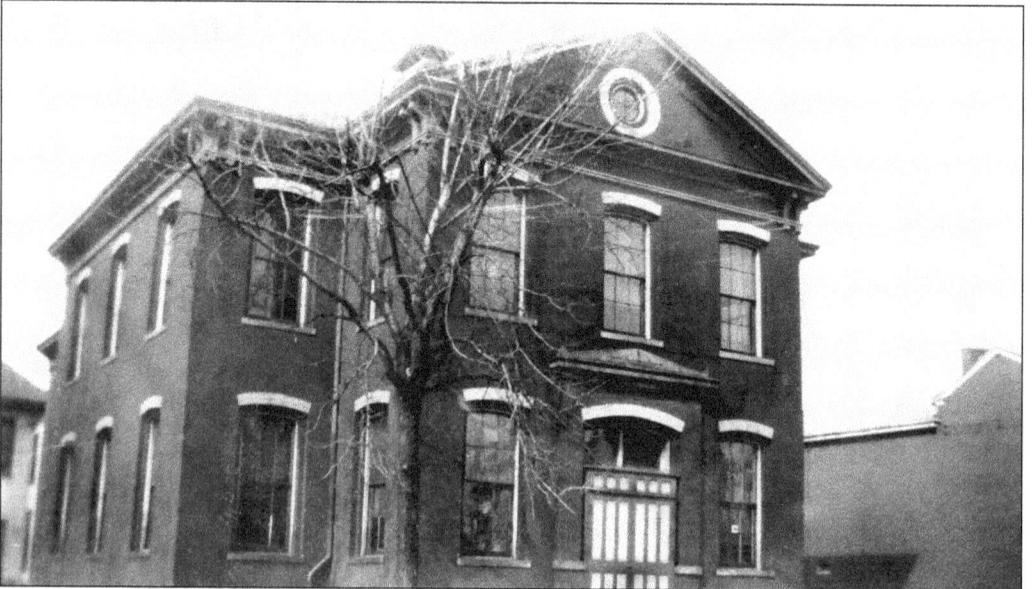

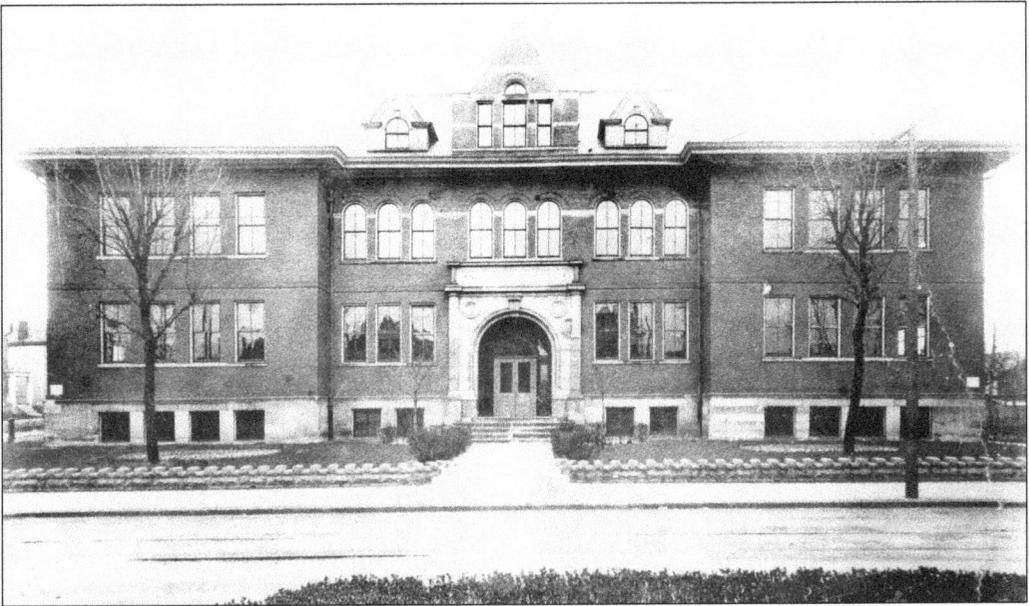

The second Bellevue School building was constructed at the corner of Washington and Center Streets in 1902. The brick Renaissance Revival building was designed by architects W. P. Bausmith and Drainie. After the present high school was completed in 1931, the Center Street building became a grade school. It served as a refuge for flood victims during the 1937 Ohio River deluge. Following the construction of Grandview Elementary, it became a recreation center. In 1986, the building was renovated as senior citizens' housing. The former school building is listed in the National Register of Historic Places.

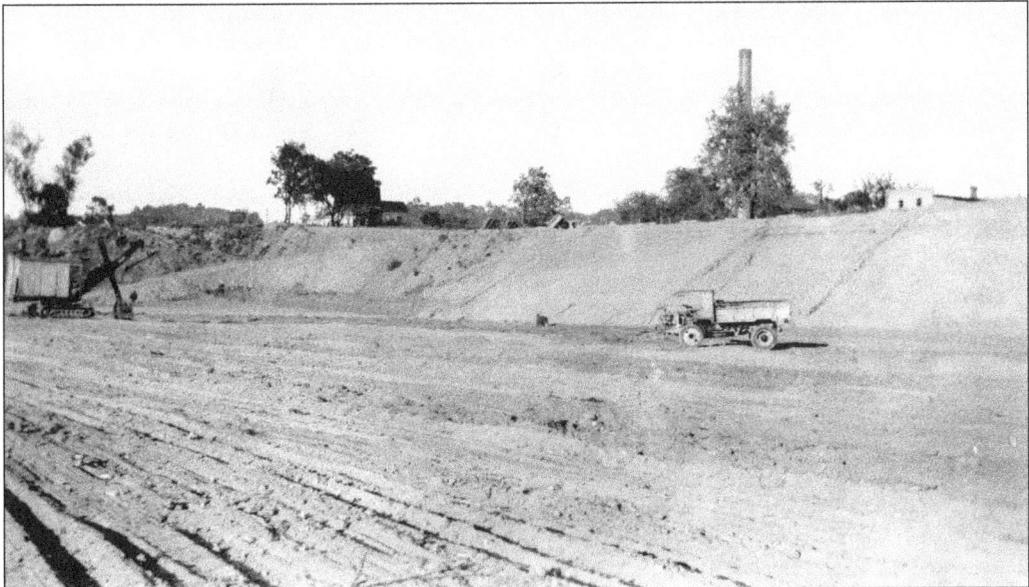

Located near the Sixth Street Fill, Gilligan Stadium played home to numerous Bellevue sporting events and is still the home field for the Bellevue High School football team. This 1936 photograph shows the field and stadium in the early stages of construction.

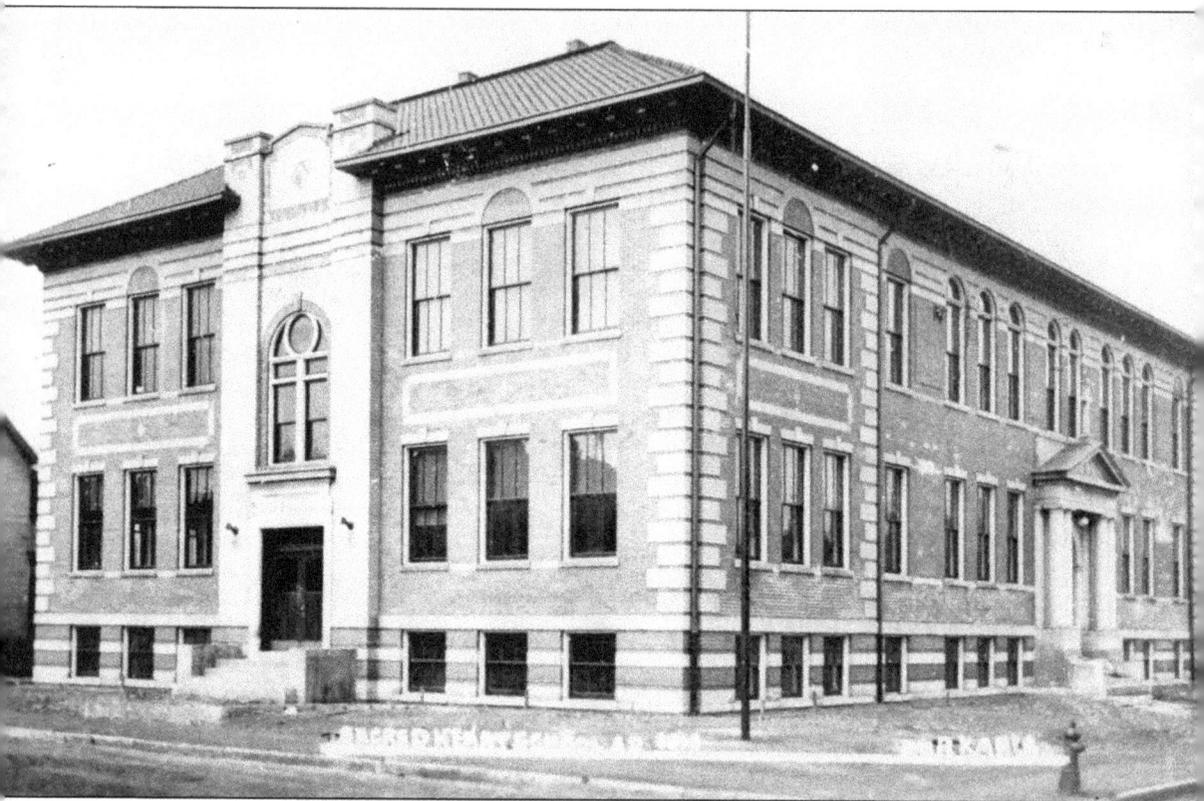

Opened in 1875 as the parish school for Sacred Heart Catholic Church, the Sacred Heart School moved to this location on Taylor and Division Streets in 1915. Opened to serve the growing number of German-speaking Catholics in Bellevue, the school originally taught primarily in German, but as time passed, the demand lessened, and the school adjusted accordingly. In 1987, Sacred Heart merged with the other Catholic school in Bellevue, St. Anthony's, to form St. Michael School. In 2002, the school combined with parochial schools from Newport and Dayton to become Holy Trinity School.

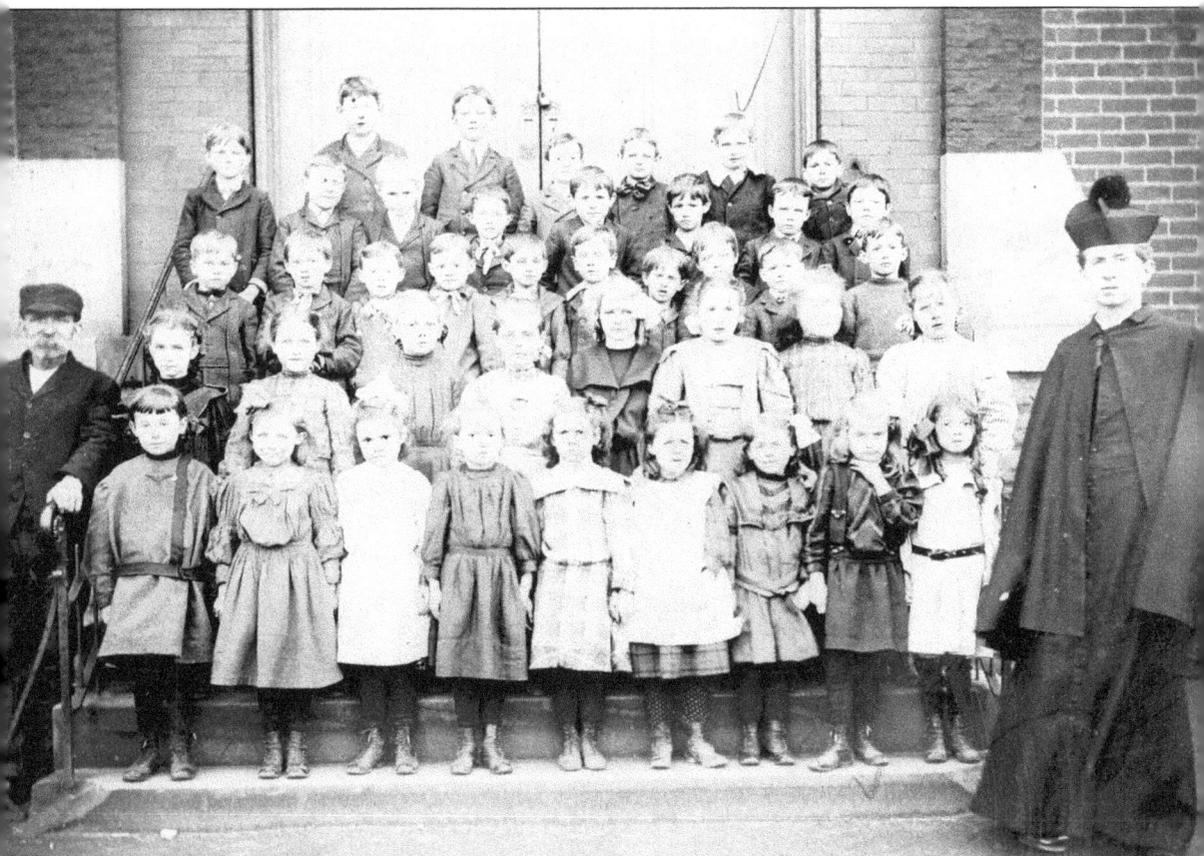

The children of St. Anthony School stand for their picture in front of the church *c.* 1910.
Formed in 1888 for the non-German speaking Catholics of Bellevue, the school was held in the
church building until a proper building was opened in 1930.

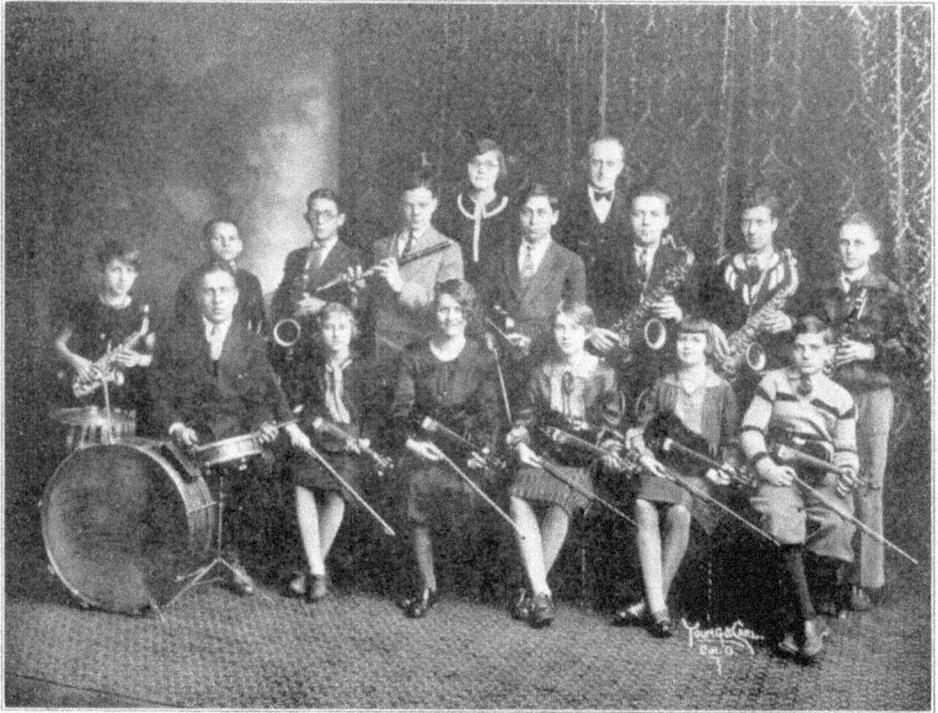

B. H. S. Orchestra

ORGANIZATION

Accompanist—
Edna Hunter
Director—
Oscar Schmidt
Violins—
Jeanette Hunter
Forest Lee Lucas
Anna Fay Albea
James Wooten
John Clark
Louis Meyer
Ruth Willis
Clarinet—
Rolland Clarke

Saxaphones—
Donald Pingueley
Donald Griggs
Alvia Anderson
Patricia Conley
Flute—
Laurance Kepler
Cornets—
Robert Whitehead
Hazel Hise
Drums—
Arthur Sandford

Music was a popular activity at Bellevue High School. The high-school orchestra performed at various events throughout the city, including parades and festivals, dances, and parties.

The Bellevue High School football team of the 1920s and 1930s did not have the same history of success as either baseball or basketball. They were, however, a winning team that always provided a good game against their neighboring city and biggest rival, Dayton, Kentucky.

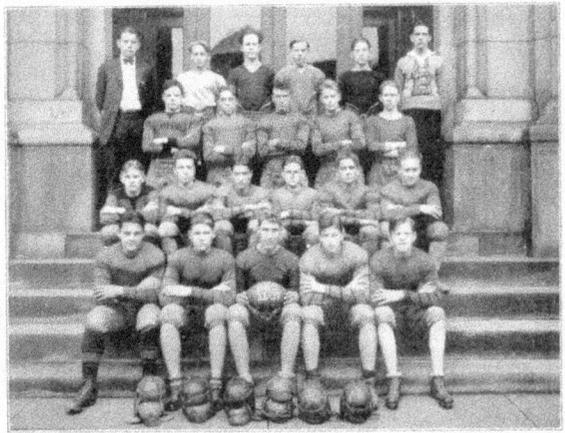

Football

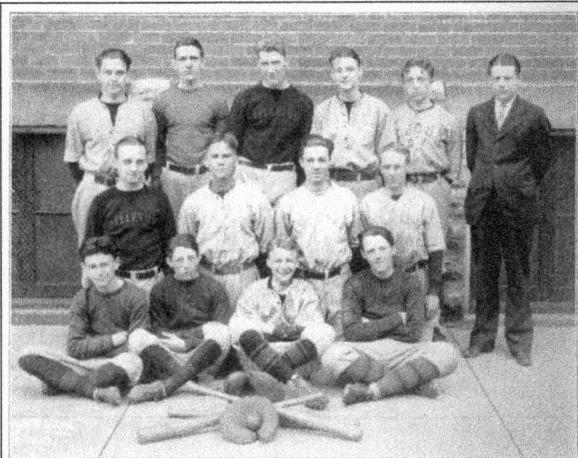

Baseball

A welcome addition to the sports available at Bellevue High School, this, the first baseball team in Bellevue High history, defied expectations in its first year in the league. As a city rich with baseball history, it was only a matter of time before the high school put together a team capable of competing with other well-established teams.

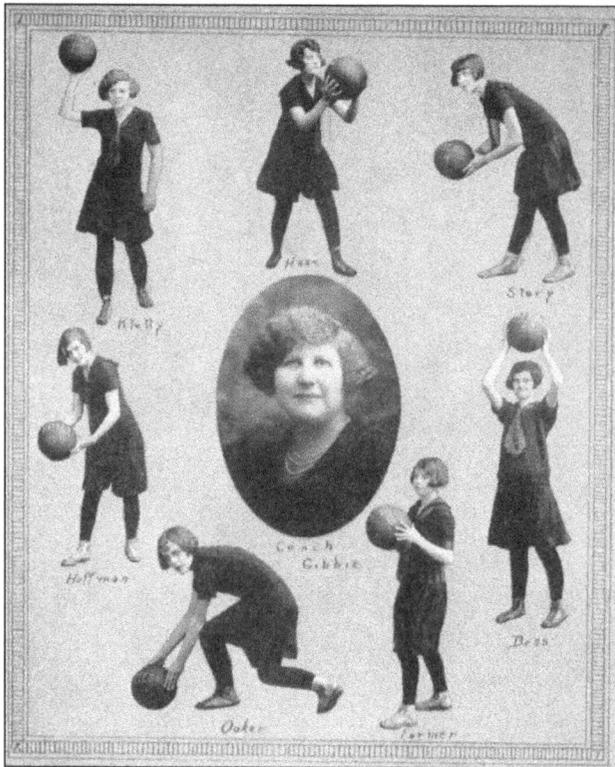

Here is the Bellevue High School girls' basketball team of 1927. Success in amateur sports was not limited to the men of Bellevue. The high-school girls' basketball team experienced unparalleled success from the World War I years through the early 1920s, when they won numerous titles locally, regionally, and at the state level.

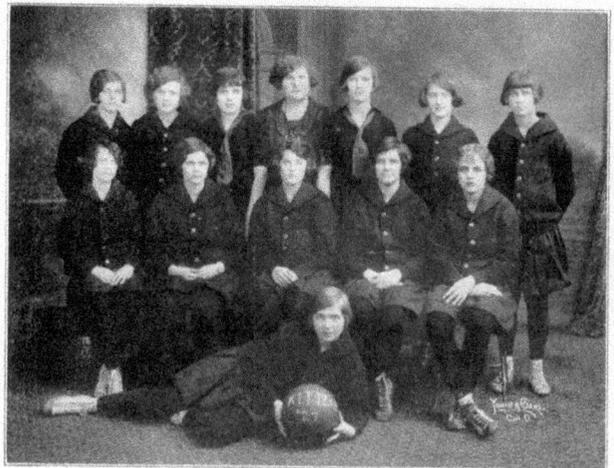

Girls' Group

GIRLS' GROUP

Hazel Hise, *Captain*

Virginia Klett, *Manager*

Aileen Mae Gibson, *Coach*

TEAM

Forwards—Hazel Hise
Ethel Mae Farmer
Helen Story
Ethel Hoffman

Guards—Virginia Klett
Bessie Adams
Inez Collins

SUBS

Margaret Douglas
Sadie Skirvin
Evelyn Tutt

Ava Holmes
Edrie Braun

Here are some of the stars of Bellevue High School's 1927 basketball team.

Coach Phil Sid Bubs Hank Dutch

Bellevue Hi Tigers

Earl Frierdich, *Captain* Henry Koehler, Manager

John Schaar, *Coach*

Forwards—Frierdich Applegate Billy Thomas
Bus Clark Kettenacher
Guards—Harry Thomas Phil Meyer Sheldon Wagner
Center—Henry Koehler

BELLEVUE HI SCHEDULE

B.H.S.		Oppo.	B.H.S.		Oppo.	B.H.S.		Oppo.
18	Y Commercial	15	28	Immaculata	30	43	Ludlow	29
59	Terrace Park	8	23	St. Stephens	18	22	*Ludlow	17
31	Baraca	21	29	Batavia	18	27	*Dayton	11
25	University S.	16	15	Ludlow	22	20	*Covington	48
2	Dayton‡	0	28	Dayton	37	55	Highland	26
18	Alumni	19	28	Hamilton Hi	25	20	Immaculata	35
10	Highland	21	42	Batavia	24	47	M.t Auburn	24

Total Points—Bellevue 590; Opponents. 464.

The 1927 Bellevue High School men's basketball team finished the year with 14 in 20 games, continuing the history of success in amateur sports.

57

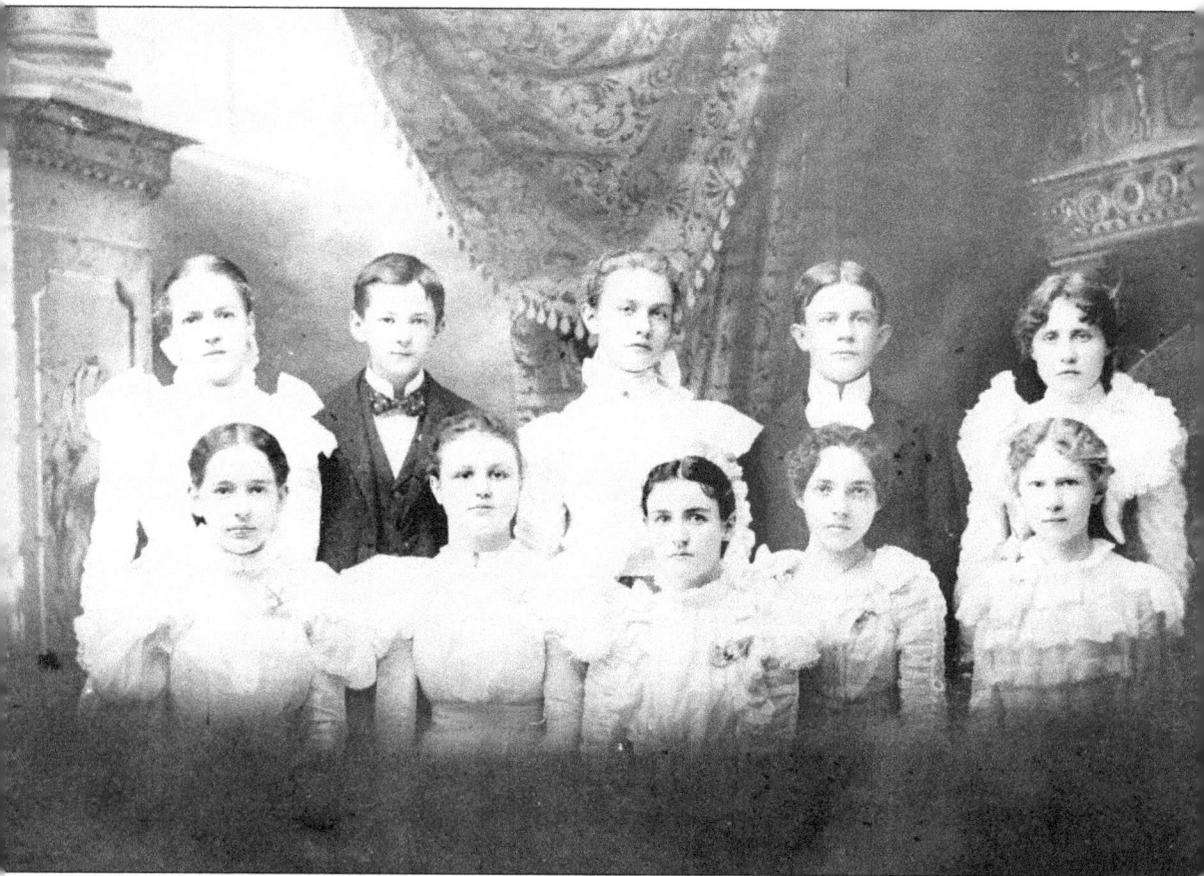

The Bellevue High School Class of 1898 is as follows, from left to right: (first row) Estella Disz, Clara Brookbank, Mabel McClaran, Alwilda Griffith, and Elsie Jone; (second row) Abbie Gribbs, Ed Robbe, Ethel Pierson, Charles Miller, and Lutie Tenley.

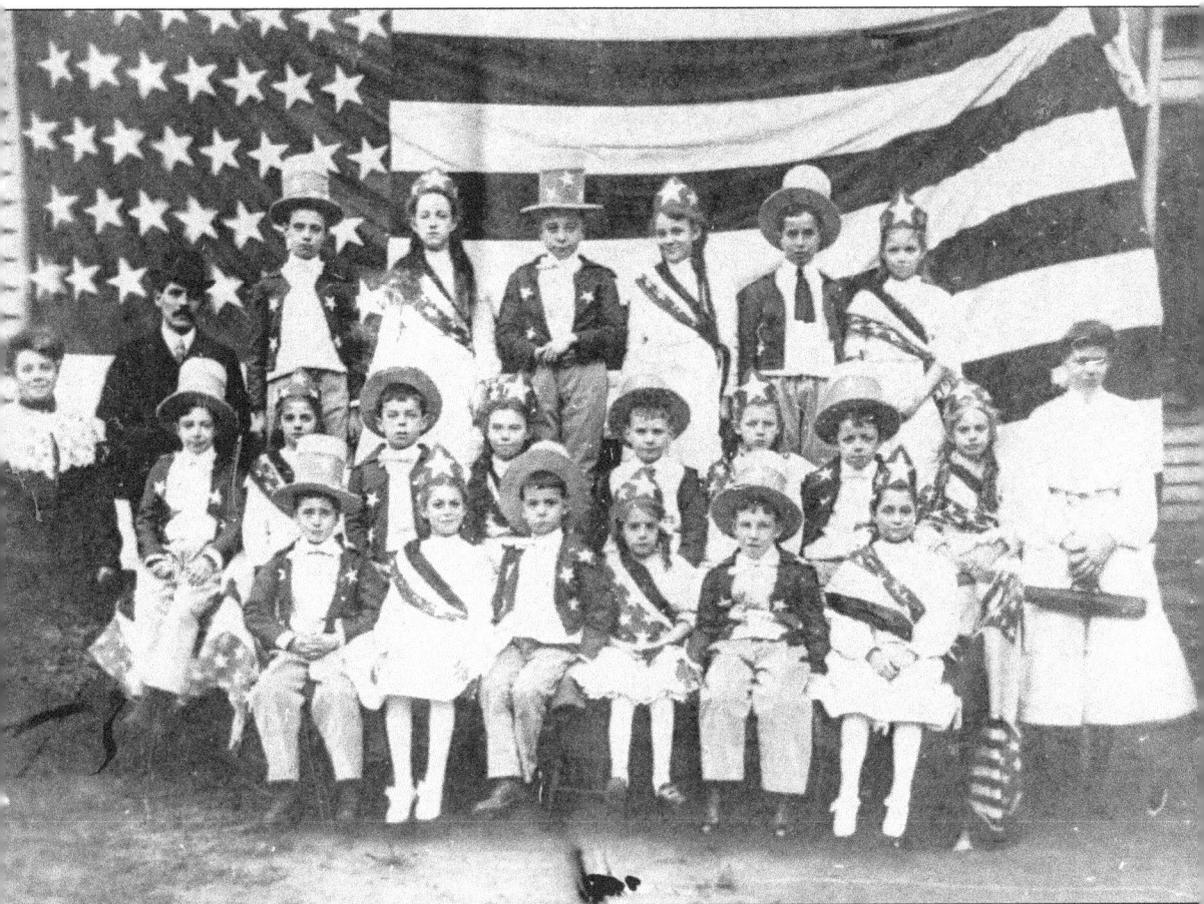

This photograph was taken in 1880, about 10 years after Bellevue's incorporation. The photograph shows the patriotism of this group of students who were preparing for an Independence Day program. Note that the flag hanging in the background has 38 stars. At the time of the photograph, Colorado had been a state for only four years, and North Dakota, the 39th state, would not join the Union for another nine years, in 1889.

In 1906–1907, Earl Schuler was able to make the academic Role of Honor at the Bellevue High School. His outstanding academic achievement produced these two documents congratulating him on his performance. Within a few years, Earl Schuler would be drafted into the U.S. Army to serve in World War I.

Four

RELIGIOUS LIFE

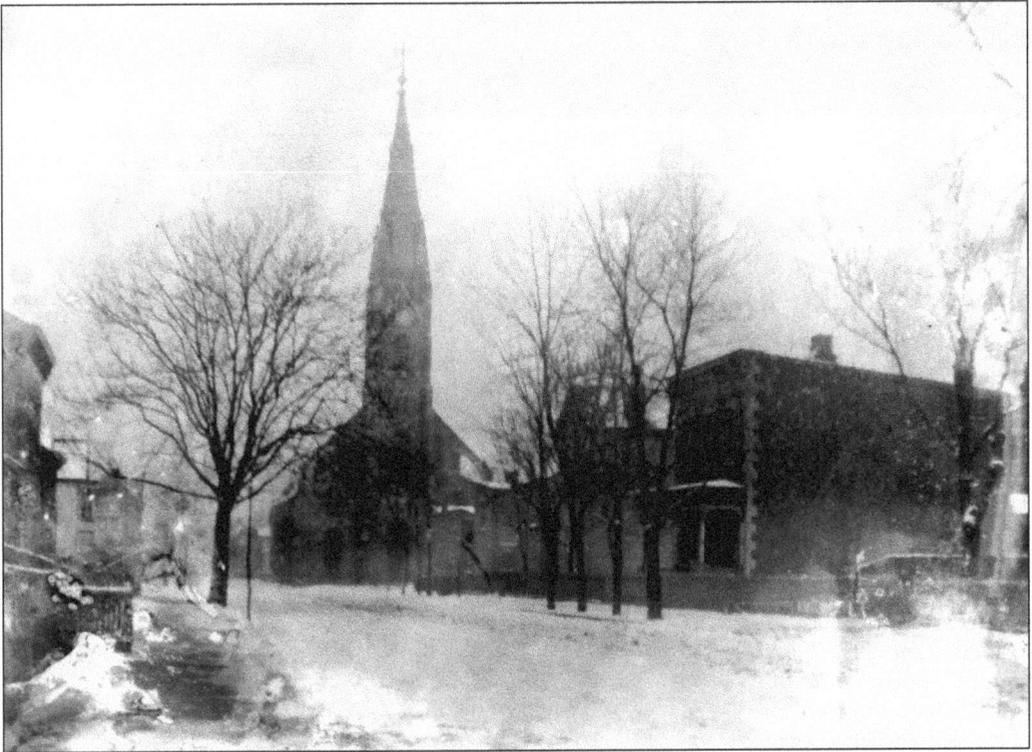

Prior to 1915, Sacred Heart Catholic Church had one of the tallest steeples in Northern Kentucky. The Bavarian design reflected the heritage of its congregation and made the church one of the most visually distinct churches in the area. This photo shows the church as it looked until 1915, when a tornado struck Bellevue, toppling the steeple. After the tornado, the damaged steeple was replaced with a shorter cupola.

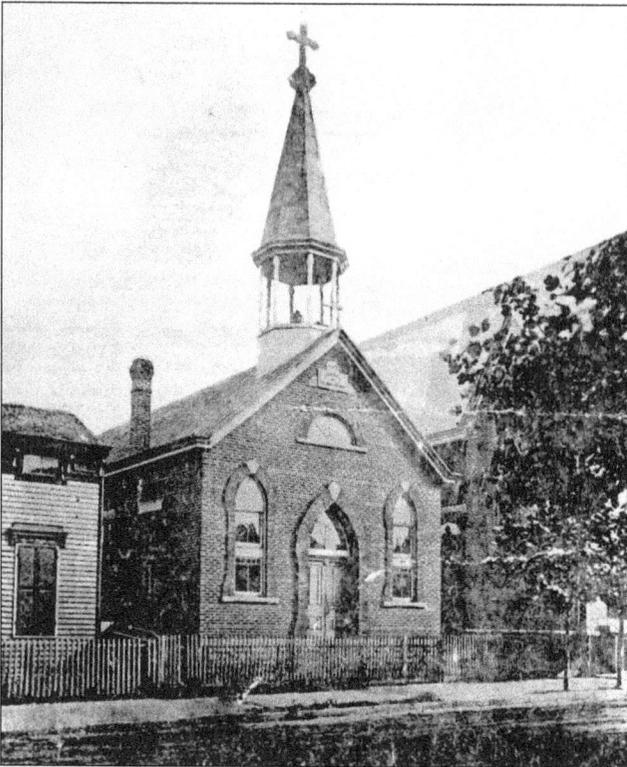

Prior to opening its new building in 1894, St. Anthony Catholic Church met here at this small one-room brick building on Poplar Street. St. Anthony used this building as its home for five years. This church has also been the temporary home of several other local congregations.

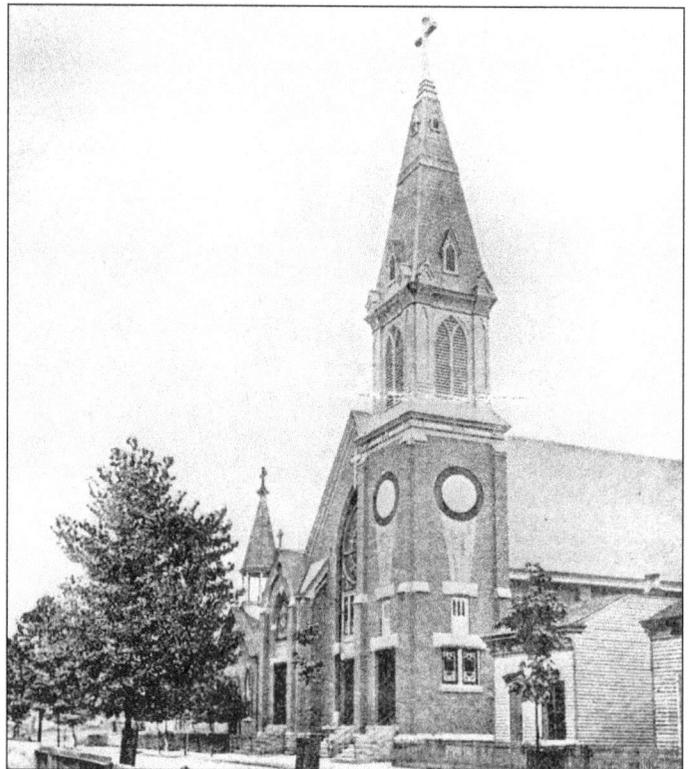

In 1889, St. Anthony Catholic Church was formed to serve the Irish members of the community in Bellevue, who were tired of traveling to Newport for mass. This building served as the congregation's home until the parish joined with Sacred Heart to form Divine Mercy parish.

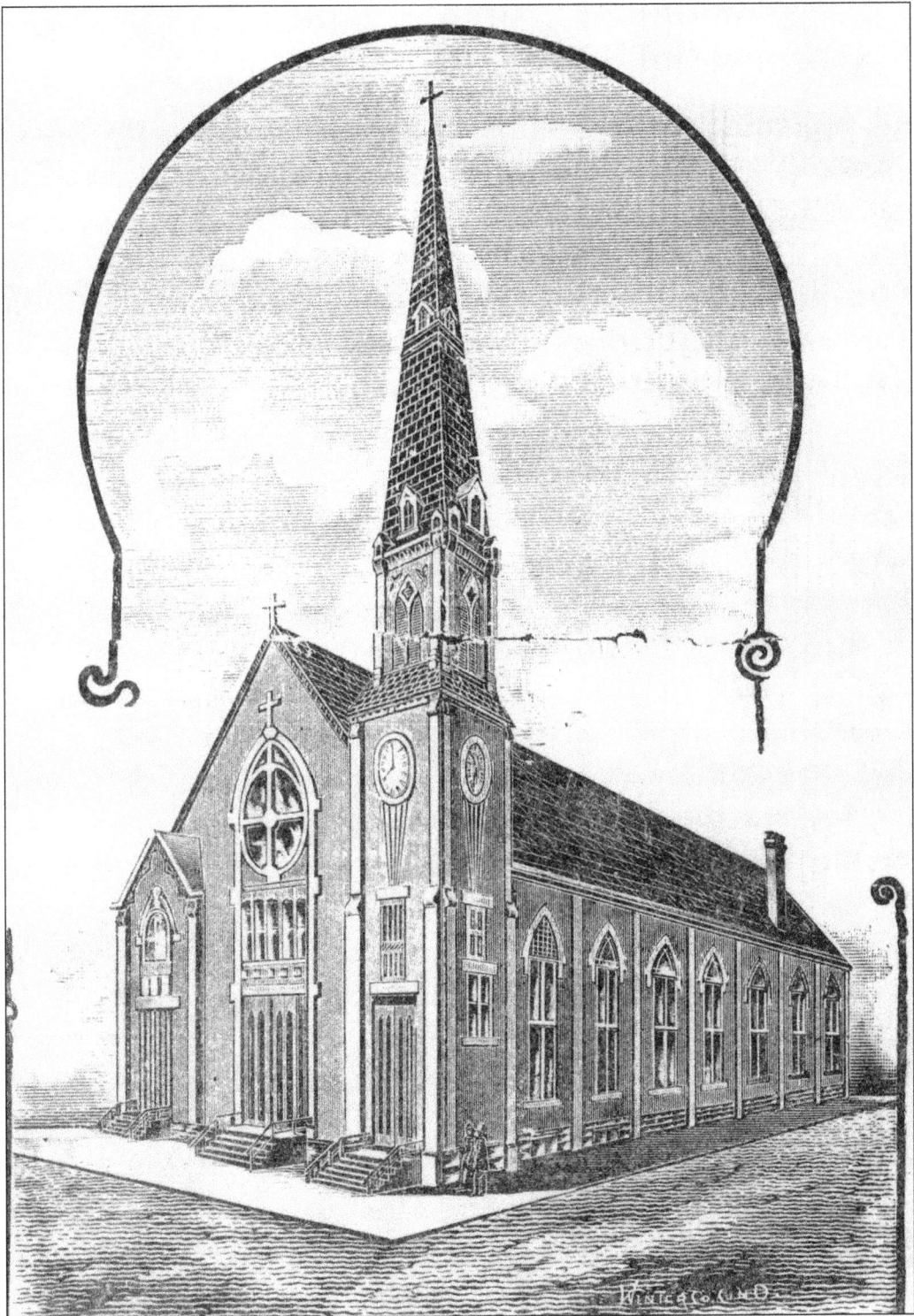

This early drawing shows the planned appearance of St. Anthony Catholic Church. This drawing does not show other buildings that sat to the east and west of the new church.

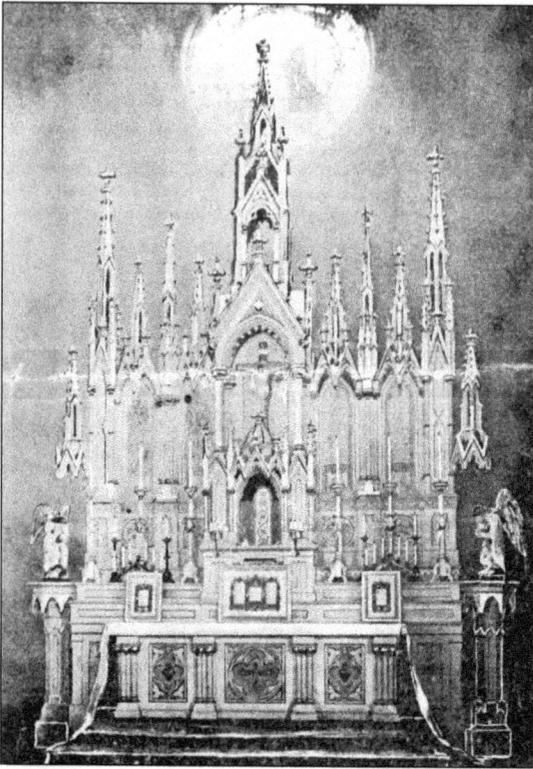

Decorated with this high Gothic altar, the interior of St. Anthony Church was the talk of town when the church was dedicated. This outstanding altar was the prize work displayed at the 1894 church dedication, but it was removed in the 1960s as the church worked to meet new Vatican standards.

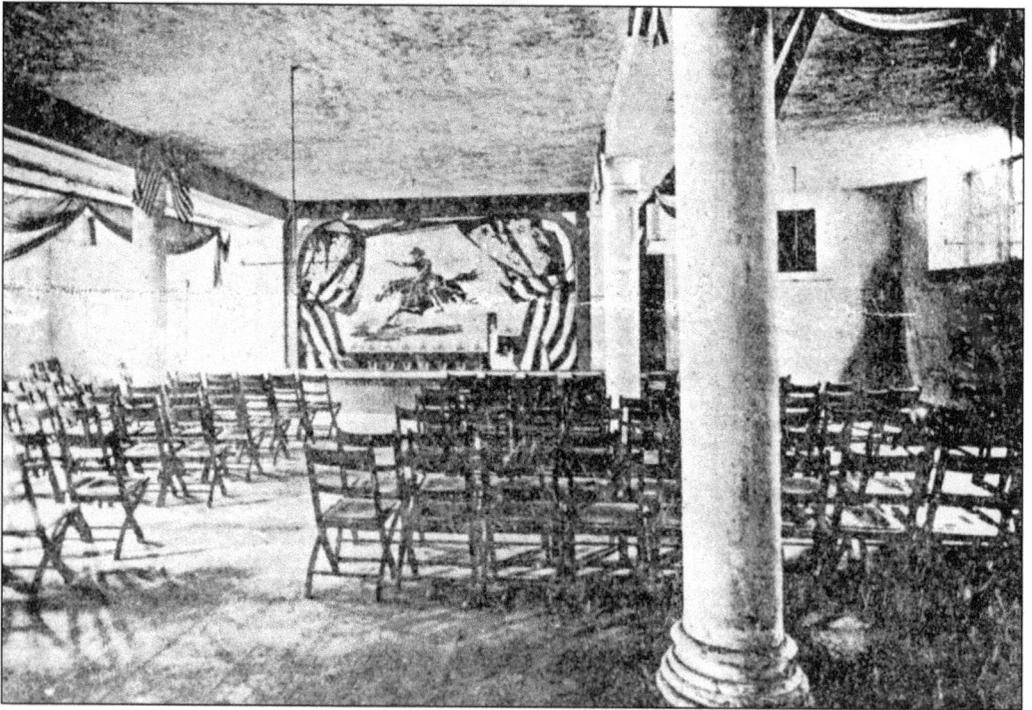

St. Anthony Hall, the social chamber of the church, served as home to youth organizations, bible study, church elder meetings, and saint's day festivals.

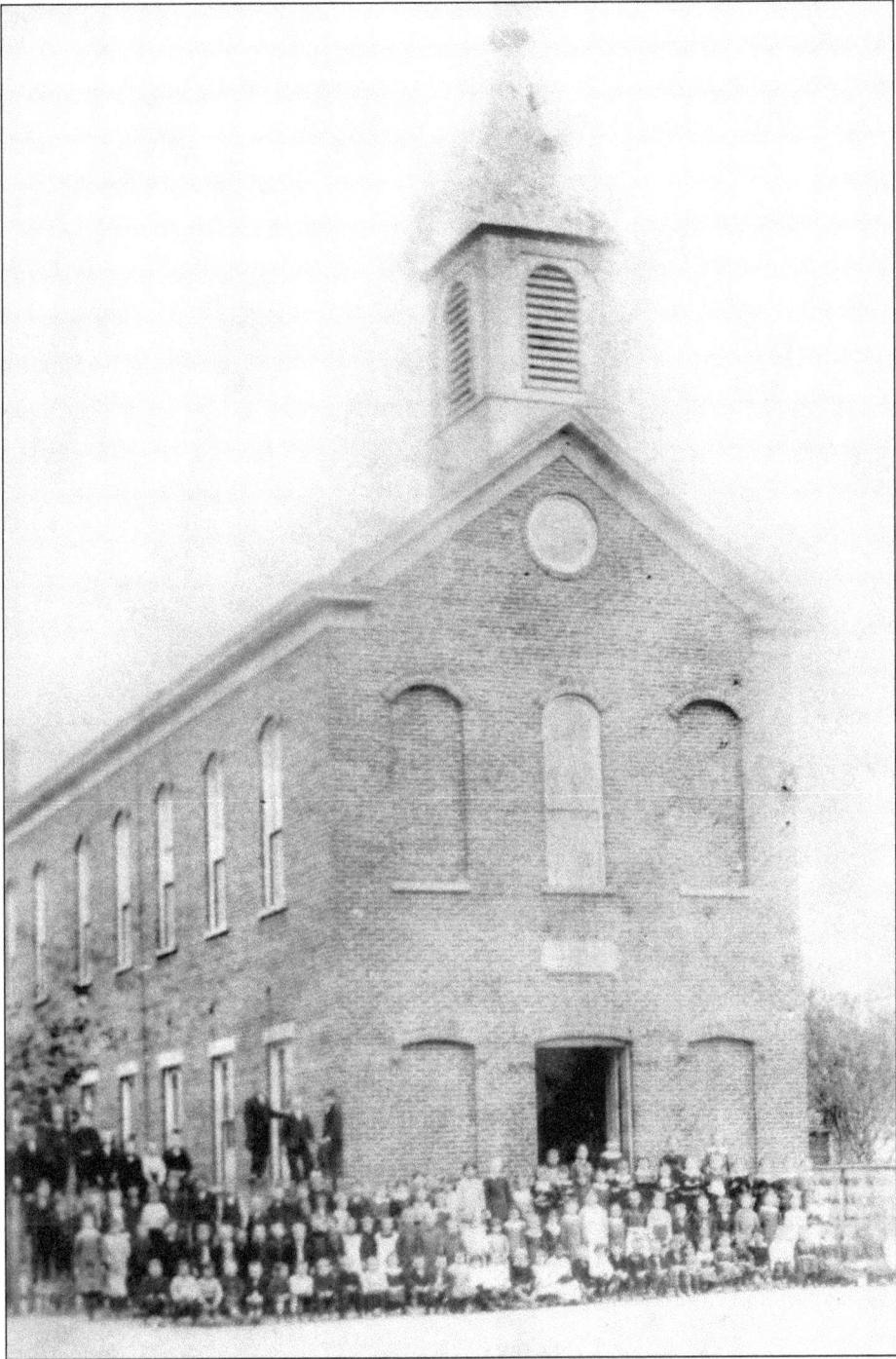

When Bishop Toelbe approved of the creation of Sacred Heart Church, it became the first church in Bellevue. Four years after its creation, the congregation had outgrown its temporary home in the firehouse at Center Street and Lafayette Avenue and built this small brick church on Taylor Avenue. This building served as the church's home until the opening of their grand building in 1893.

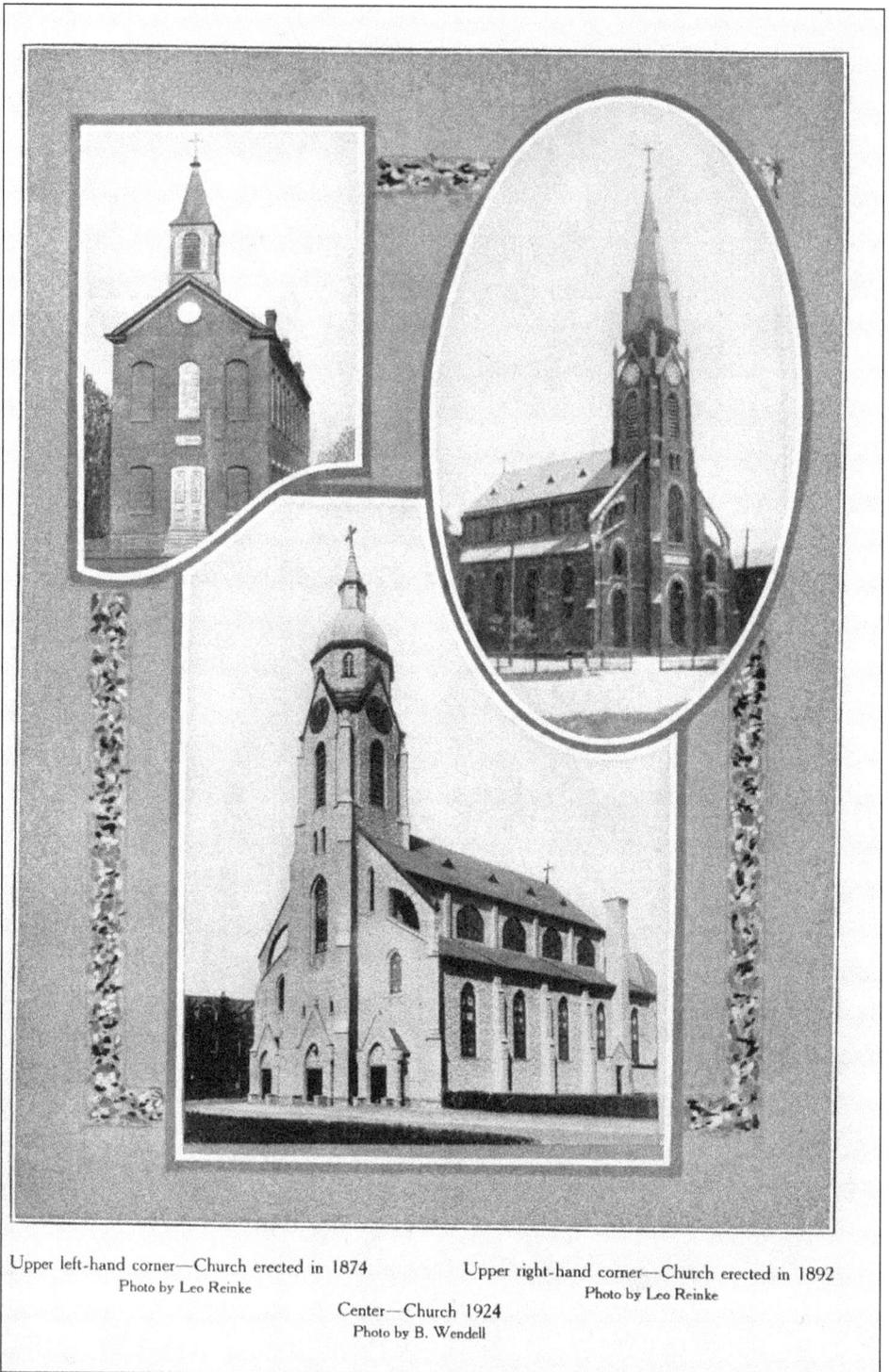

Upper left-hand corner—Church erected in 1874
Photo by Leo Reinke

Upper right-hand corner—Church erected in 1892
Photo by Leo Reinke

Center—Church 1924
Photo by B. Wendell

From 1874 to 1892, services at Sacred Heart were held in a small brick church before being moved to the new grand building on Taylor and Division Streets. After repairing the damage done by the 1915 tornado, the church replaced the tall steeple with the cupola seen here.

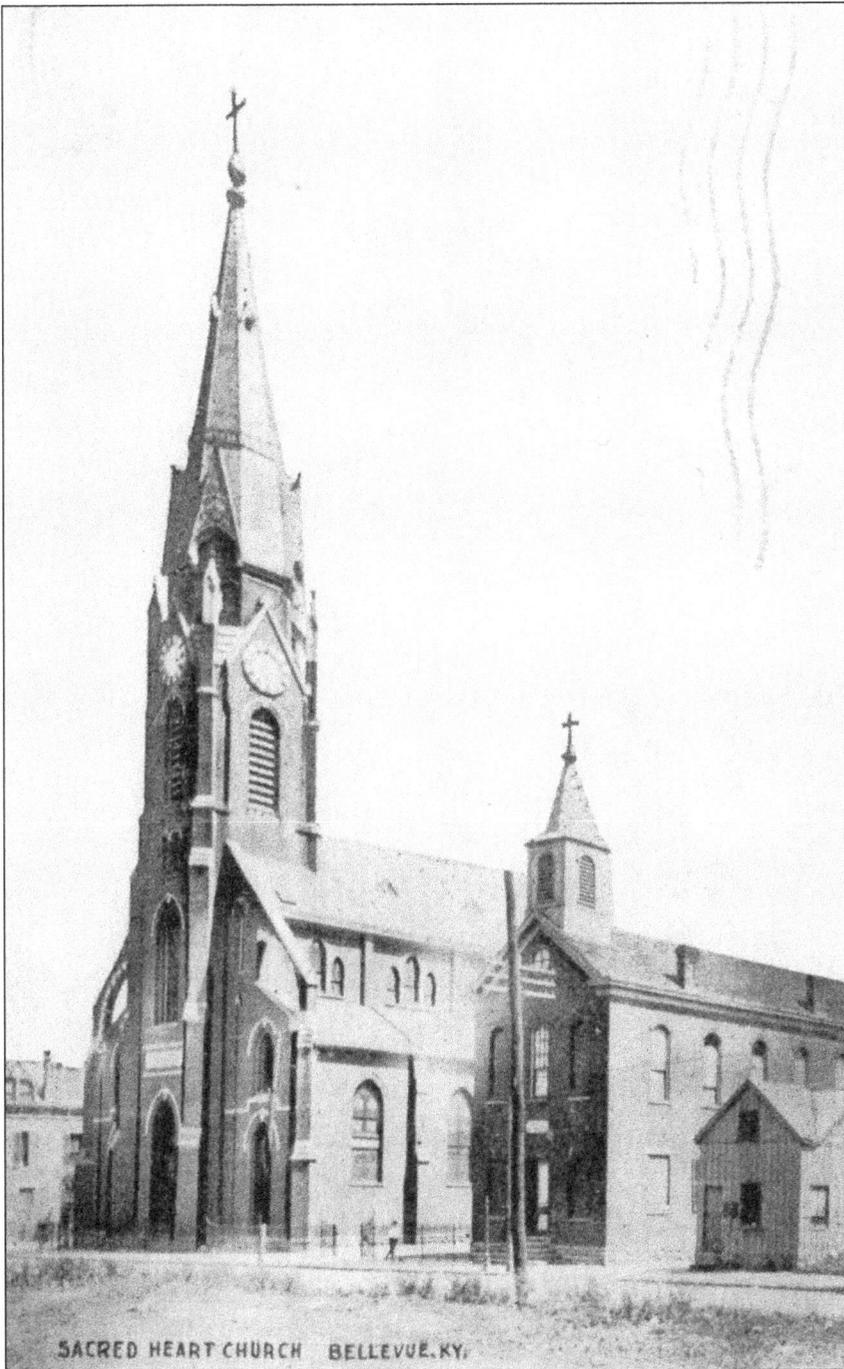

SACRED HEART CHURCH BELLEVUE, KY.

Sacred Heart Catholic Church moved into this building on Taylor at Division Streets in 1893. The original church building is on the right, and the new and grander building is on the left. The church's new home was built to resemble the catholic churches of Bavaria in an effort to make the mostly German congregation feel comfortable. Sacred Heart once had one of the highest steeples in Northern Kentucky. This is one of the many Bellevue photographs used to create postcards in the early 20th century.

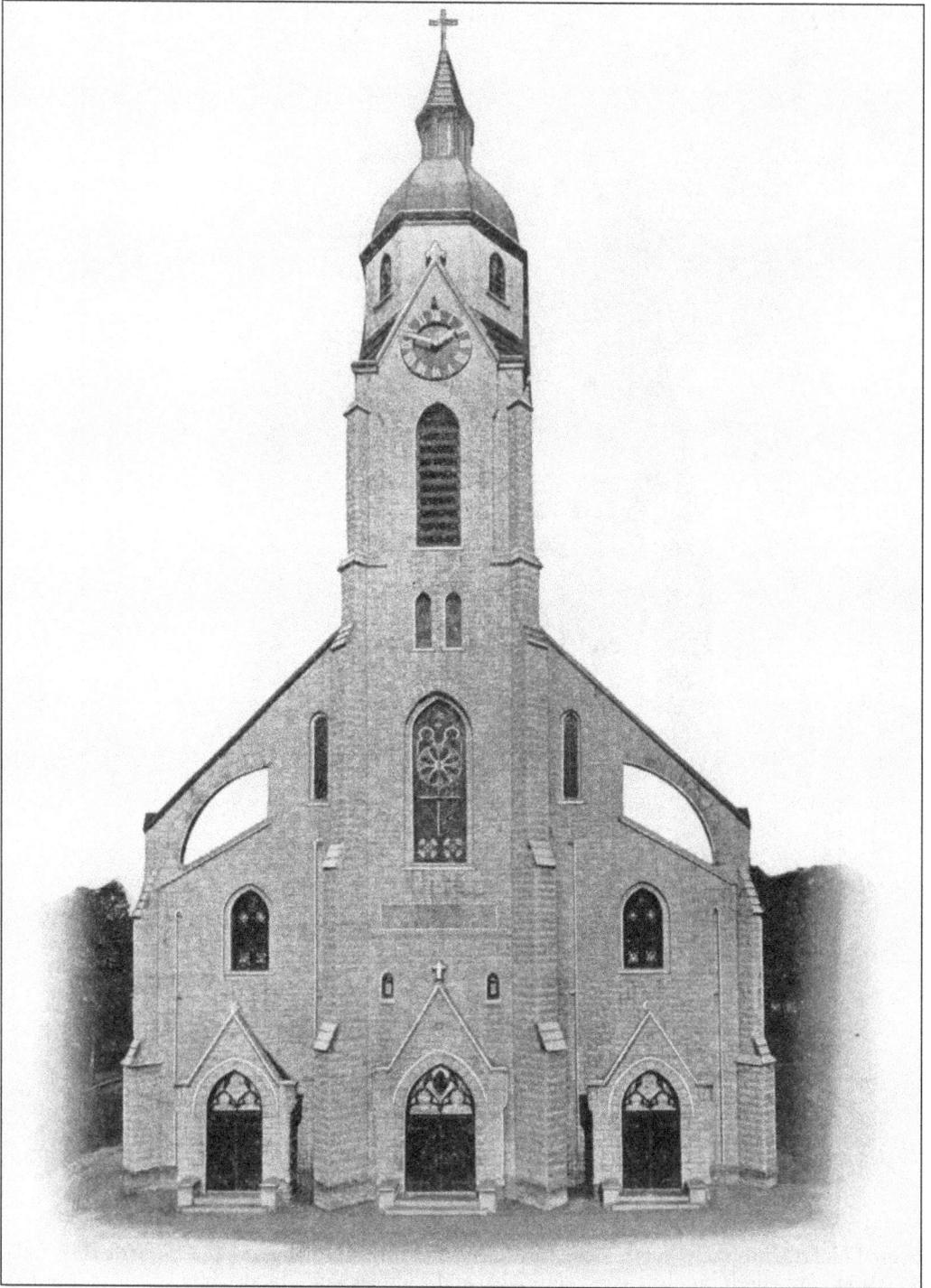

In this picture taken shortly after the completion of the cupola, the new look of Sacred Heart Church on Taylor Avenue is seen as it is today. After the tornado stripped the church of the original steeple that gave it a distinctly Bavarian appearance, Sacred Heart's exterior character changed, but it still remained very German.

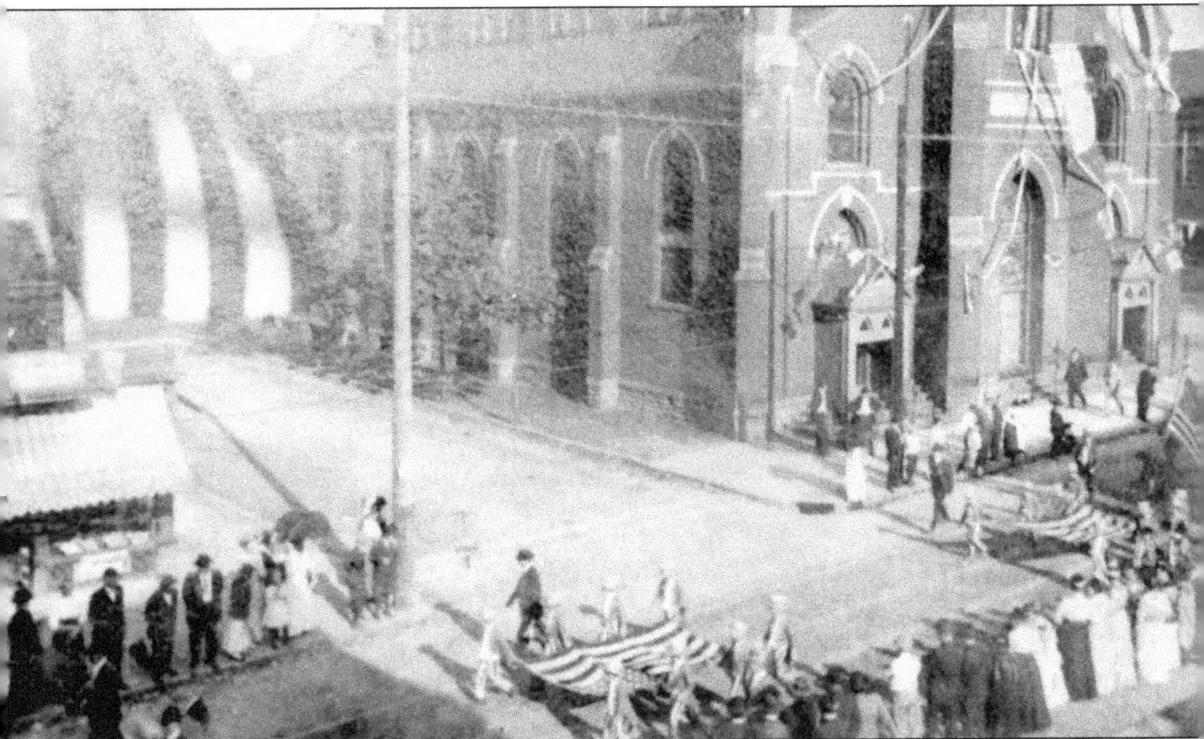

A parade marches down Taylor Avenue past Sacred Heart Church on its way to Fairfield Avenue. Patriotic parades, of which there was no shortage in Bellevue, regularly took this route.

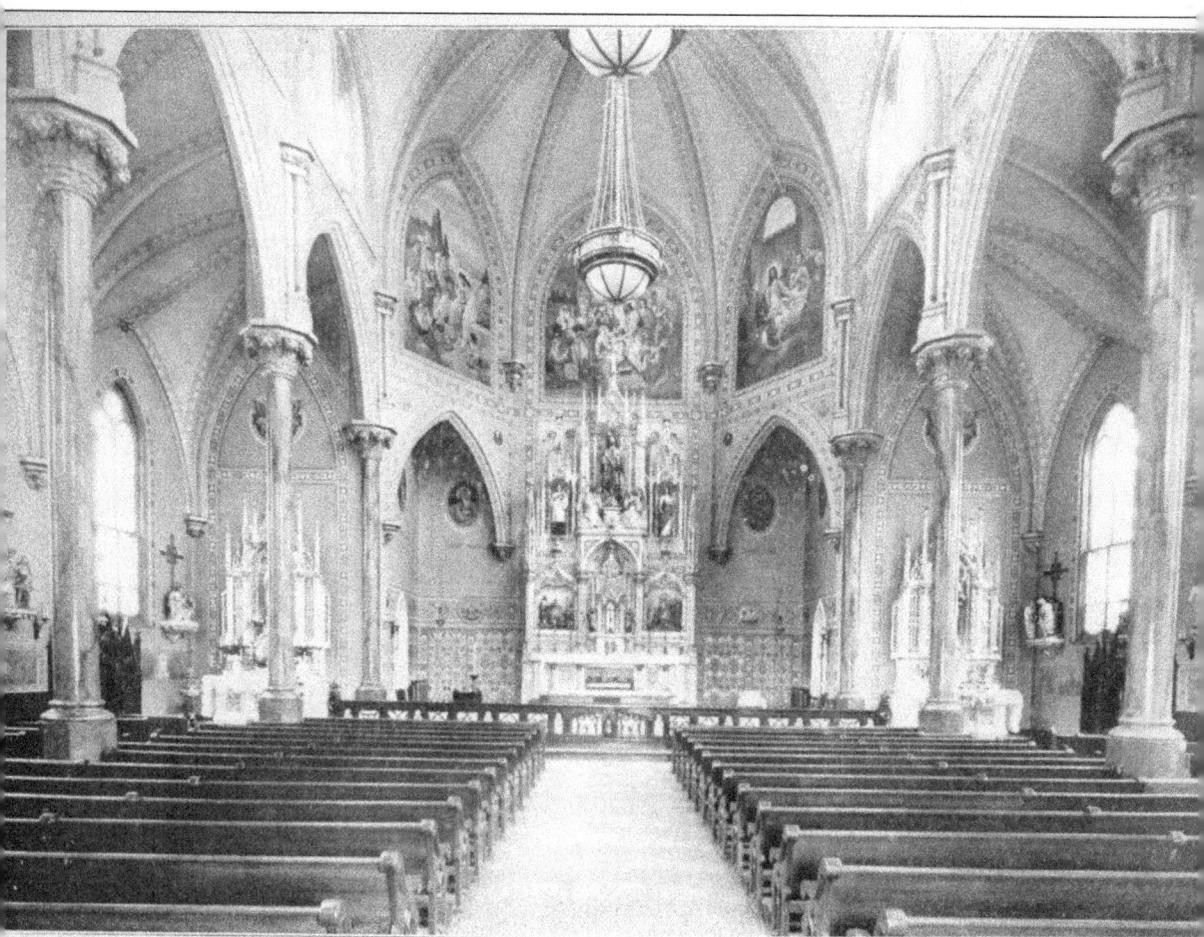

NEW INTERIOR OF SACRED HEART CHURCH

The new sanctuary of Sacred Heart Catholic Church is shown here. Most of the interior of the church was redecorated in preparation for the Golden Jubilee of the founding of the church in 1924. The murals over the sanctuary were painted by Theodore Brasch, whose firm was responsible for the redecoration. The frescoes of the stations of the cross were painted by Leon Lippert, who was trained by the renowned artist, Frank Duveneck, of Covington, Kentucky.

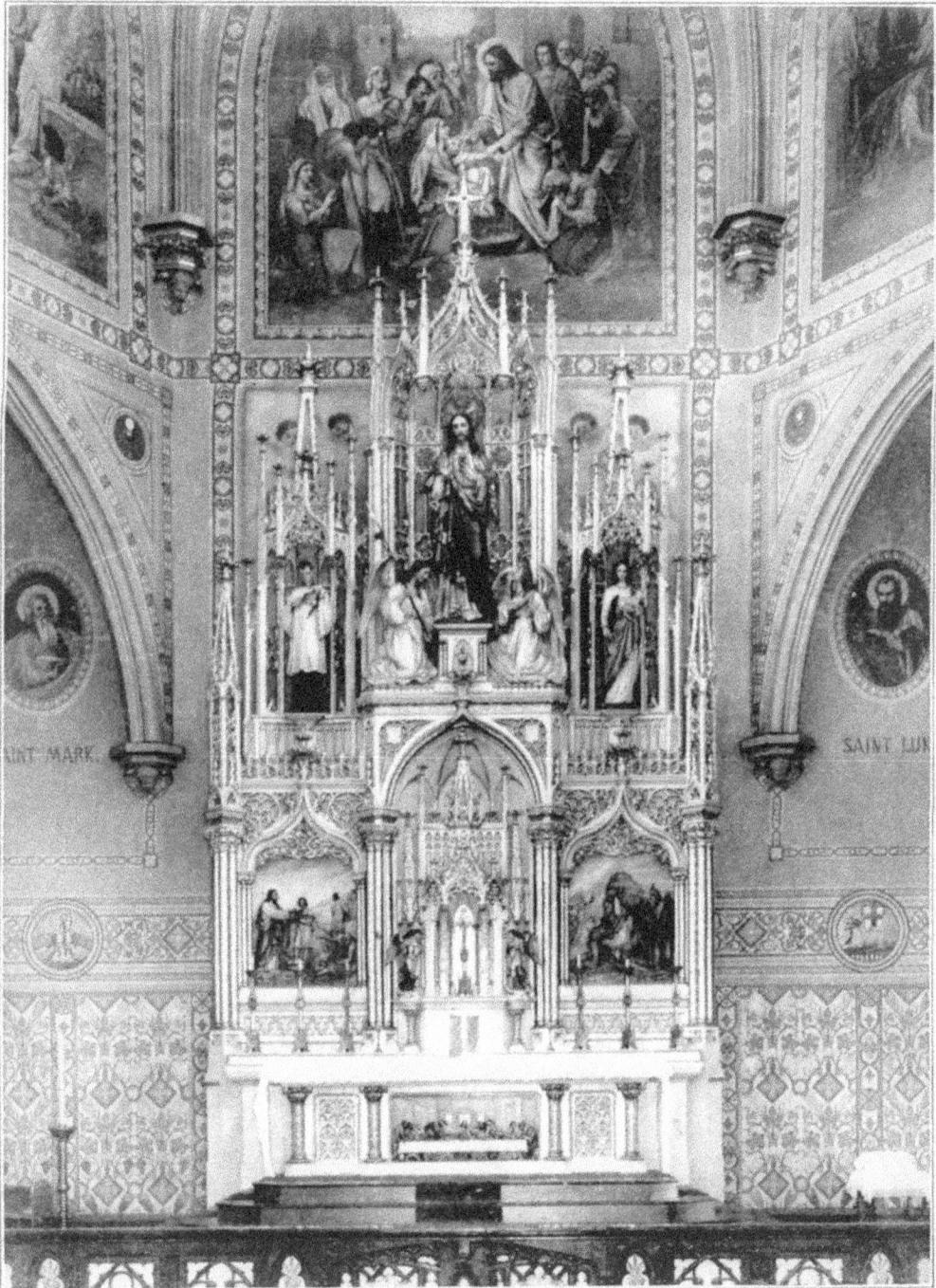

MAIN ALTAR, SACRED HEART CHURCH

The main altar at Sacred Heart Catholic Church is seen here after the renovation in 1924. The new renovation replaced the old altar with this very intricate altarpiece. The old great dark altars where replaced with hand-carved ones of a lesser size, but containing more delicate details.

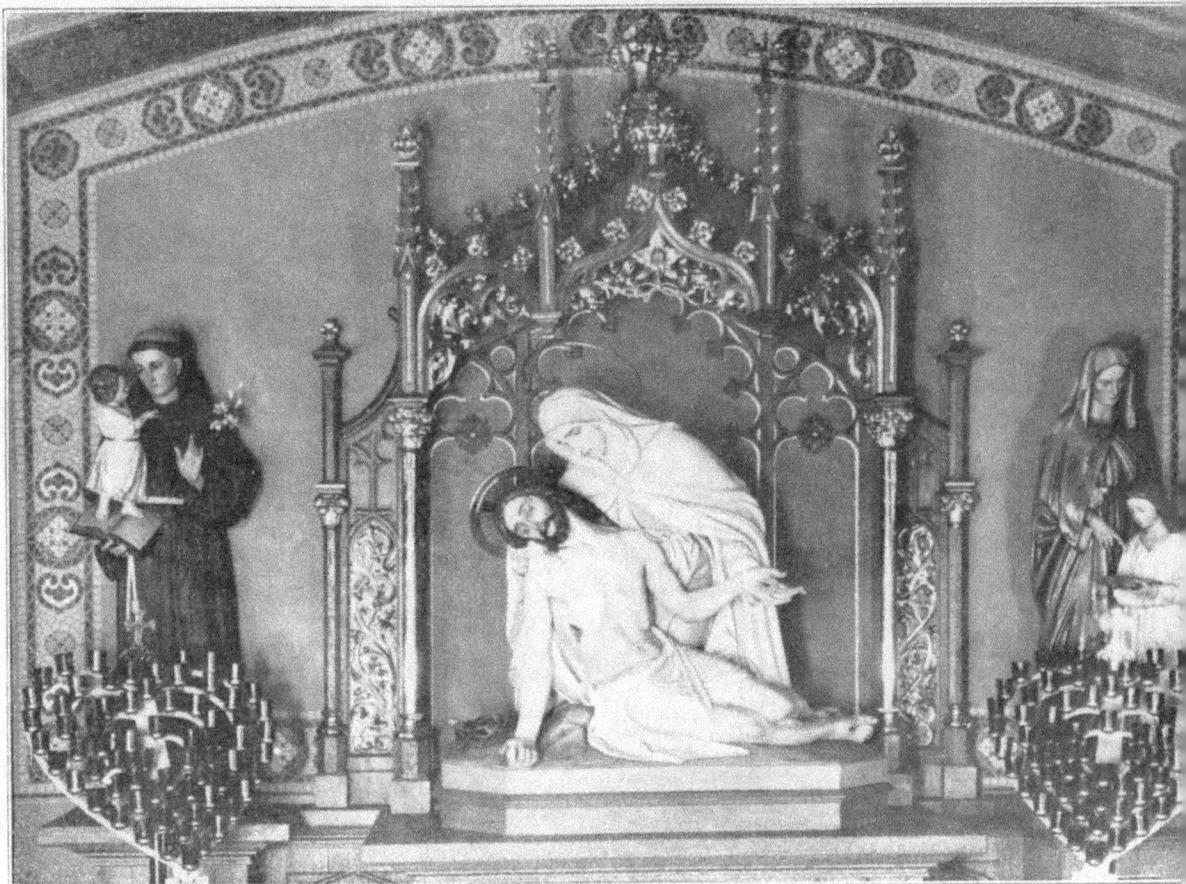

NEW SHRINE, SACRED HEART CHURCH

The new renovations also brought to Sacred Heart a hand-carved pietá, which was the centerpiece for a shrine to the resurrection.

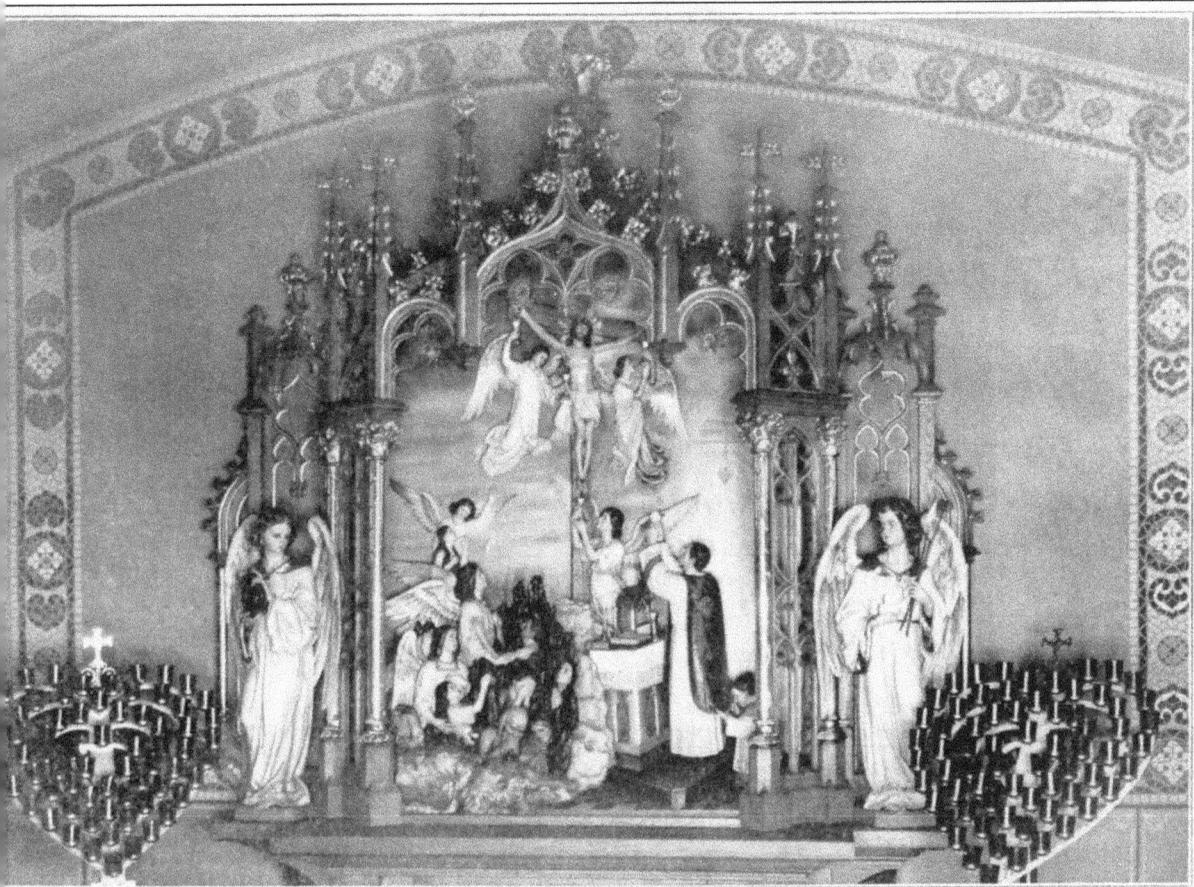

NEW SHRINE, SACRED HEART CHURCH

This photo shows the shrine of the Passion at Sacred Heart Catholic Church.

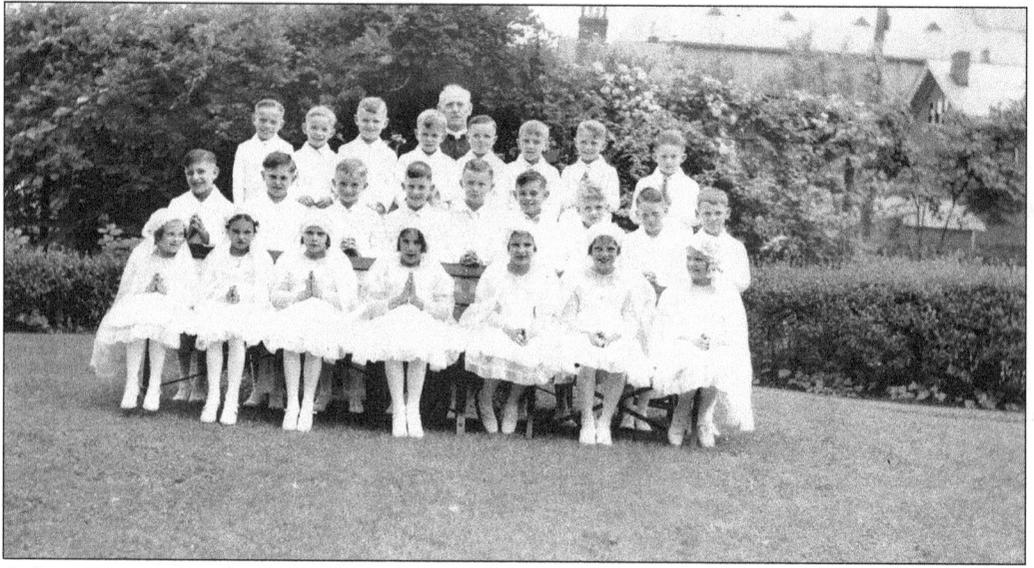

A first-communion class in Bellevue poses for a picture commemorating their special day.

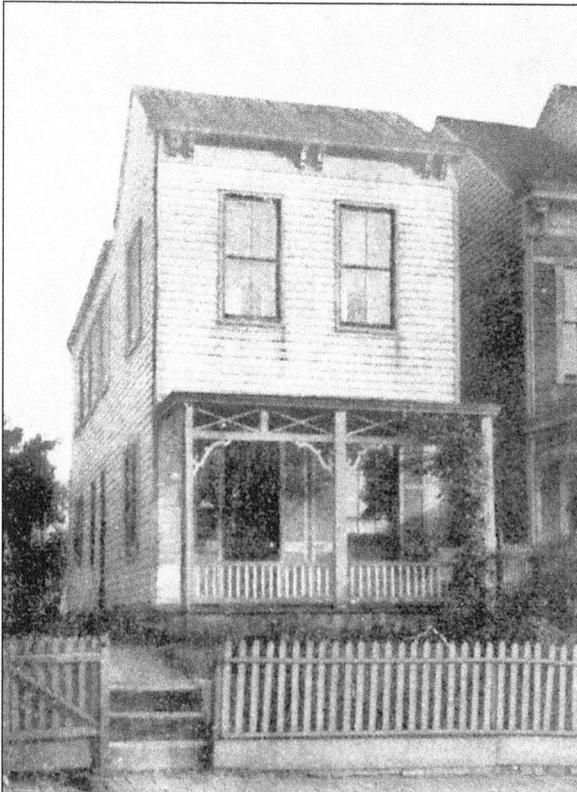

Dozens of narrow, two- to three-story dwellings were built in Bellevue in the late 19th century. Ideally suited to the city's narrow lots, they provided middle-class families with the most house for the least money. This handsome frame residence at 212 Prospect Street was built c. 1873–1874 for E. L. Higdon. Later, when the home was owned by the Nakenhorst family, the St. John Evangelical Protestant Church (now St. John United Church of Christ) was formed here. The church went through a series of moves before arriving at its present home on Fairfield Avenue.

Home to St. John until the 1932 opening of the Fairfield Avenue location, this church on Foote Avenue had become a Bellevue landmark. This building marked the third time a Bellevue congregation had abandoned a small brick building for a larger church to support an ever-growing congregation—a testament to the city's faith and its continued growth.

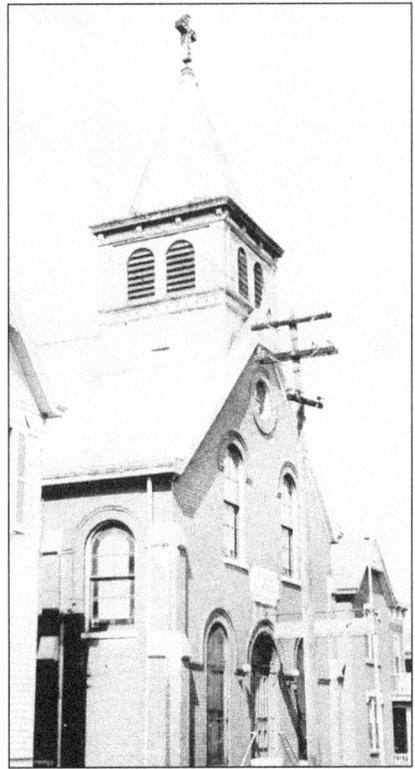

The children of St. John Church gather on the stairs for a photograph. The slate held by the boys is dated October 25, 1908.

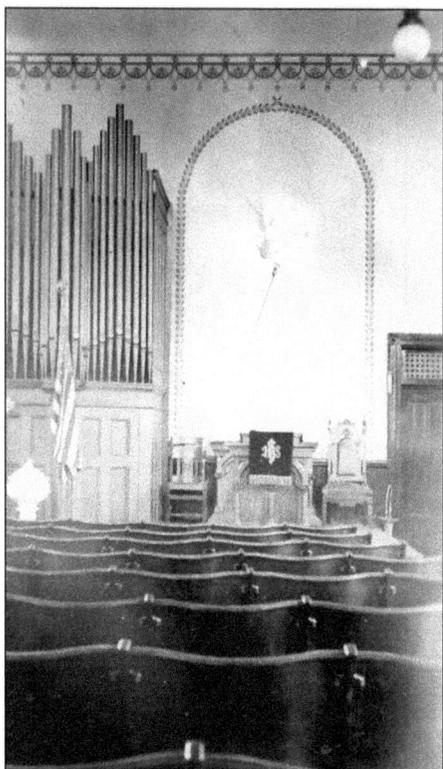

The pulpit at St. John mirrored the simple interior of the rest of the sanctuary, leaving only the pipes of the organ to distract the congregation.

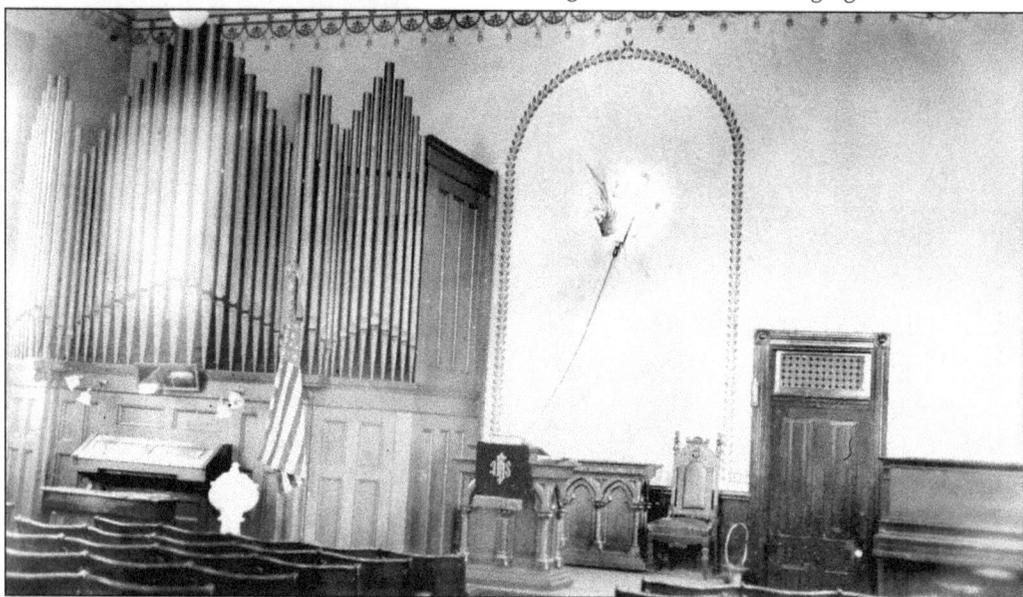

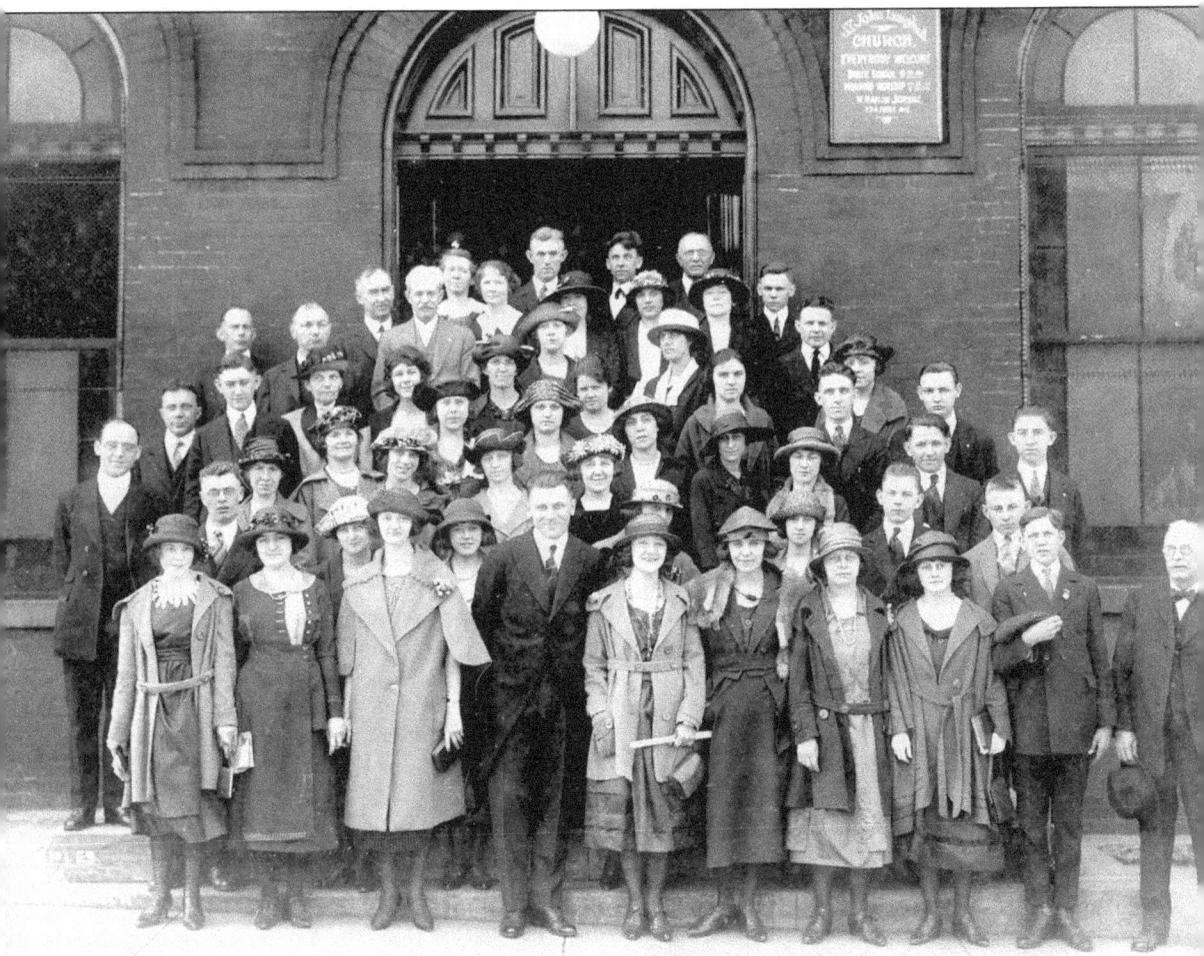

Bellevue's teens were always in search of social opportunities, and they found what they were looking for with the Young People's League. Formed by St. John Church, this group encouraged young people to be active in society as well as the church and provided numerous social outlets for area youth.

The sanctuary at St. John Christian Church was tasteful and conservative. The church had numerous homes, including Balke Opera House, before moving into this building on Foote Avenue in the 1930s. The church has also had several names while its congregation remained constant. Some names included the St. John Evangelical Church, St. John Christian Church, and St. John United Church of Christ.

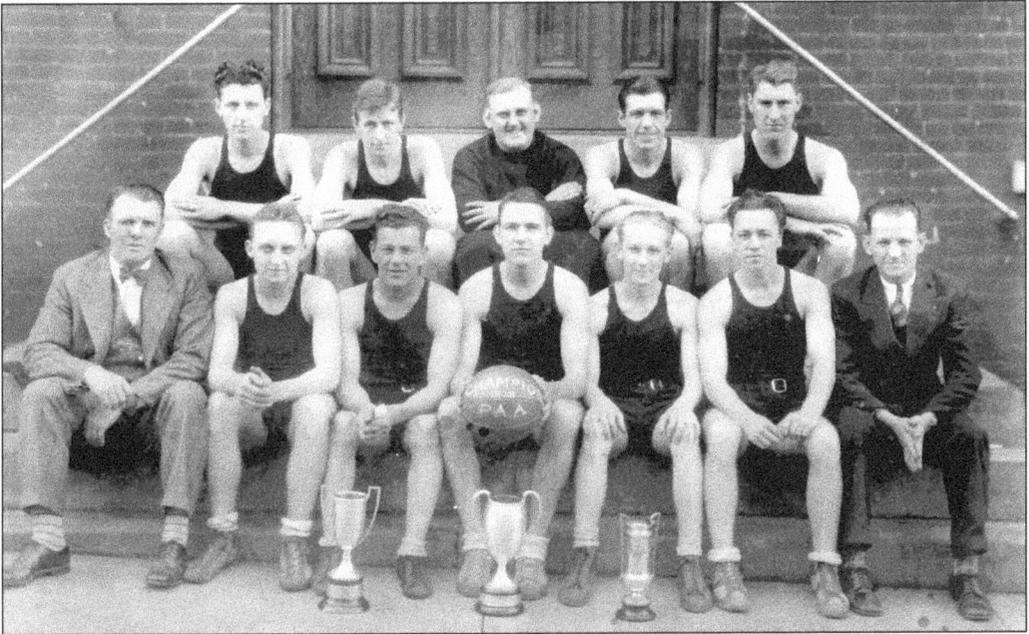

By 1928, success in amateur sports in Bellevue had become the norm. Bellevue teams began to win championships in everything from swimming to basketball. The 1928–1929 St. John basketball team brought one of those championships to Bellevue as winners of the Cincinnati Protestant Athletic Association League.

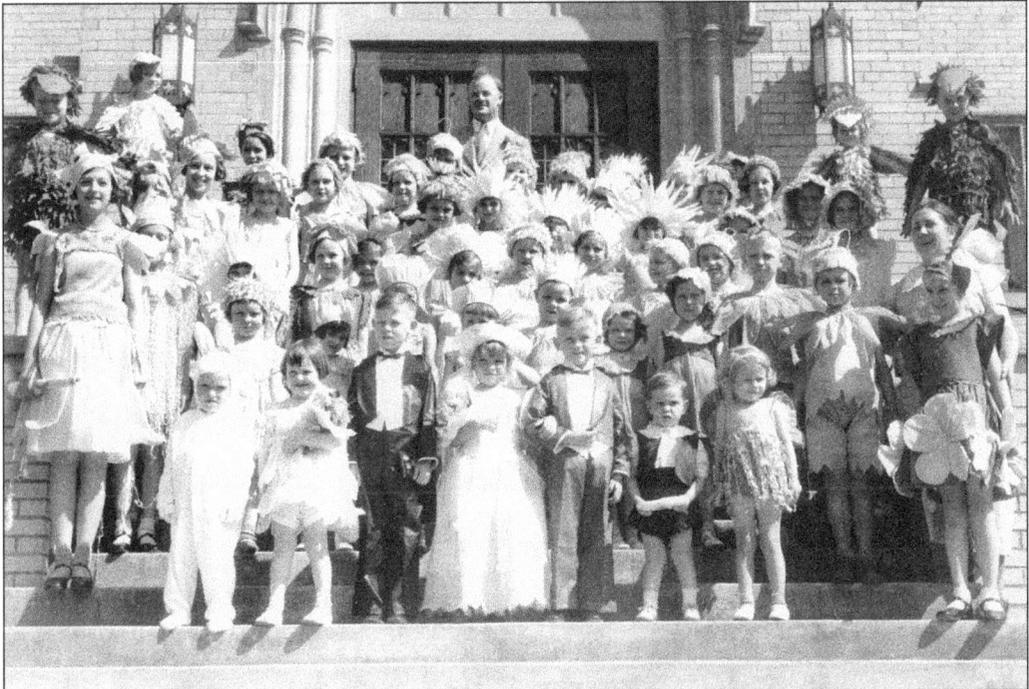

The cast of Tomb Thumb's Wedding was made up of members of the Sunday school classes at St. John Christian Church. During the 1930s, the play was among the most popular children's plays and was being performed by churches all over Northern Kentucky.

Sunday mornings in Bellevue were always reserved for attending church. With five churches serving a town of one square mile, the role of religion is apparent. Here two 1936 Sunday-school classes at Saint John poses for a photograph during a break from their morning activities.

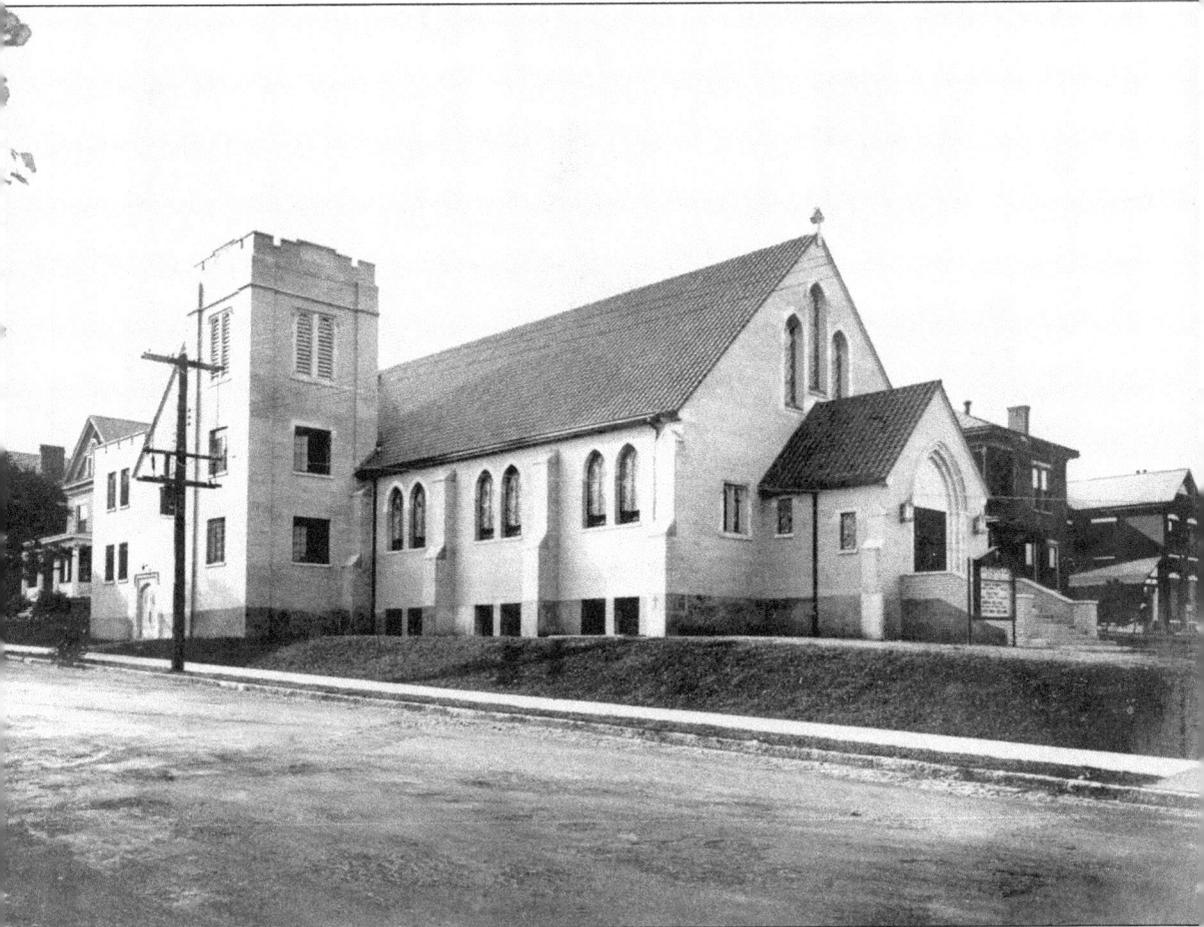

With construction nearly complete in 1932, the congregation of St. John was preparing to move into this larger, modern building on Fairfield Avenue. The new building provided the church the opportunity to upgrade its facilities and increase the size of its congregation with the additional space and high-profile location.

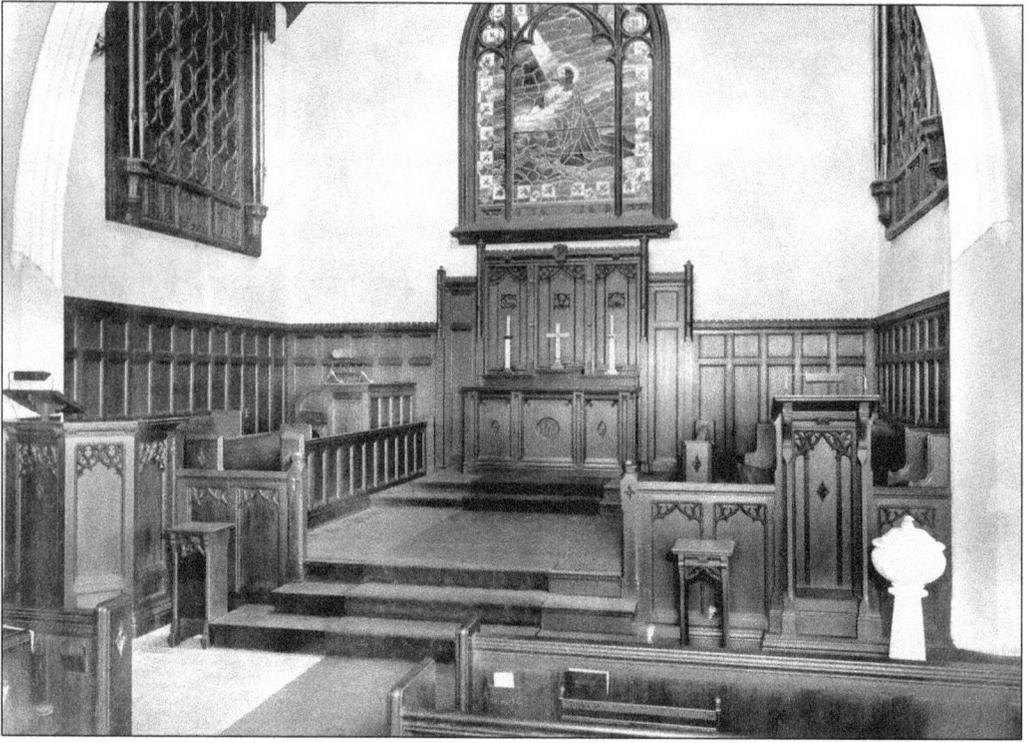

The altar at St. John Church is accented with a beautiful stained glass window

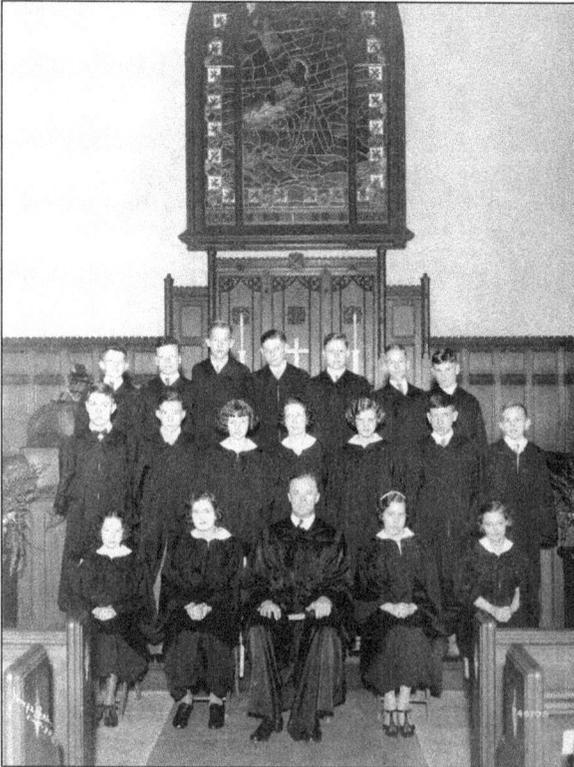

The choir at St. John poses for a picture for the 1936 church newsletter. The St. John choir was a major attraction for the church's congregation.

Five

PUBLIC SERVICE

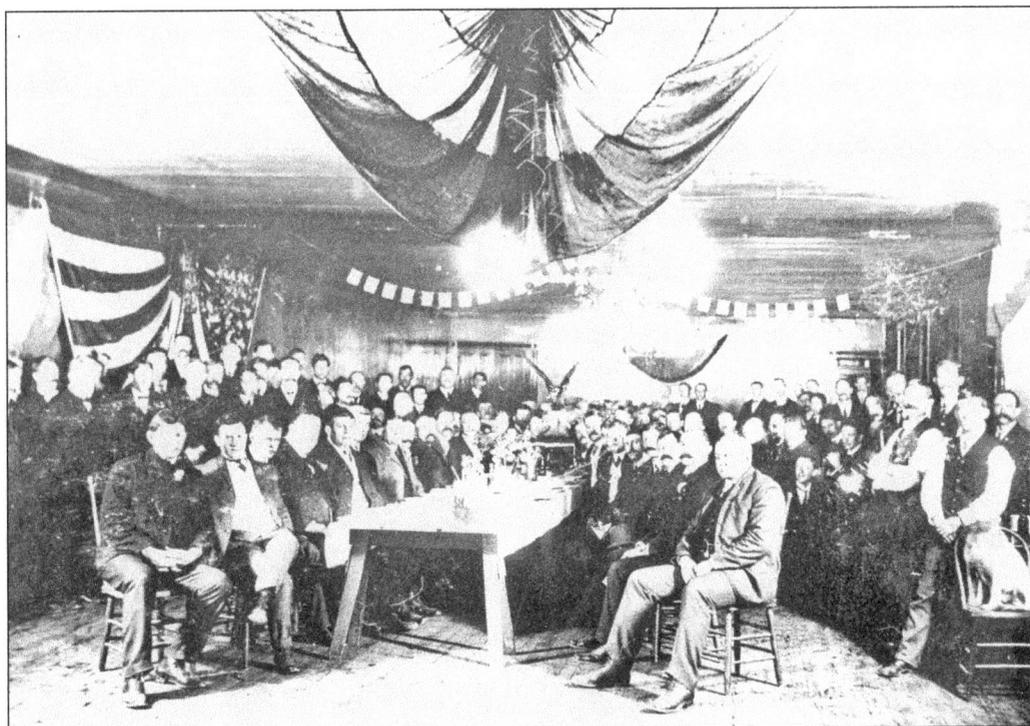

In 1900, the events of the day in Bellevue were shared over a drink at one of the local public houses. Here the men from the town get together to discus the latest news at the Old Homestead, a popular meeting hall and even more popular tavern and pool hall.

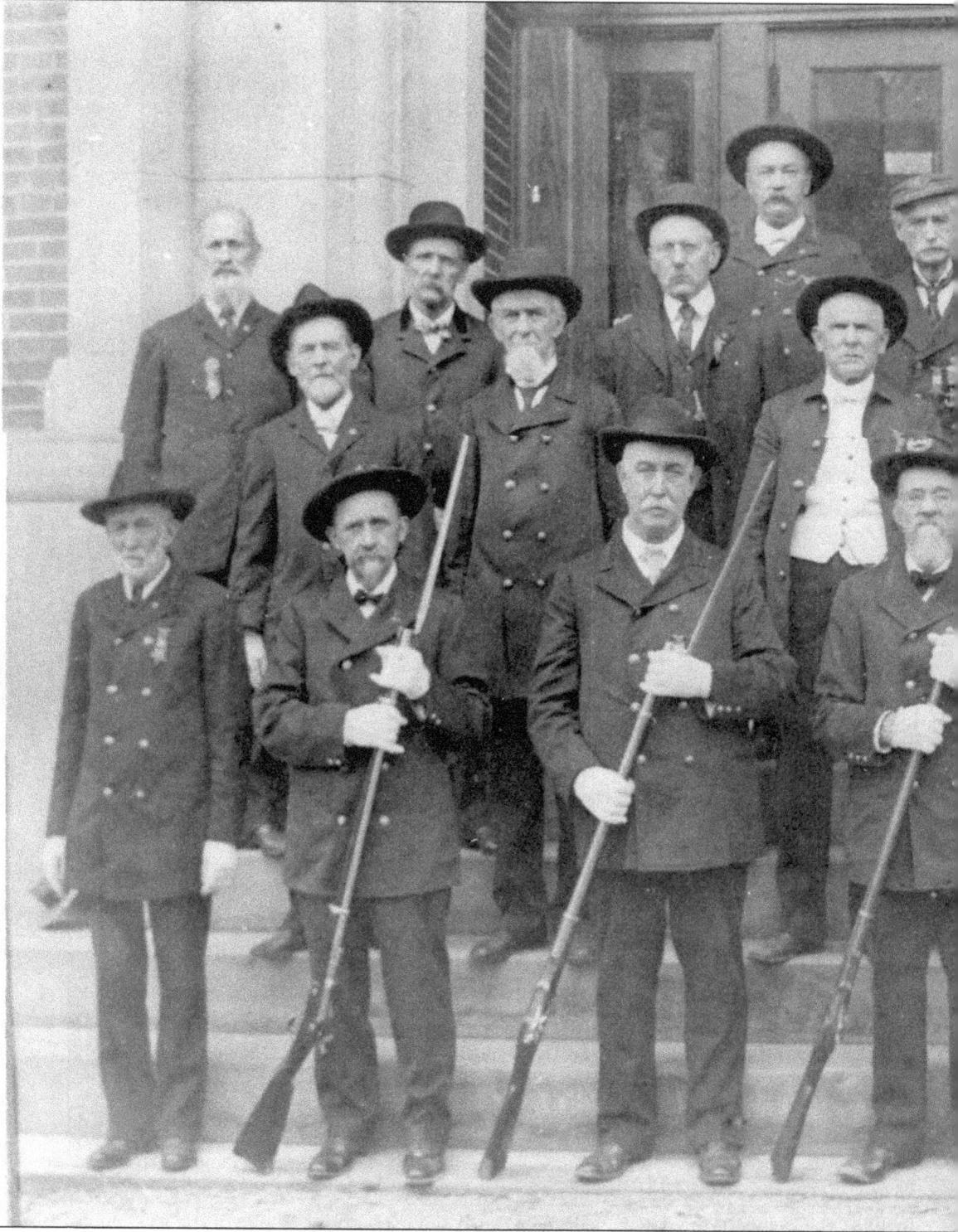

In 1903, Bellevue's surviving veterans from the War Between the States gathered at Bellevue High School for this photograph. Like many towns in the border state, Bellevue had citizens

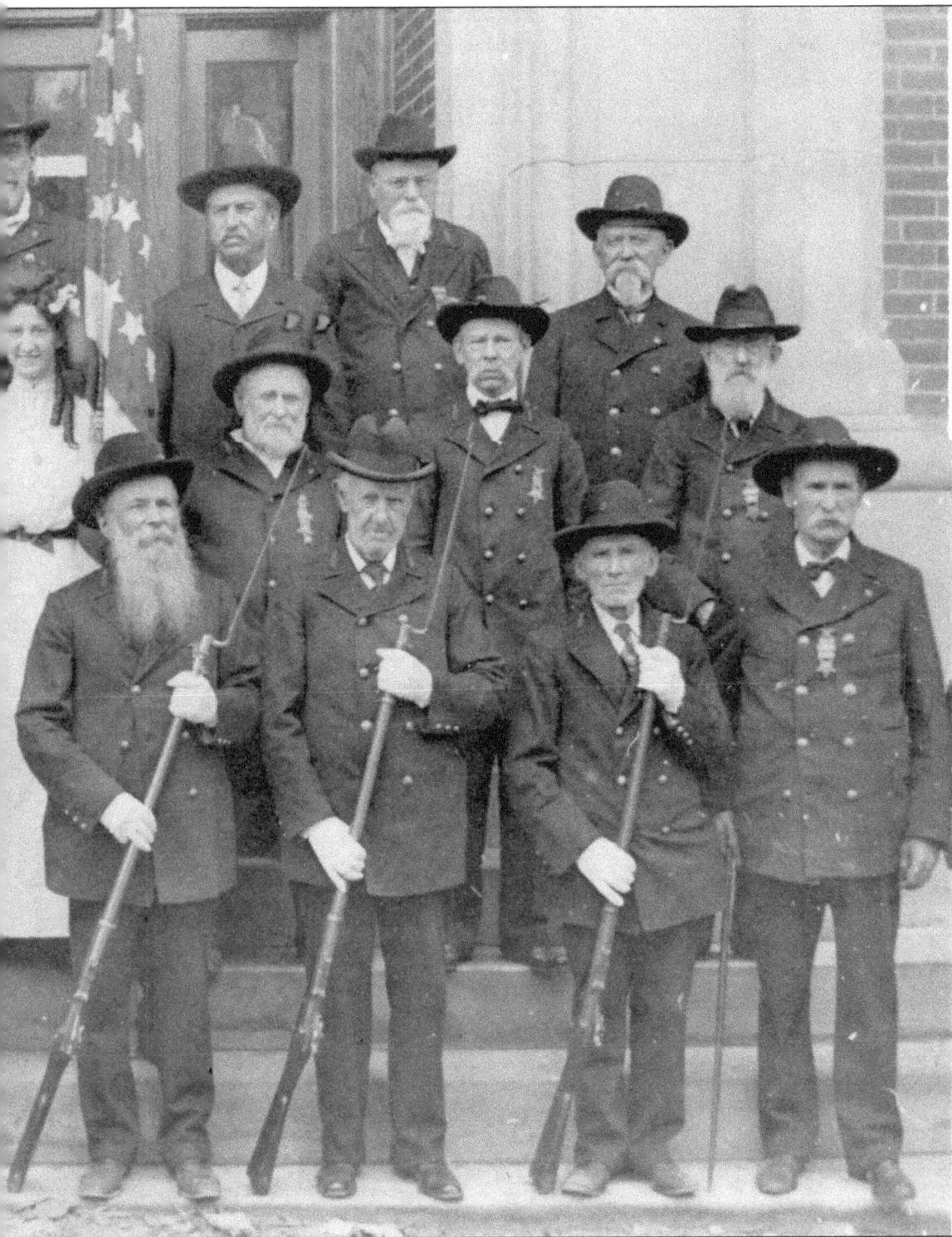

who fought on both sides during the war, but by the time of this reunion, differences had been set aside. Admiration and respect remained.

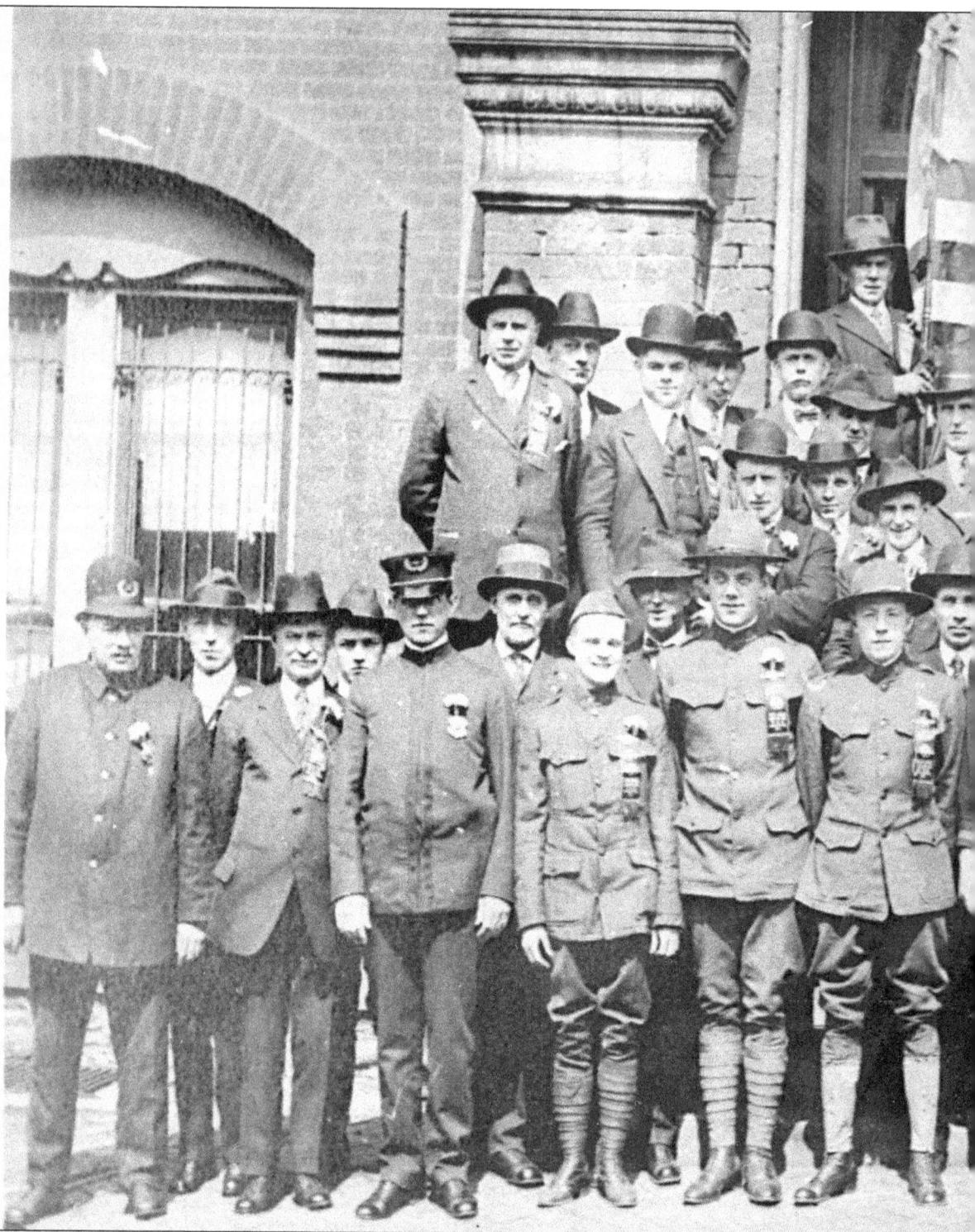

This group of men assembled in front of the Balke Opera House after returning from Europe in World War I. This photograph was likely taken in 1919. Several of the men are wearing medals

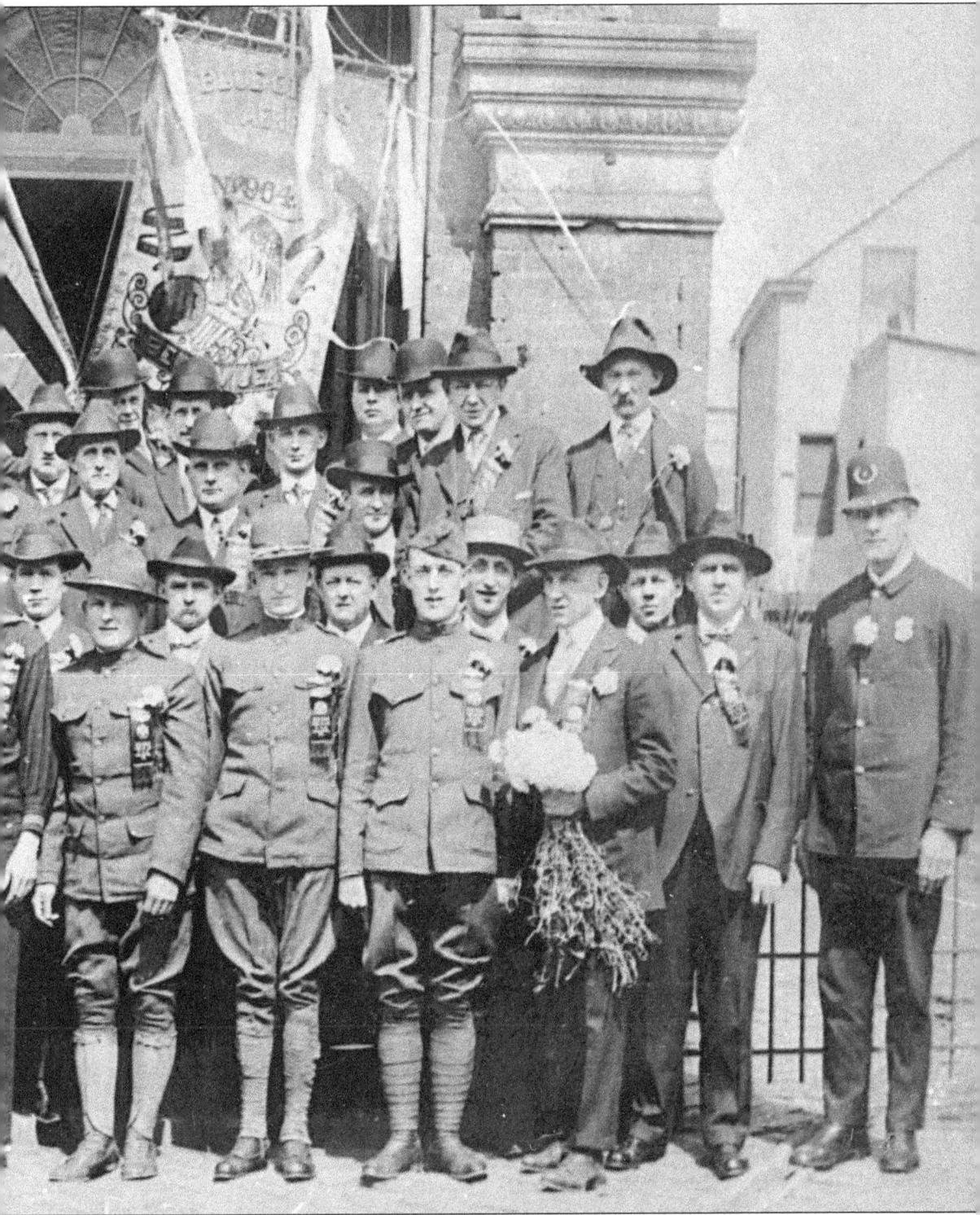

and ribbons won for their heroic service in the war. Three of the men went on to serve as Bellevue police officers after the war.

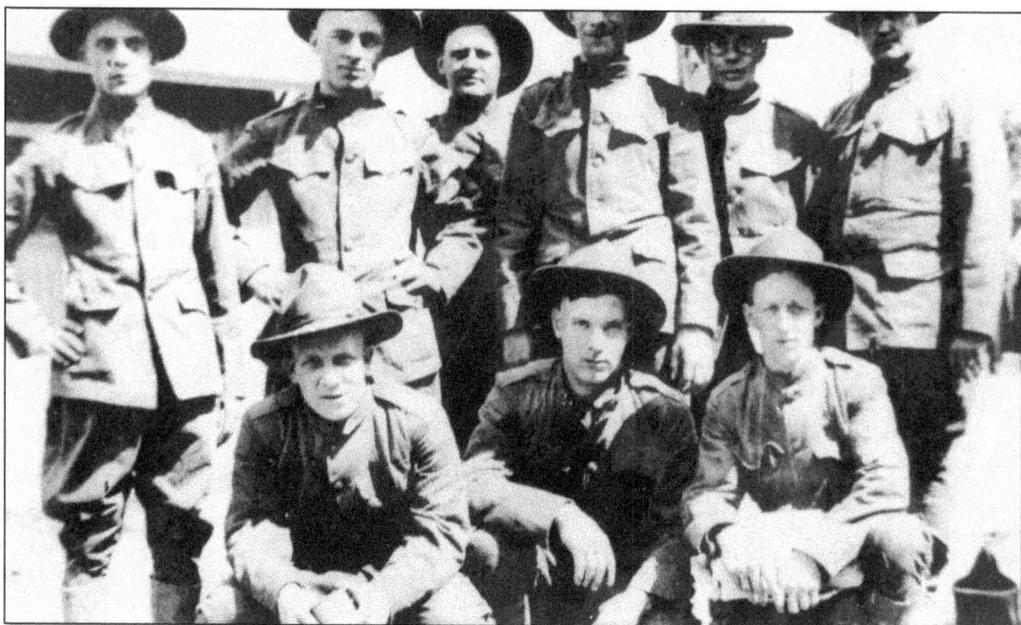

Bellevue's patriotism never shined brighter than when the call came for young men during World War I. This group of men became known as the Bellevue Boys. All nine joined at approximately the same time and were honored by the city as they left for Europe in 1916.

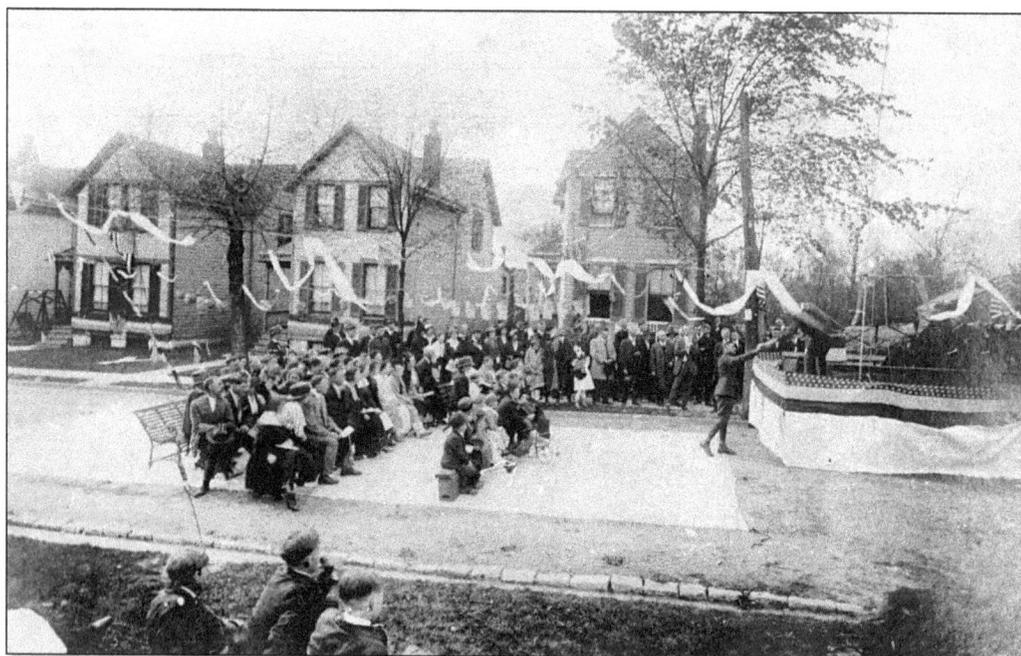

Many of Bellevue's young men went to fight with the allies in World War I, and those who came back received a hero's welcome. This homecoming celebration honored Captain Pickleman after a long tour in Europe. Celebrations like this marked many homecomings for the returning solders after the First World War.

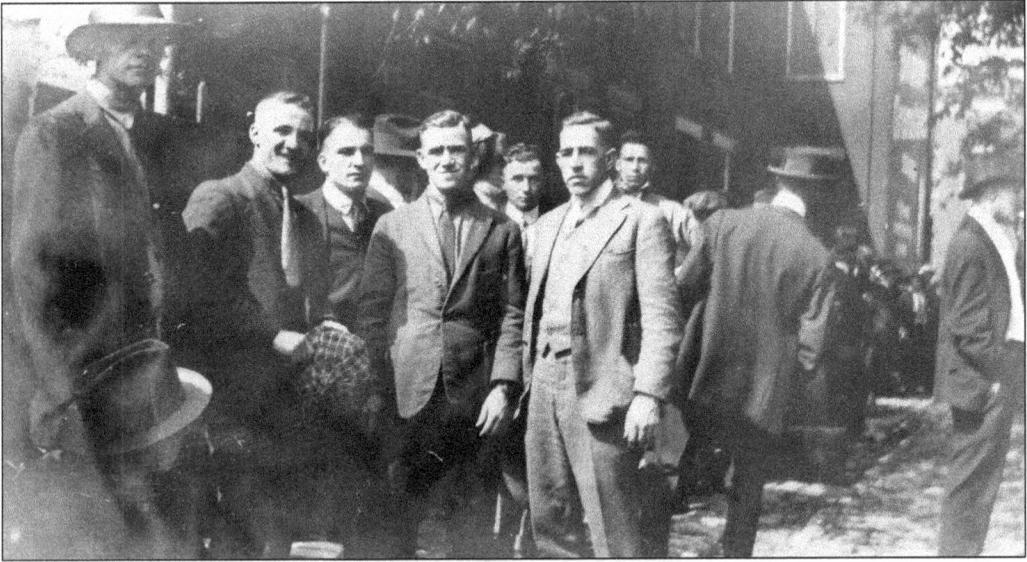

With the United States fully involved in World War I, men from across the nation began to flock to recruitment stations to serve their country. Bellevue was no exception: the city's young men scrambled to join the fight. Here George Camm (center) poses in 1917 just after walking out of the recruitment station to join his generation in Europe.

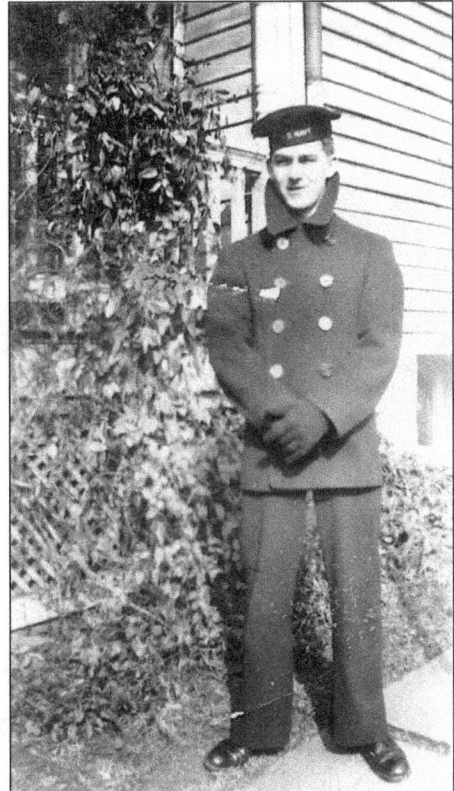

Bunk Camm poses in his sailor uniform at his home on Covert Run Pike in 1944 before heading to fight in World War II. Many of Bellevue's youth answered the call to duty in the 1940s, continuing the city's long history of service to the armed forces.

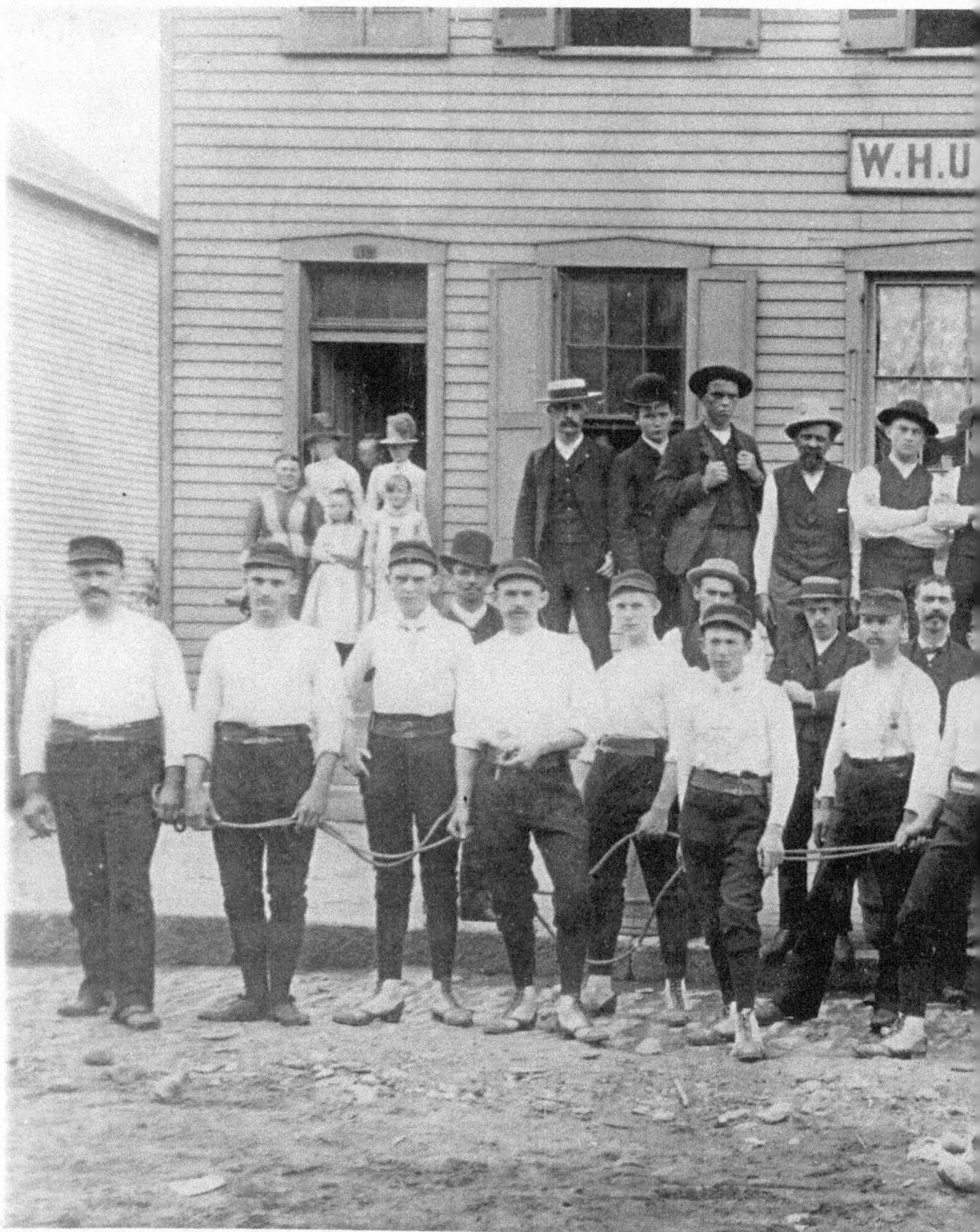

Bellevue's first volunteer firefighters pose with their hose cart shortly after the department's

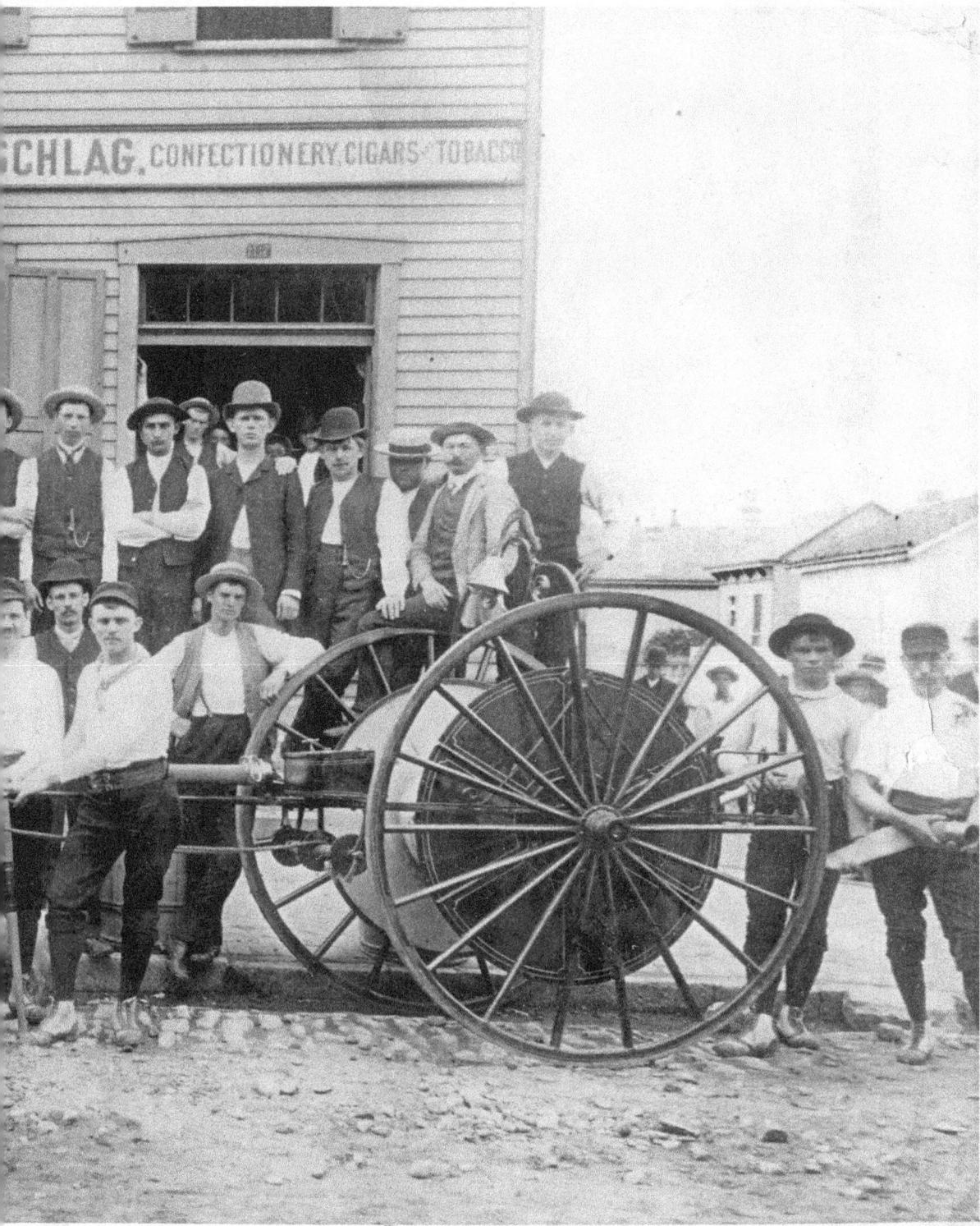

formation in 1886.

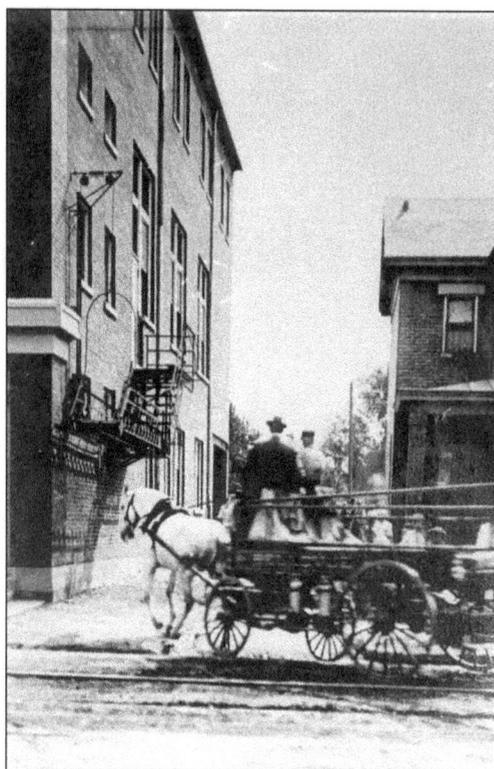

Still using horse and wagon, the Bellevue Fire Department returns from a fire in 1912. At the time, the fire department was located in the rear of the Garfield Building at 350 Taylor Avenue. Some time later, this building would serve as the home of Bellevue's first post office.

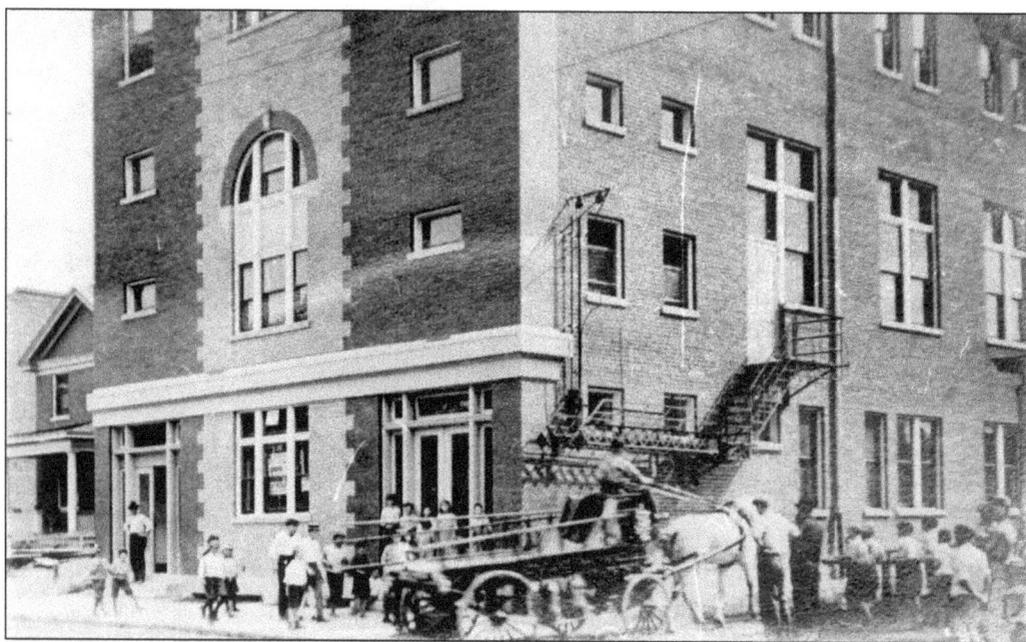

The Bellevue Volunteer Fire Department comes to a stop in the alley next to their home at 350 Taylor Avenue, the Garfield Building. Then, like today, everyone loved to see the fire vehicles.

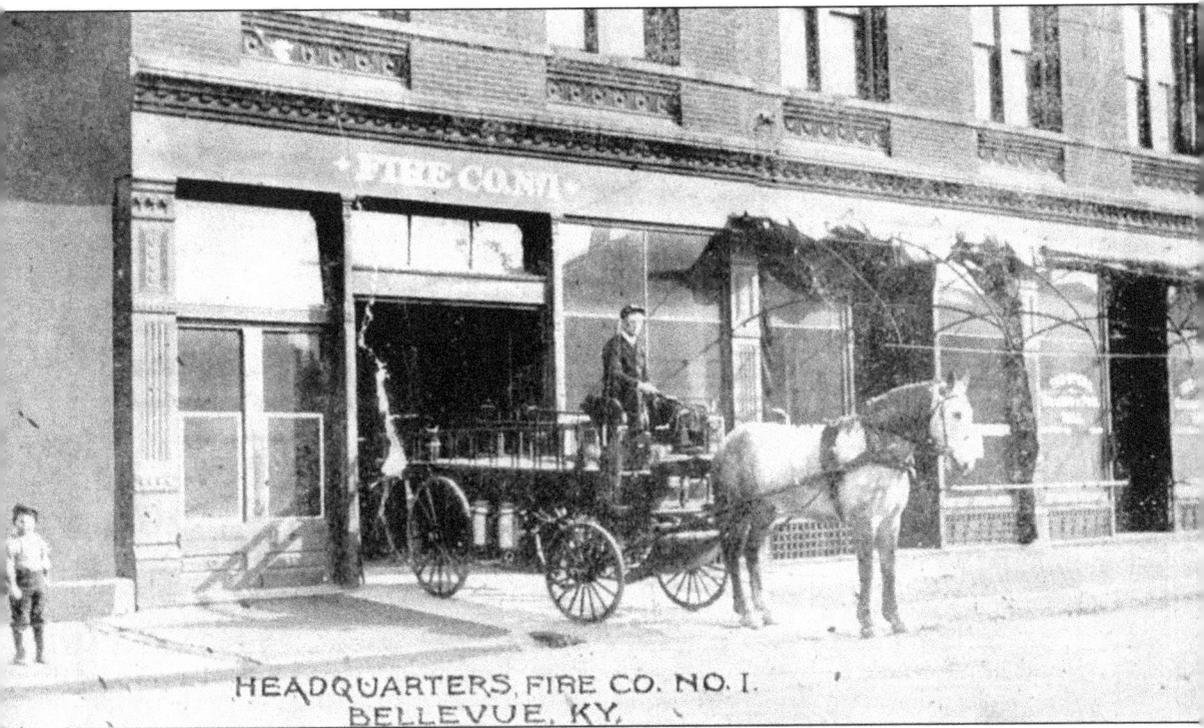

HEADQUARTERS, FIRE CO. NO. I.
BELLEVUE, KY.

This turn-of-the-century photograph shows Bellevue Fire Company Engine No. 1. The fire company was located in a section of the Balke Opera House at Fairfield and Berry Avenues. Even 100 years ago, young boys were fascinated by fire vehicles.

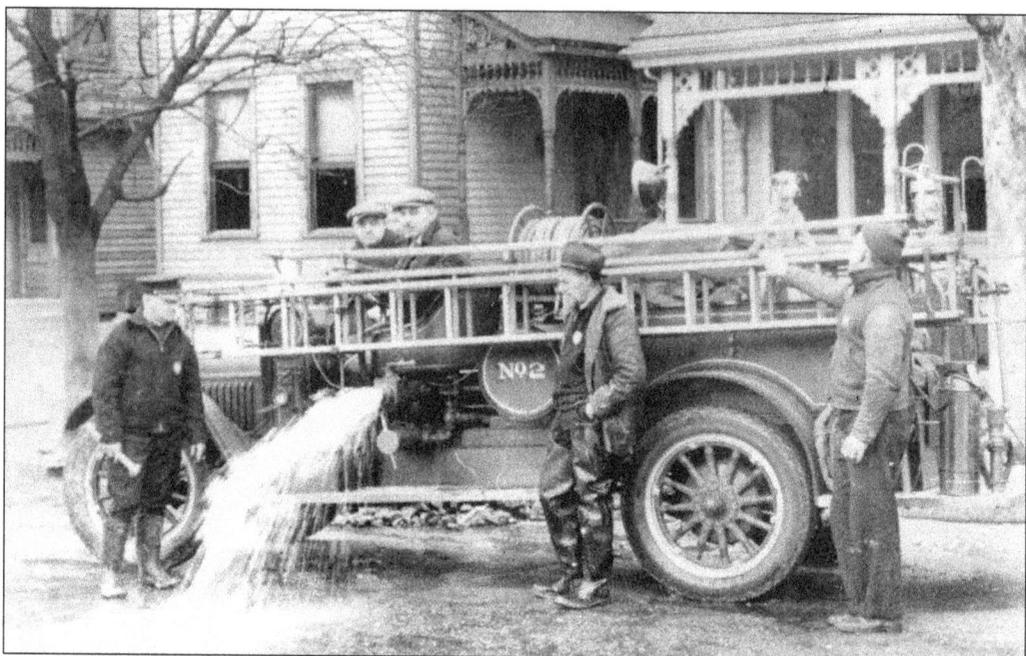

Three men from the Bellevue Fire Department test the new truck bought in 1918 that replaced the old horse-drawn trucks and carts used for decades.

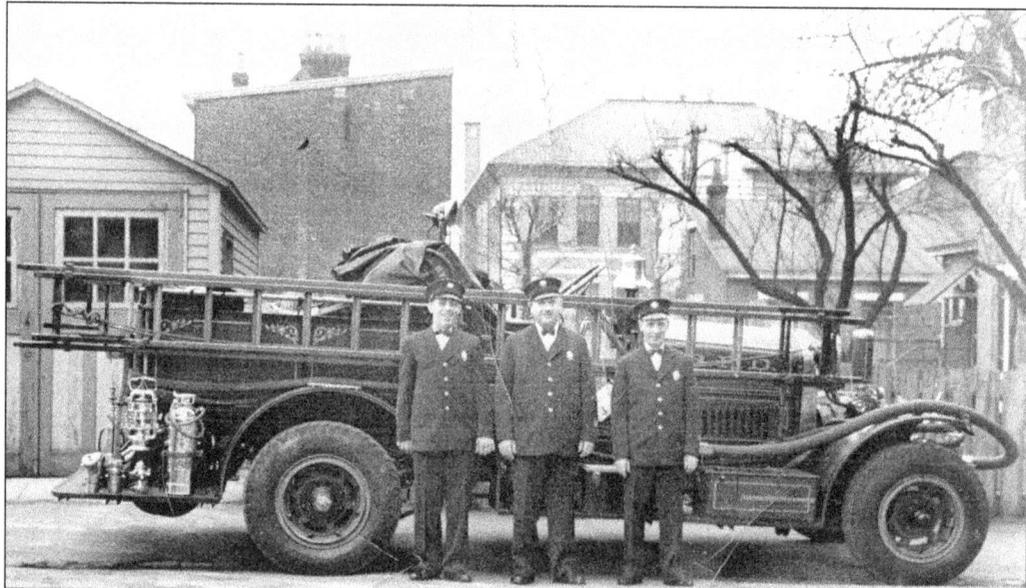

Three members of the Bellevue Fire Department pose with their truck in the alleyway in the 300 block of Walnut and Retreat Streets. Ahrens-Fox built fire apparatus across the river from Bellevue in Cincinnati. This 1918 model K-34 was delivered to Bellevue on November 2, 1918. Most Ahrens-Fox engines had piston pumps, but this is one of the few rotary pumps they built. It originally had wooden spoke wheels and solid rubber tires. At some point, the truck was converted to the steel discs and pneumatic tires seen in this photograph. This truck was still in active service when used by the Walton, Kentucky, Fire Department from 1965 to 1985! It is now in the hands of a collector.

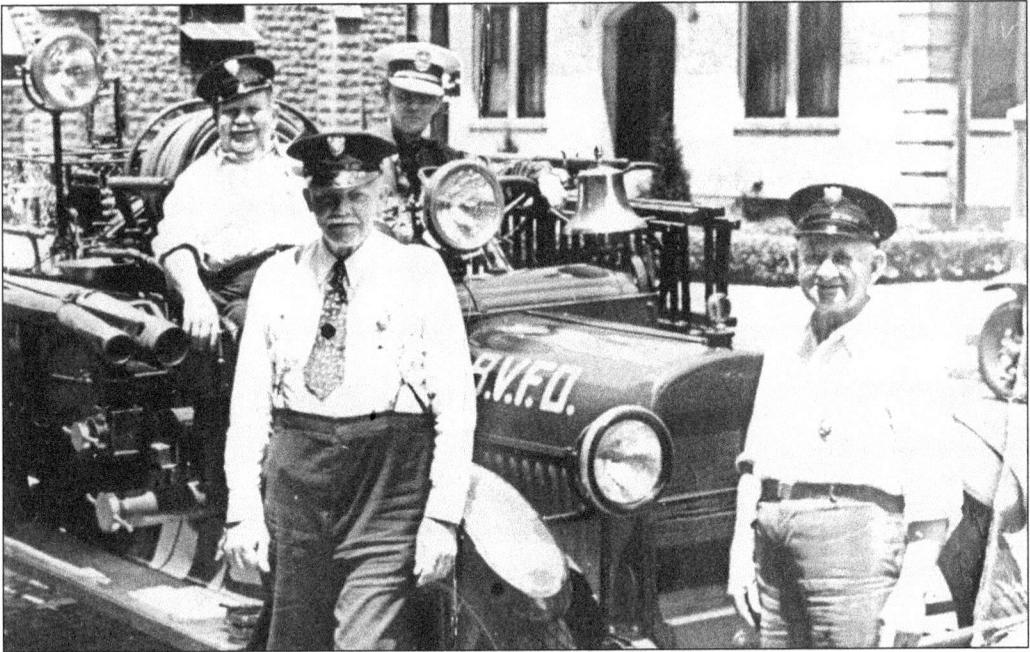

This 1936 photograph shows three of the early members of Bellevue's volunteer fire department. At that time, fire protection for Bellevue was provided exclusively by a group of dedicated, community-oriented volunteers. There was no paid fire department in Bellevue. The police chiefs through the 1960s were also members of the volunteer fire department. In this photo, Police Chief Edward Winters sits in the driver's seat.

Bellevue Engine No. 2 travels down one of Bellevue's main streets during the July Fourth parade in 1946.

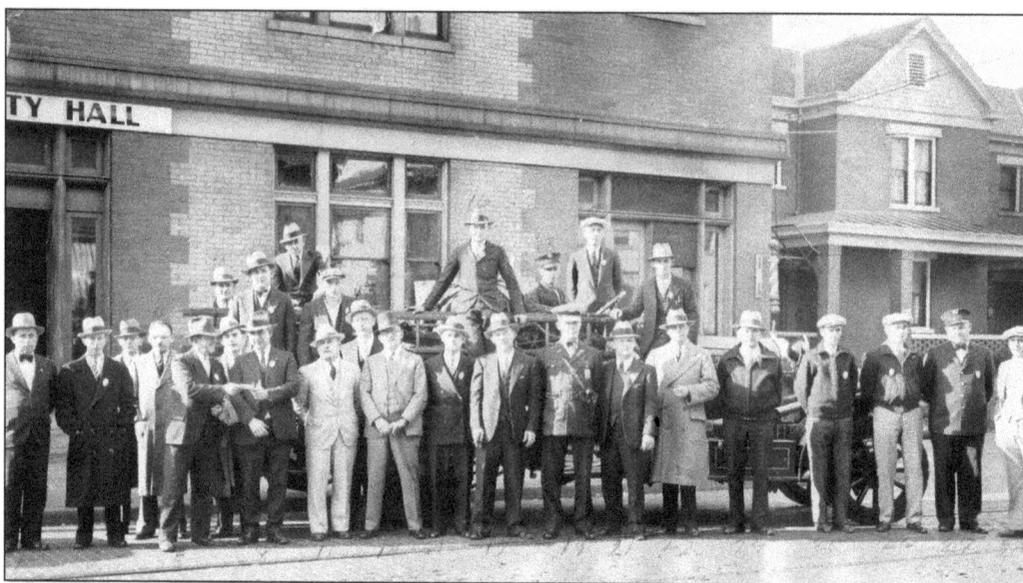

This photograph was taken c. 1936, with city officials and firemen posing around the fire truck parked in front of City Hall. City Hall was located in the Garfield Building at 350 Taylor Avenue, which also served as a meeting hall and held Bellevue's first post office and barber shop at different points in its life. At the center of this photograph is Edward Winters, who served as police chief from 1935 to 1937. Chief Winters was known for wearing a bow tie with his uniform as well as a cross-draw style holster for his revolver. It is common to see Bellevue's police chief posed in photographs until the late 1960s because the policemen of that day pulled double-duty as volunteer firemen as well.

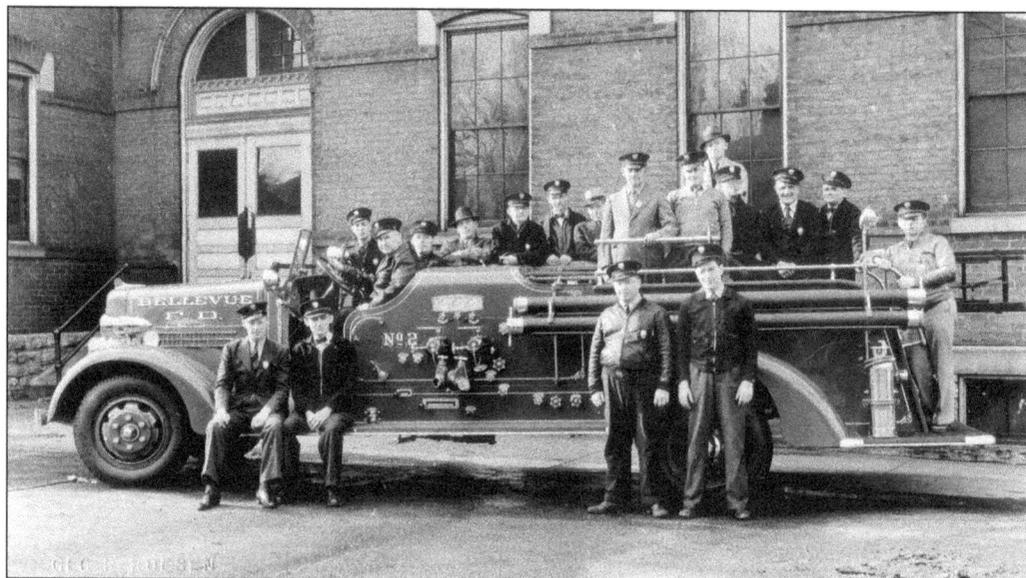

This photograph is the fire department's 1940 Ahrens-Fox parked at the rear of the Bellevue City Building at 616 Poplar Street. The building was originally built as an elementary school around 1888. At the time of this photo, the building was used as the City Building and fire department. The tall windows behind the truck let light in to the tight garage area where this truck and one other would park.

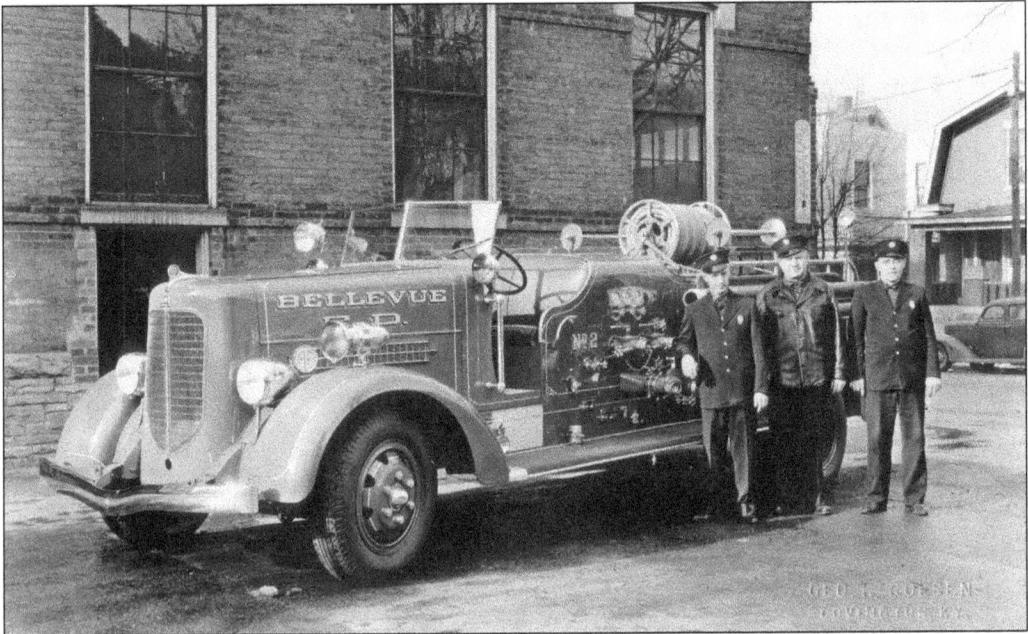

In 1940, the department traded its engine for this new Ahrens-Fox model EC built on a Schaft truck chassis. Schaft trucks were built in Cincinnati and were taken over by LeBlond Machine Tool of Cincinnati in 1927. Schafts were used for the chassis of many fire trucks. In 1935, LeBlond-Schaft bought a controlling interest in Ahrens-Fox and moved production to the Schaft plant. Shortly after this truck, Schaft ceased production, but Ahrens-Fox trucks continued to be built until 1952. This truck is also in the hands of a private collector.

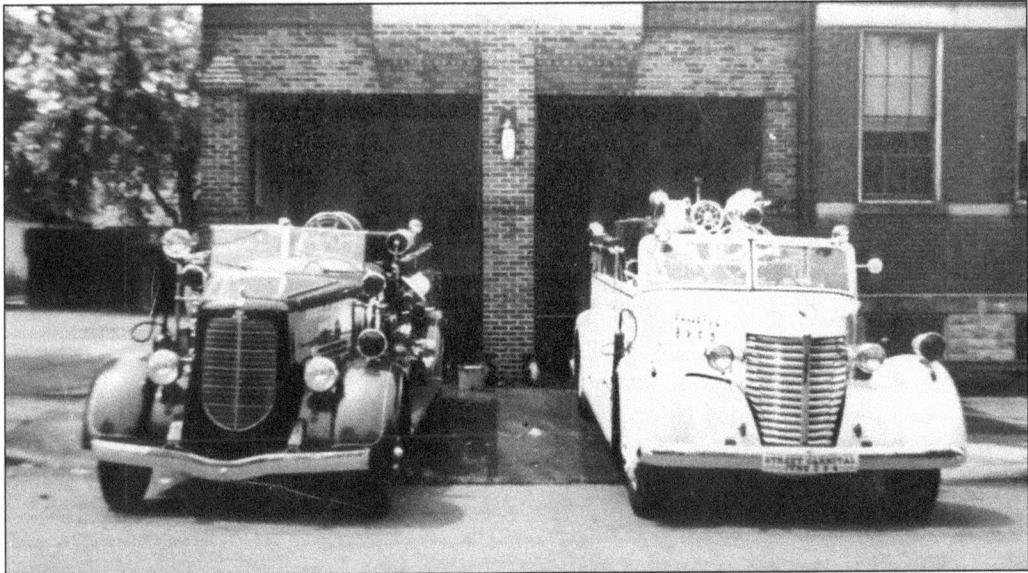

The truck on the left is the same 1940 Ahrens-Fox in previous photographs. The white truck on the right is a 1946 Buffalo. Buffalos were built in Buffalo, New York. According to an article in the *Kentucky Post*, in order to help pay for the truck, a street carnival was started in 1948. The two trucks are parked in front of an addition to the original building at 616 Poplar Street that was constructed so the fire trucks could be kept inside.

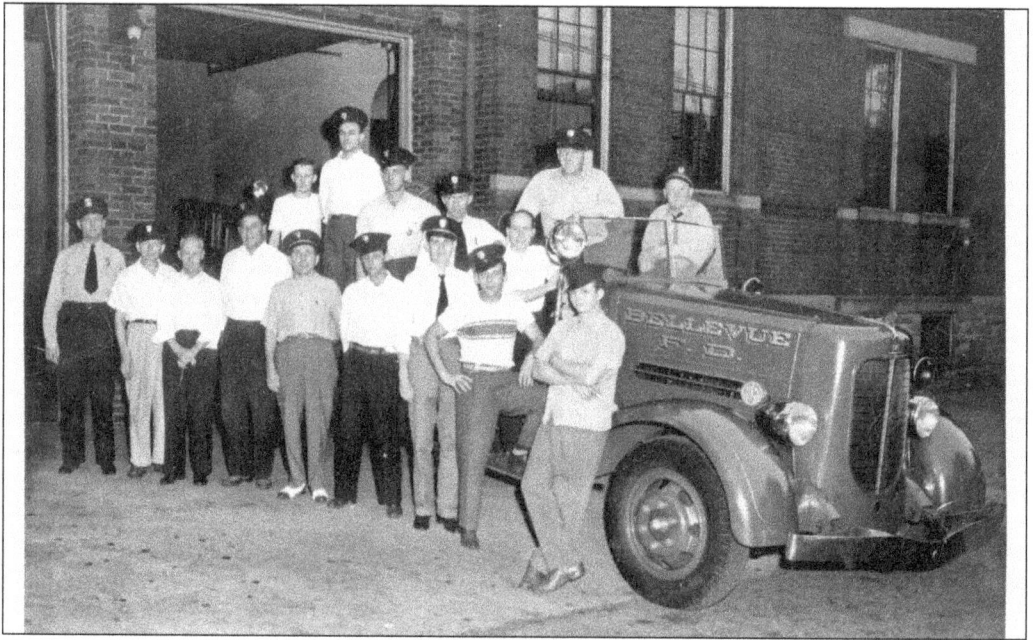

The fire department was a volunteer organization and was as important for its social aspect as it was for fighting fires. Here a group of the volunteers pose informally with the truck at the fire-department garage. Police Chief Adolph Perry is at the far left.

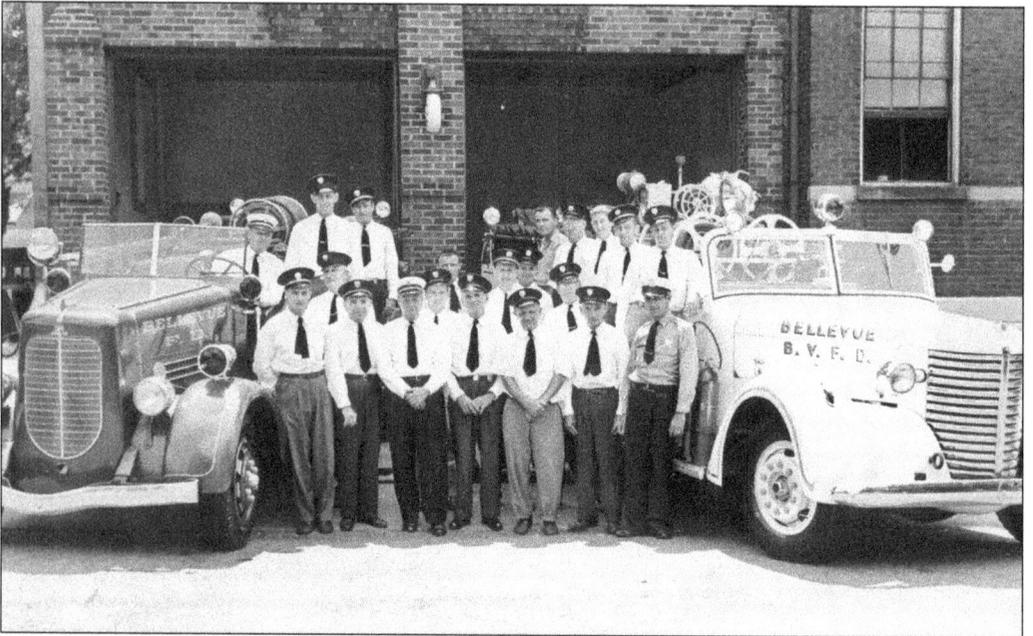

This photograph features the same 1940 Ahrens-Fox and 1946 Buffalo outside the fire-department garage. Standing next to the Buffalo in the dark shirt is Chief Adolph "Dolph" Perry. Dolph was elected police chief in 1948, and he served in that position through 1967. Into the early 1960s, the position of police chief was an elected one. Chief Perry was one of the most popular police chiefs to serve Bellevue. He has the distinction of being the last elected police chief, and the first appointed police chief in Bellevue.

Here some of the firemen pose next to the second addition to the Bellevue City Building. The concrete-block addition was used to dry fire hoses. Large pulleys were installed at the top of this hose tower so the hoses could be hung up to dry after they were used. In later years, when new hoses were developed that did not need drying, this tower functioned as a mount for the city's alarm siren. The siren would sound as a warning for bad weather or to call volunteers in to fight a fire when needed.

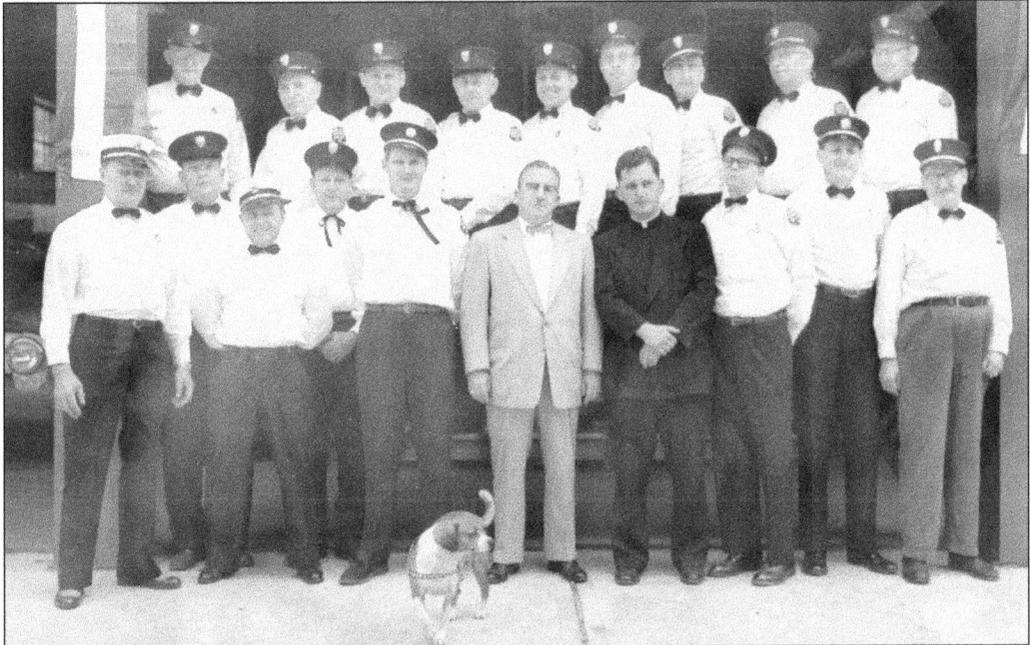

Mayor Robert Hummel (front row, center), Chief Gus Bosch (front row, left), and others pose in front of the new fire hall on Poplar Street. Opened in 1956 as part of the city building, the new fire hall was able to accommodate any and all of the fire department's needs. This addition expanded the old Poplar Street school building, built in 1888, that has housed the city offices since 1937.

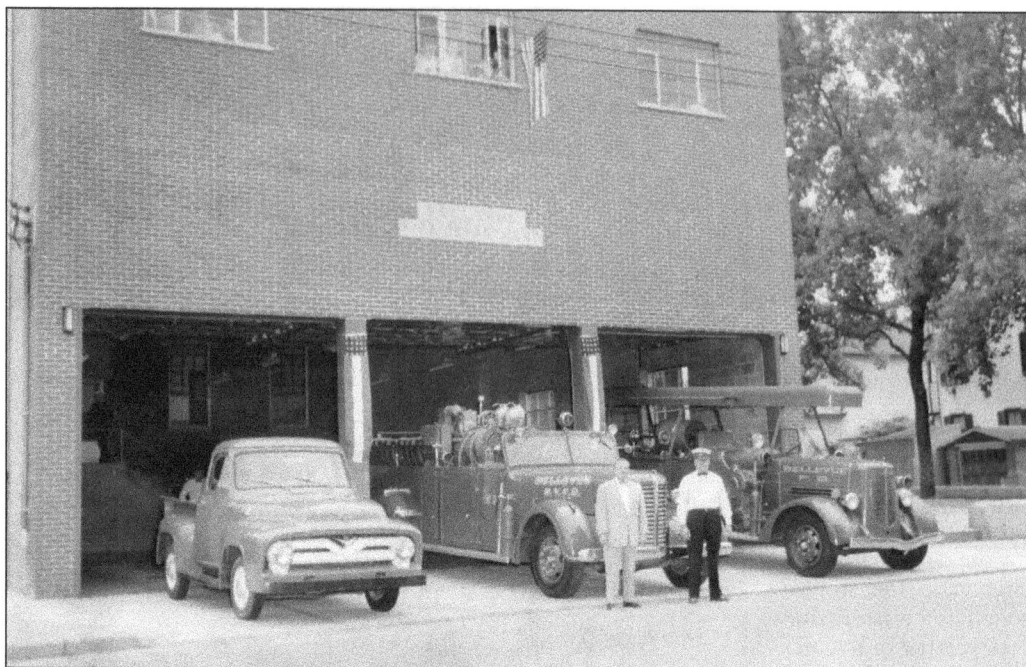

The third addition to the Bellevue City Building is this garage, finished in 1956. The pickup truck, a 1955 Ford, was also new to the fire department that year. This addition to the building included a three-bay garage that could hold up to six vehicles. Perhaps just as important, the addition included a dance hall and meeting room on the second floor. This addition not only gave needed room for housing equipment, it provided additional space for the social aspect that is so important in any volunteer organization.

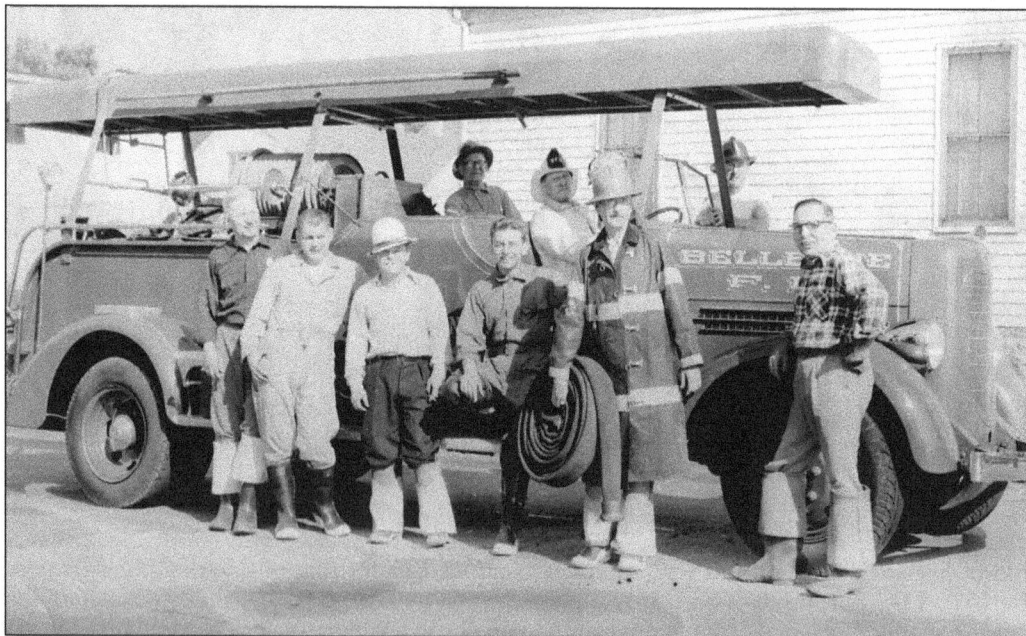

Chess Finkle, Bob Herman, Bud Moore, Joe Betigheimer, Barney Nagel, Andy Budd, Tom Oates, and Chief Bosch are included here, posing with one of the department's engines.

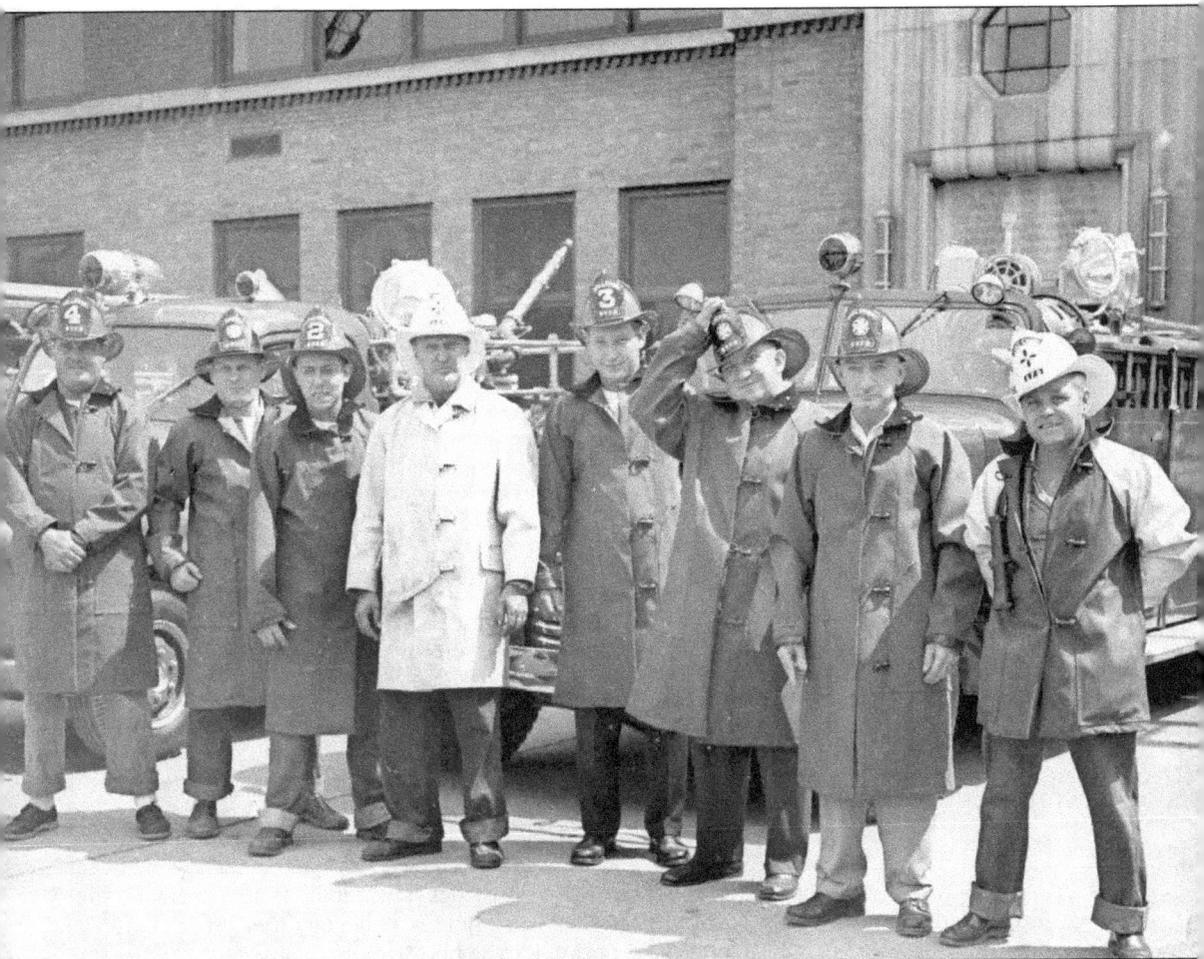

Bellevue firemen Bud Hockee, Bob Herman, Tom Rechtin, Chief Gus Bosch, Al Frommeyer, Bill Baldin, Mike Mauser, and Assistant Chief Bud Moore stand in full gear in front the department's two trucks.

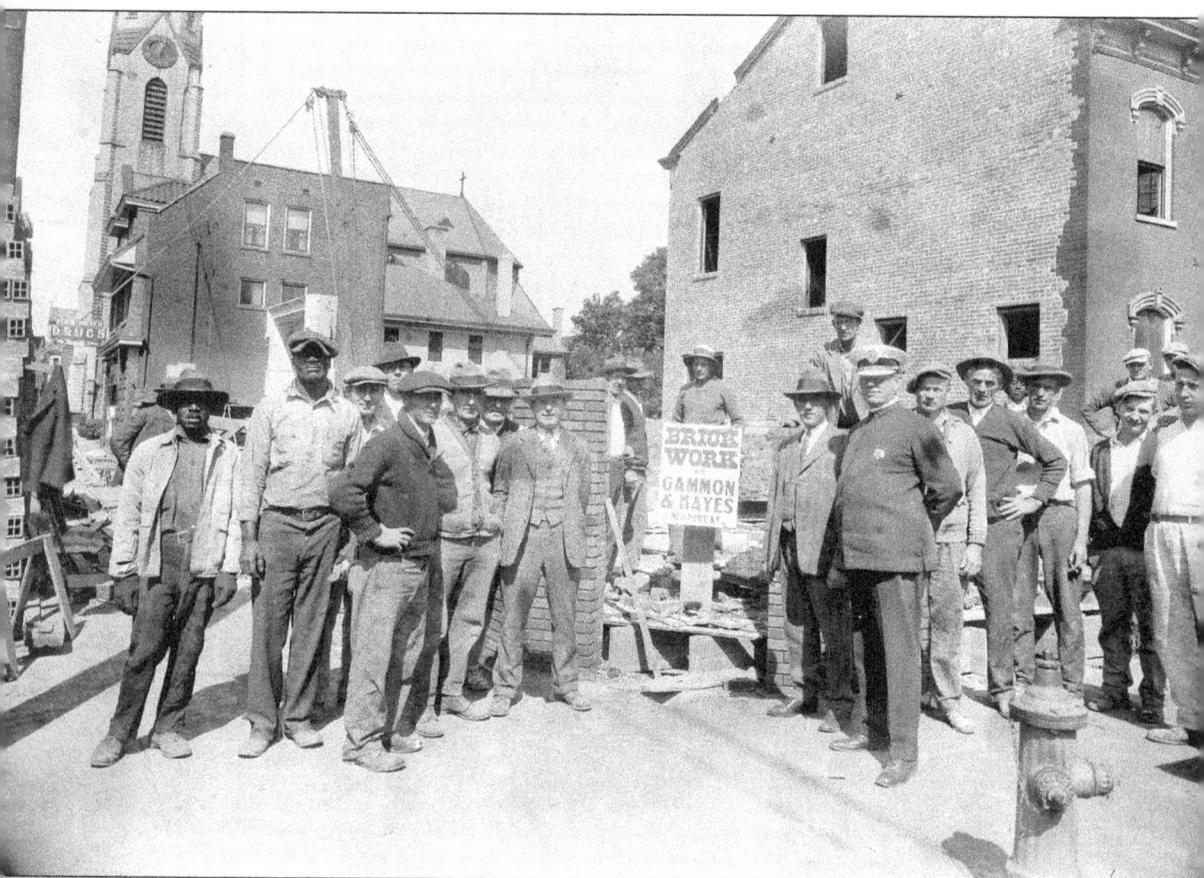

Bricklayers from Gammon and Hayes prepare to construct The Susan B apartment building at Taylor and Center Streets. Today this building also houses Bellevue's post office. Bellevue's police chief, Charles Egan, is among those posing for the photograph.

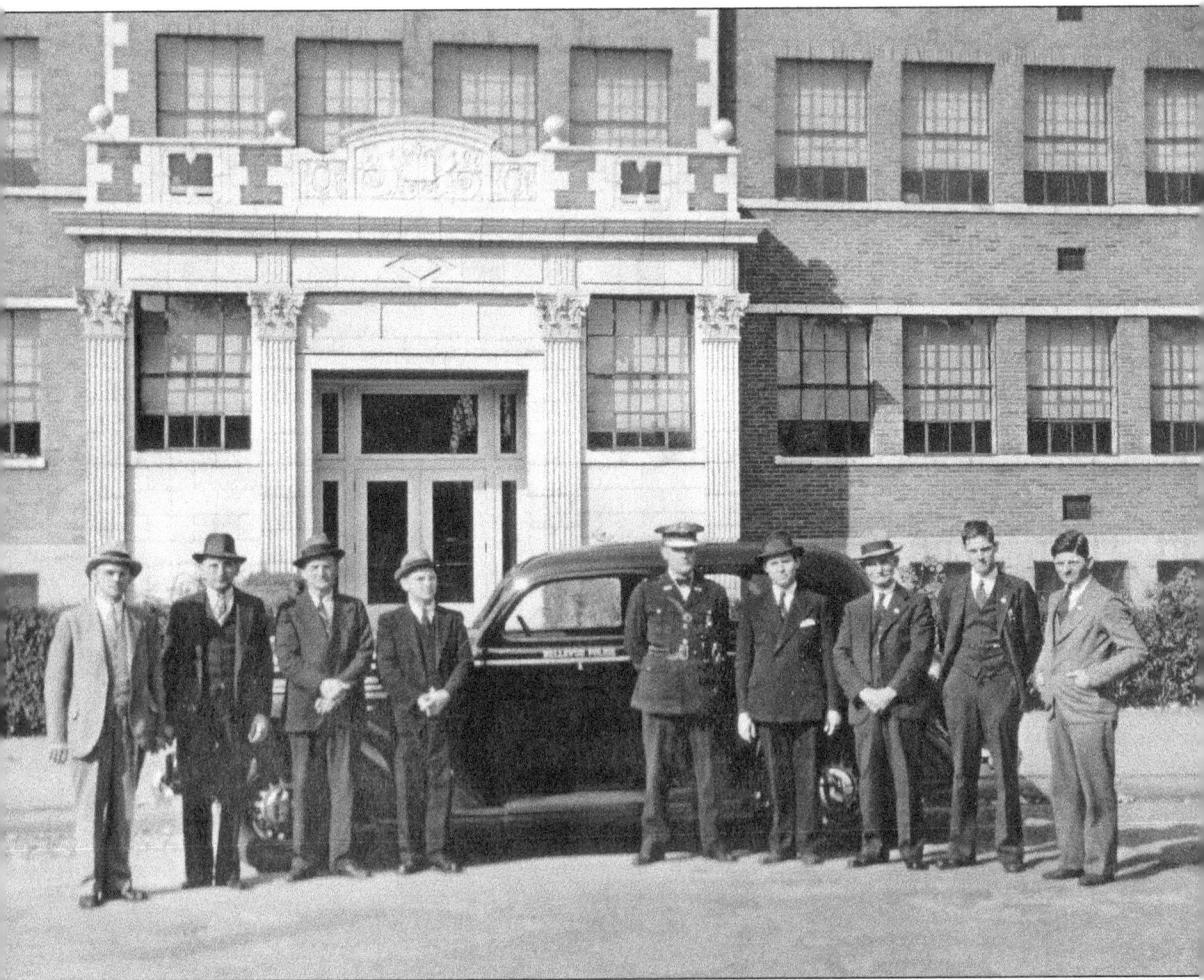

Mayor Klett, Police Chief Ed Winters, and other city officials pose here with Bellevue's first police car, a 1935 Dodge purchased in 1936. The vehicle was purchased from the Bellevue-Dayton Car Lot, owned by the Bernie Rechtin Sr. The Rechtin family has served Bellevue in several positions over the years, including members who served as mayor and on the volunteer fire department. Chief Winters served as police chief for the shortest time (about two years), but he also holds the distinction of bringing in the first piece of modern crime-fighting equipment—a police car. Bellevue still has several Dodges in its police fleet today.

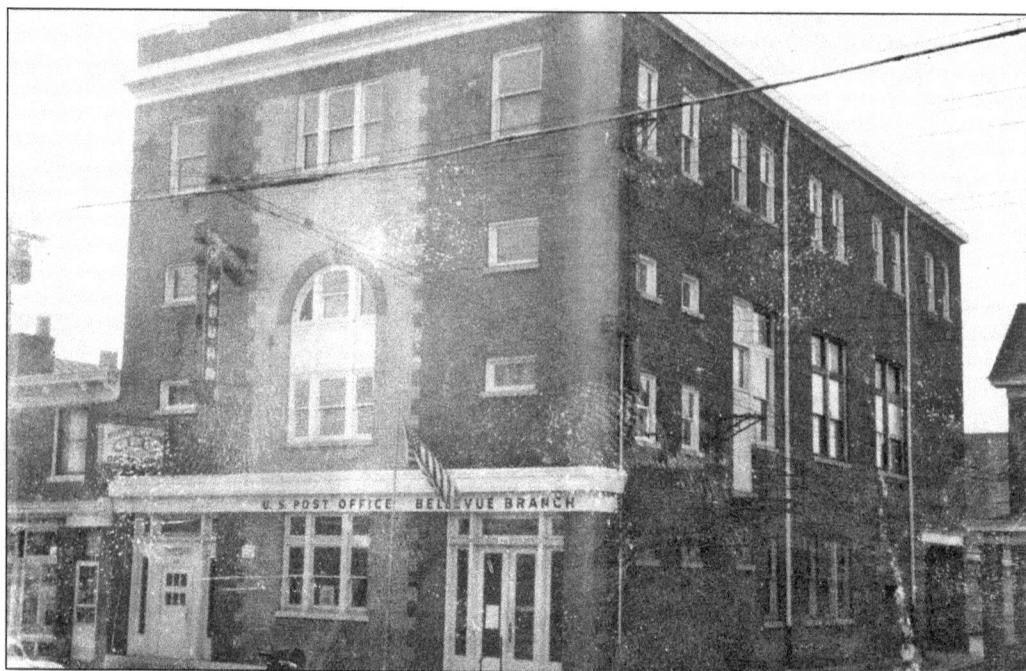

After a long fight by Bellevue's congressman, the town was finally granted a post office branch in 1920. This legitimized Bellevue's position as a Northern Kentucky city and lessened the city's dependence on its neighbors. Located in the Garfield Building at 350 Taylor Avenue, the new post office was opened shortly after the nod from Washington.

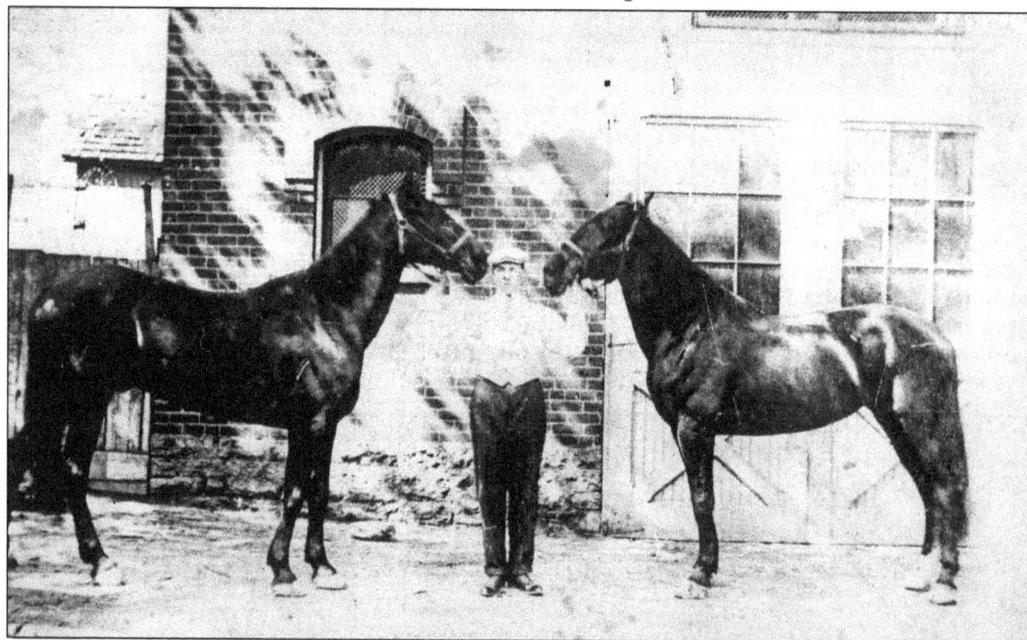

In the mid-19th century, Bellevue streets were formed for the most common kinds of travel: pedestrians and horses. This gentleman displays two of the finer horses kept in one of Bellevue's stables. Though Kentucky is now known for its racehorses, the horses in Bellevue were used for work and transportation, not racing.

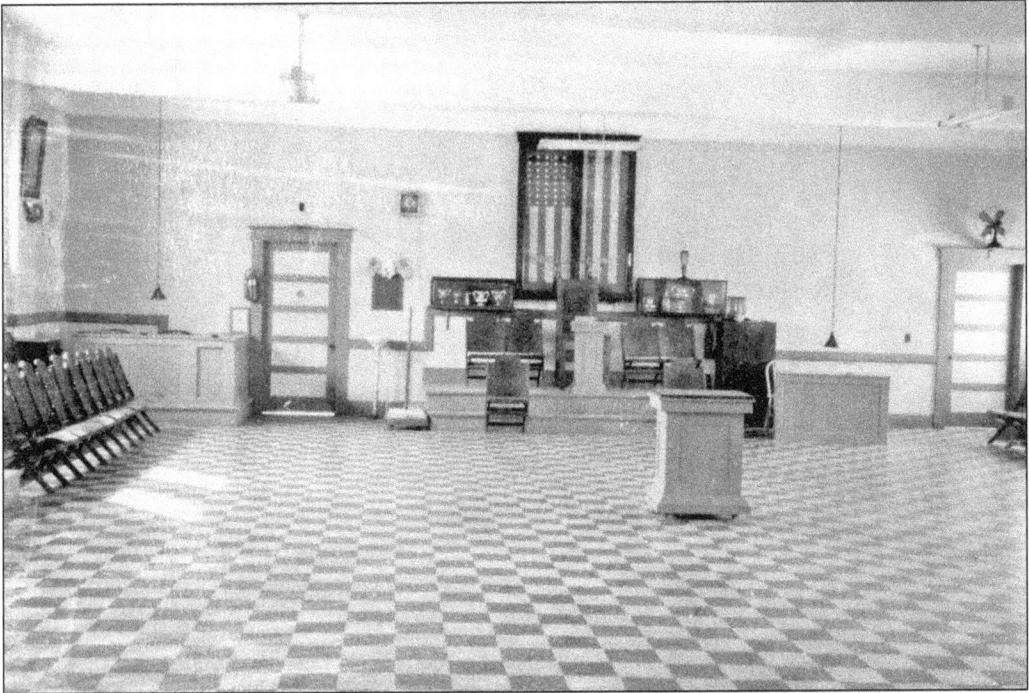

In 1920, the people of Bellevue got the final piece of the puzzle that established them as a completely self-sufficient city: a post office. Located at 350 Taylor Avenue, this upstairs meeting hall in the Post Office Building housed numerous Bellevue events. Lodge meetings, church youth group events, and Junior League gatherings all occurred here in the upstairs hall of the Post Office Building.

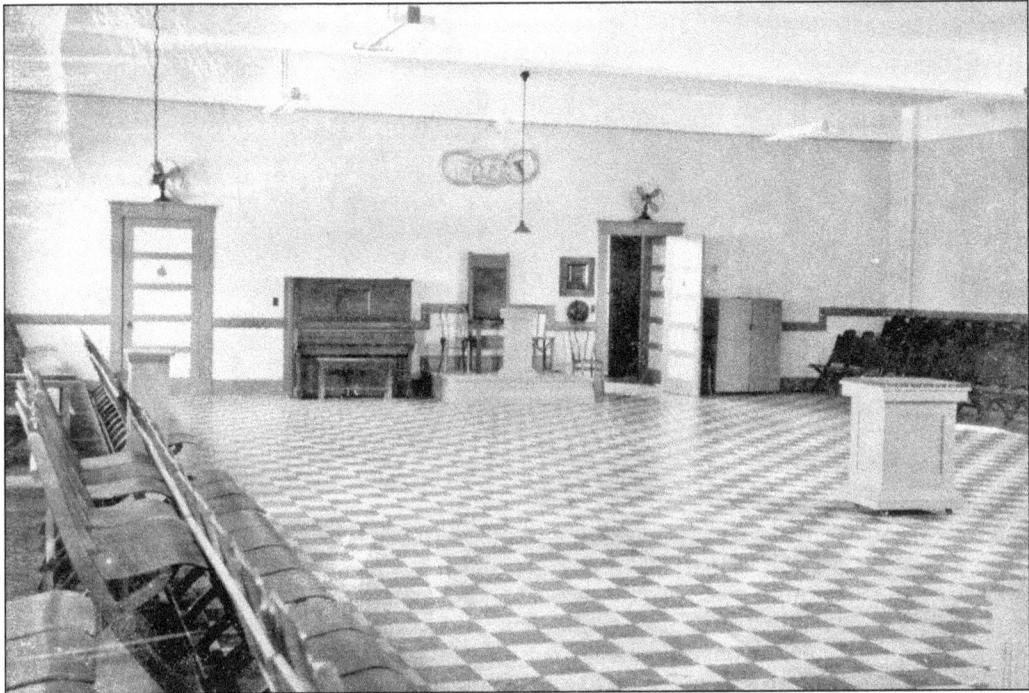

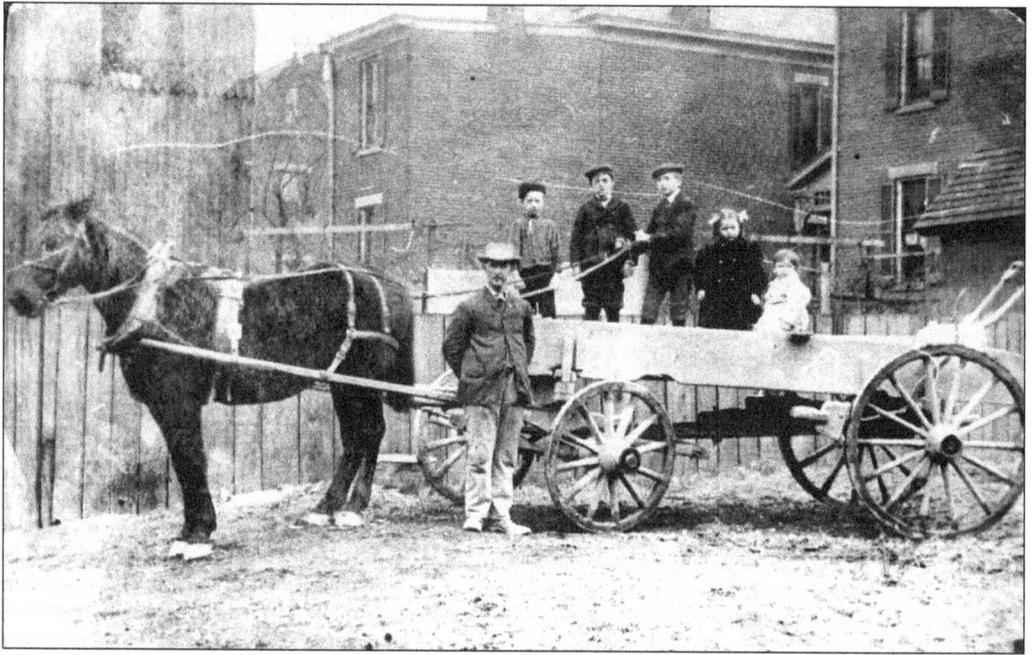

As Bellevue grew, dealing with the increased garbage became a growing concern. Using a horse and cart, enterprising citizens began to collect garbage and dispose of it outside the city for a fee, increasing the level of sanitation and making Bellevue an even more desirable community. Here children posed in the back of one of the empty sanitation wagons.

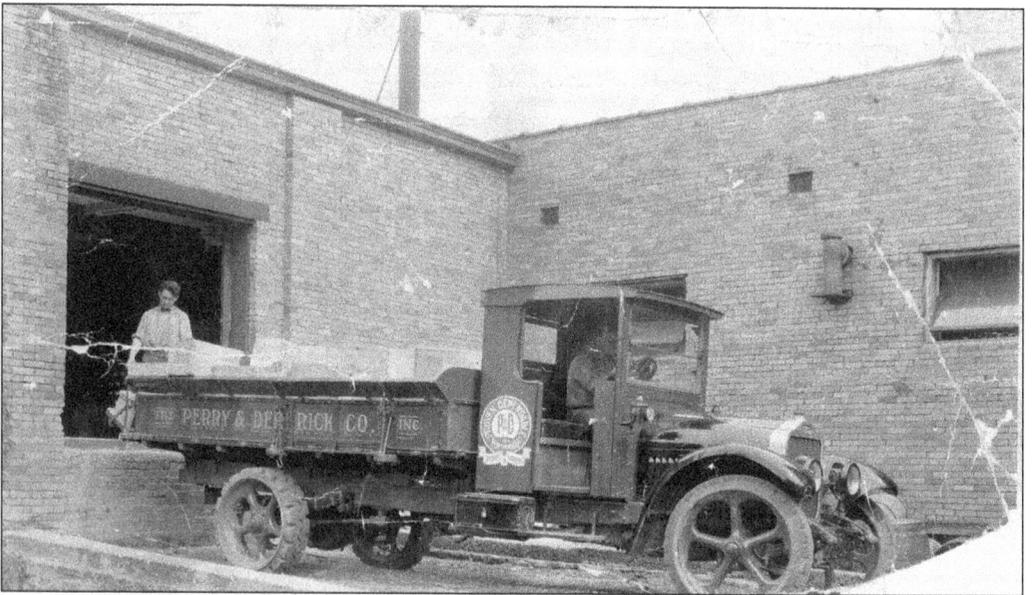

After World War I, Bellevue continued to grow, meaning that it needed building products. In this photograph, a truck unloads cases of Perry and Derrick paint for use in Bellevue's home construction. Operating a truck like this was a handful. There was no power steering, so it took a strong arm to guide the truck. Strong arms were also required just to start the vehicle, as this one required manually turning a crank at the front of the motor. The ride was rough too—this truck has solid rubber tires mounted on five-spoke, steel rims.

Six

THE AVENUE
AND BUSINESS

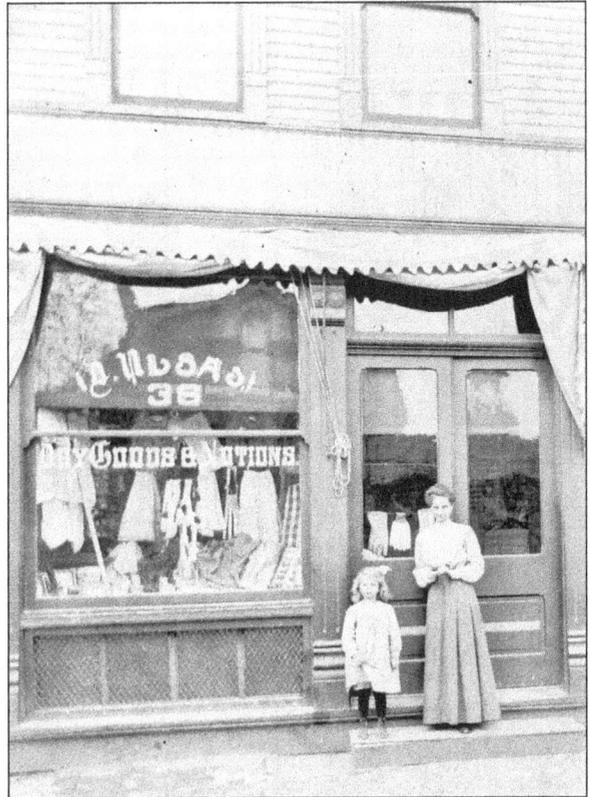

Irma Ulses Ostertag (right) and Dora Ulses stand in front of their family's dry goods store on Fairfield Avenue in 1904. The store provided the daily essentials for all and the latest fashions for the ladies of Bellevue.

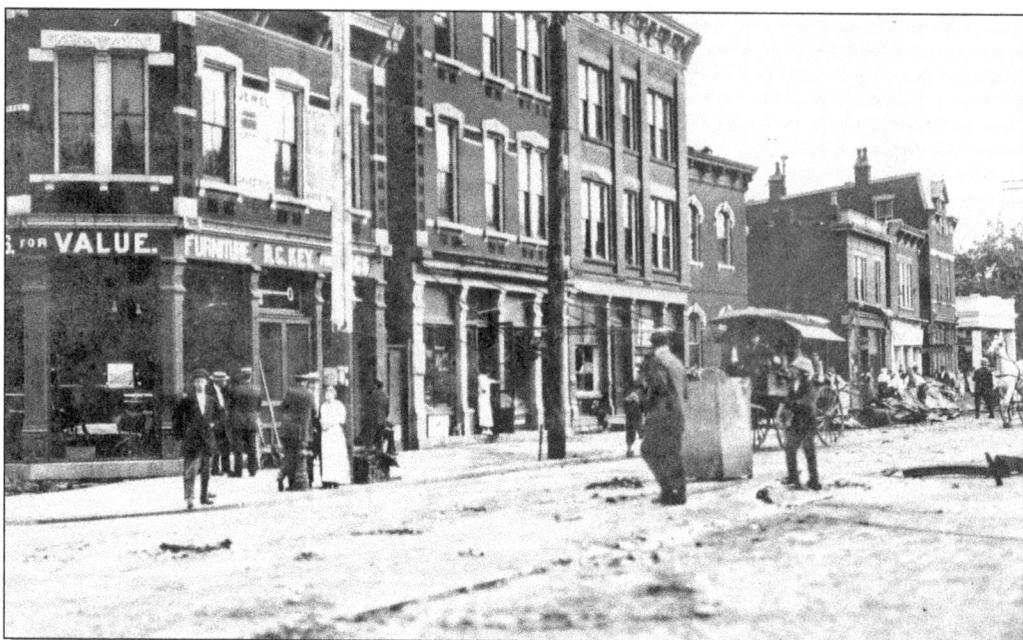

Fairfield Avenue in 1907 mirrored many other main streets across the country. The 300 block of Fairfield was lined by stores such as Key Furniture, Herold Grocery, Deweis Barber, Leigh's Candy, Netler Dry Goods, and Koch Wallpaper at the time, and the street has always been a prime business location.

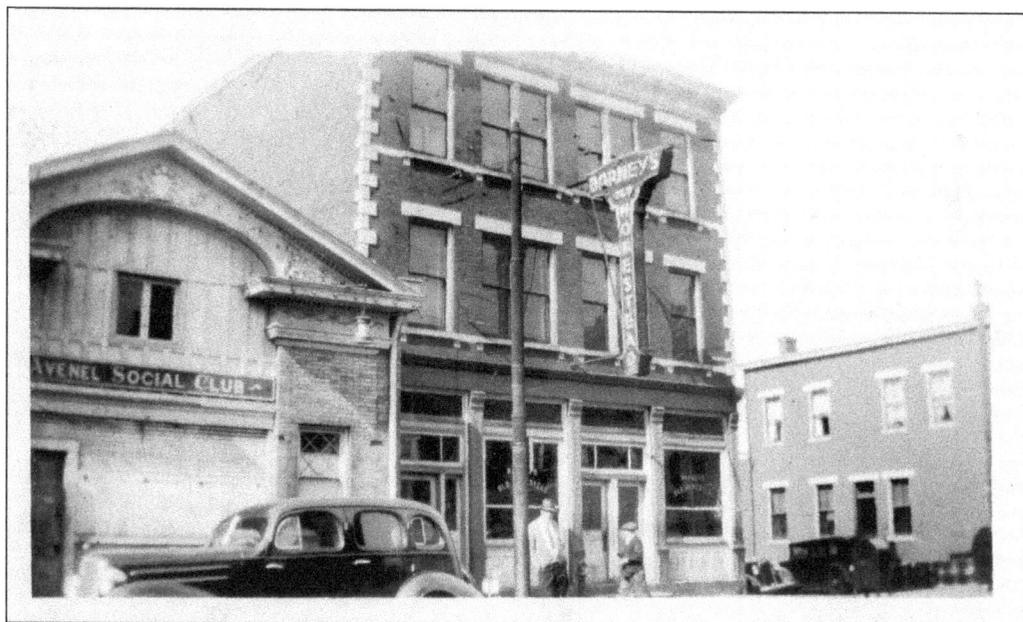

This photo from about 1938 shows Bellevue landmark Barney's Old.Homestead as well as the Avenel Social Club. The buildings, located at Fairfield and O'Fallon Avenues, were at the eastern-most border of Bellevue.

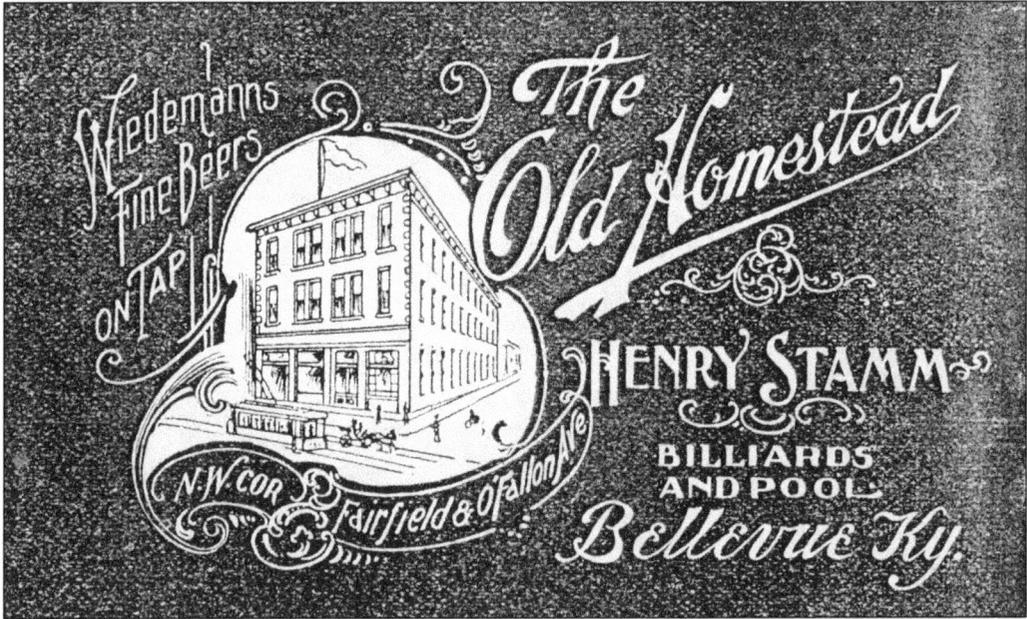

This is an advertisement for Barney's Old Homestead, Bellevue's most famous—perhaps infamous—tavern. Owner Henry Stamm turned the old Bellevue Hotel into a tavern with the largest pool hall in Kentucky, drawing patrons from throughout the state and region. Local Wiedemanns beer was proudly served. The transportation used in the image helps date this ad to the early 20th century. Notice the trolley car, horse and buggy, bicycle, and pedestrians—no automobiles to be seen here.

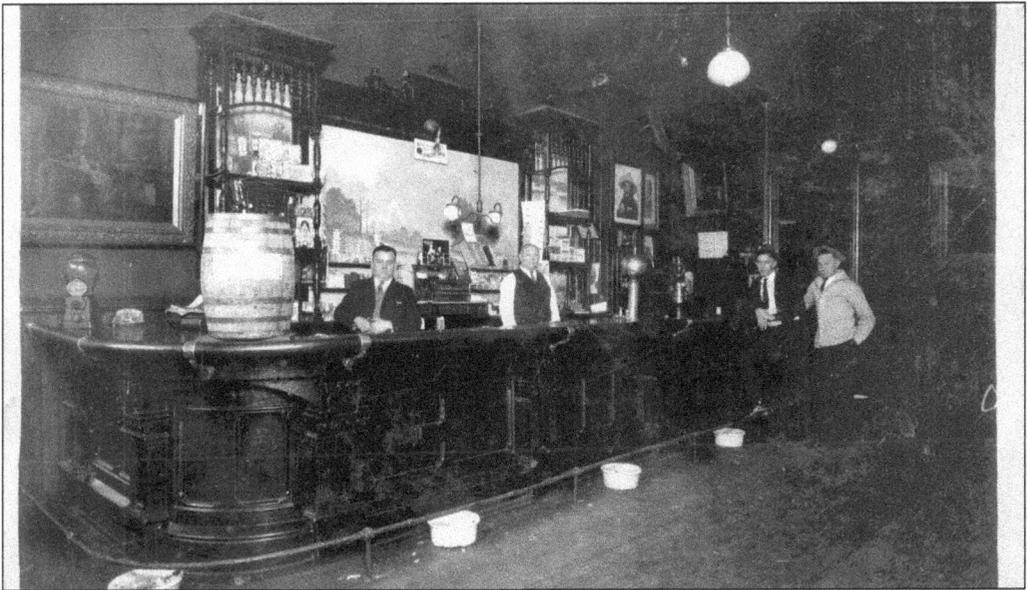

Barney's Old Homestead had one of the most elaborate hand-carved bars in town. Notice the pans across the bottom of the bar to be used as spittoons by the patrons. The painting on the left was typical of the day and shows a woman reclining across a man sitting on a sofa. In addition to beer and other drinks, the bar offered Ibold cigars and cigarettes, and prominently displayed Oh Henry candy bars.

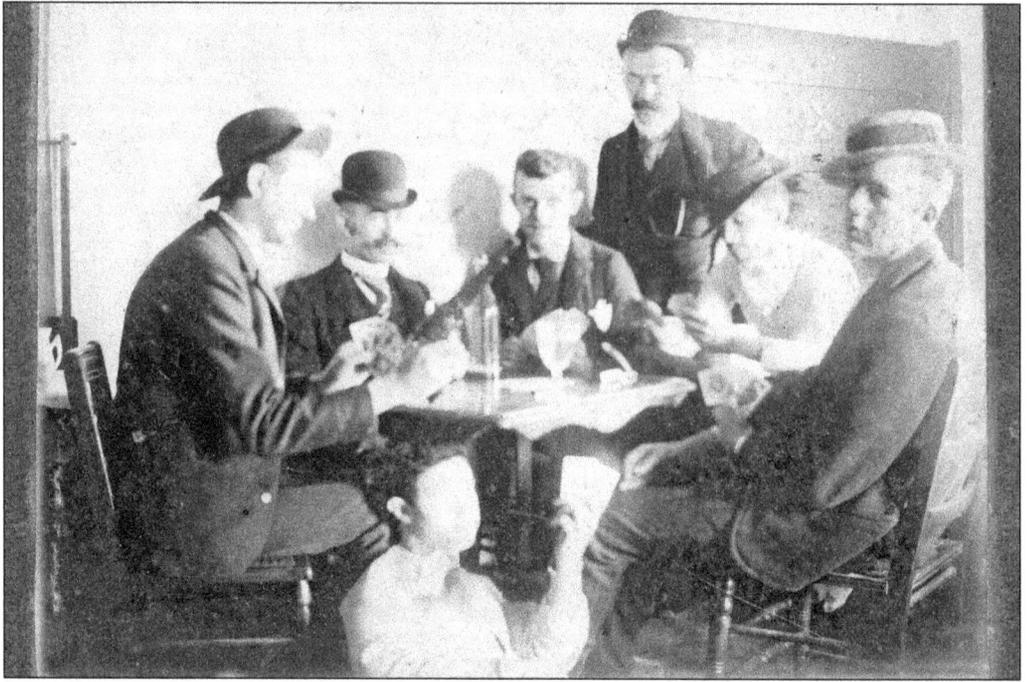

Today people pose for old "rough-and-tumble-days" gambling-themed photographs at most amusement parks. This early-20th-century photograph proves, however, that such posed photographs are not a new idea. The humorous photograph shows men playing—and cheating—during a "friendly" game of poker. The scene is complete with a man holding an early revolver, a man drawing from his helper's hand, and a whiskey bottle on the table.

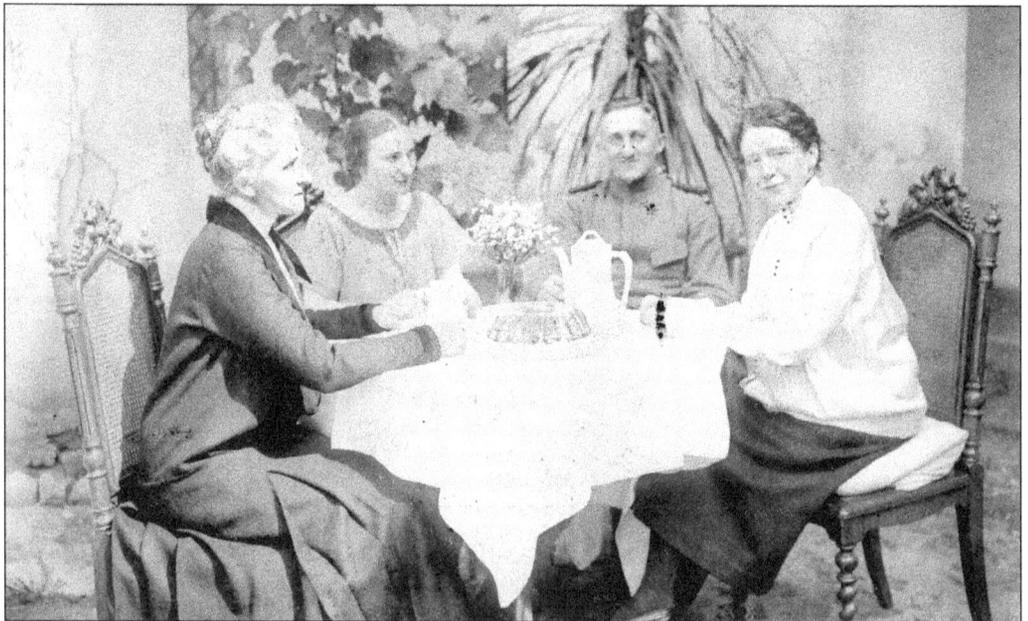

The life and culture in Bellevue reflected that of other Midwestern and Southern cities in the early 20th century. Here sit three ladies having tea and cake with a military officer in 1916, during World War I.

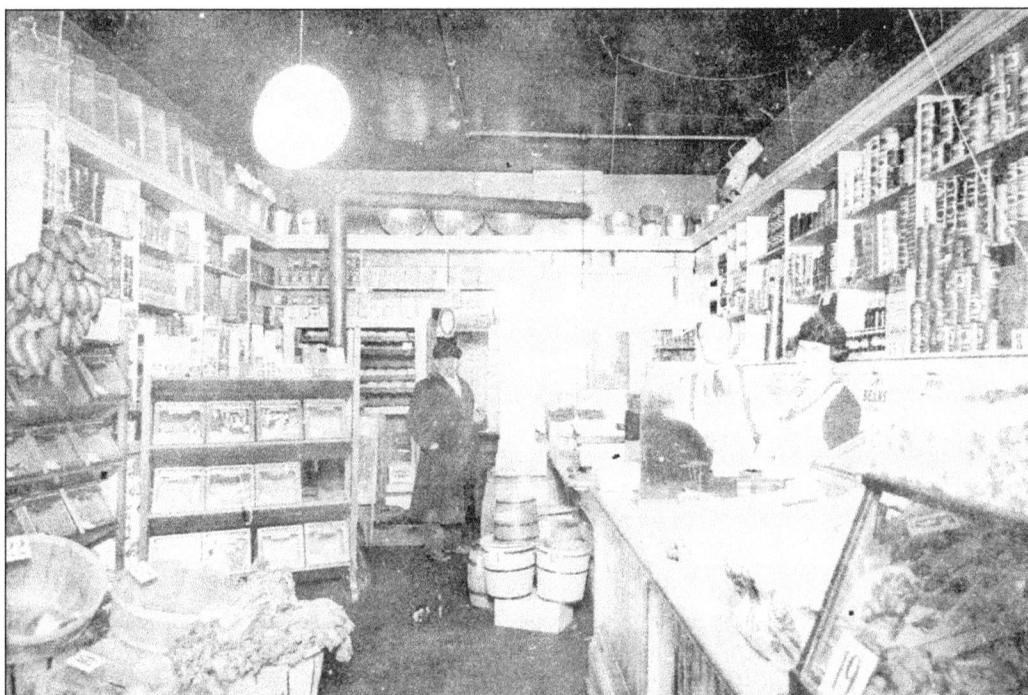

Perhaps the first Kroger store in Bellevue, this shop at 201 Fairfield Avenue provided all the daily necessities as any good grocer should. Above the store was a library and meeting space for various social organizations.

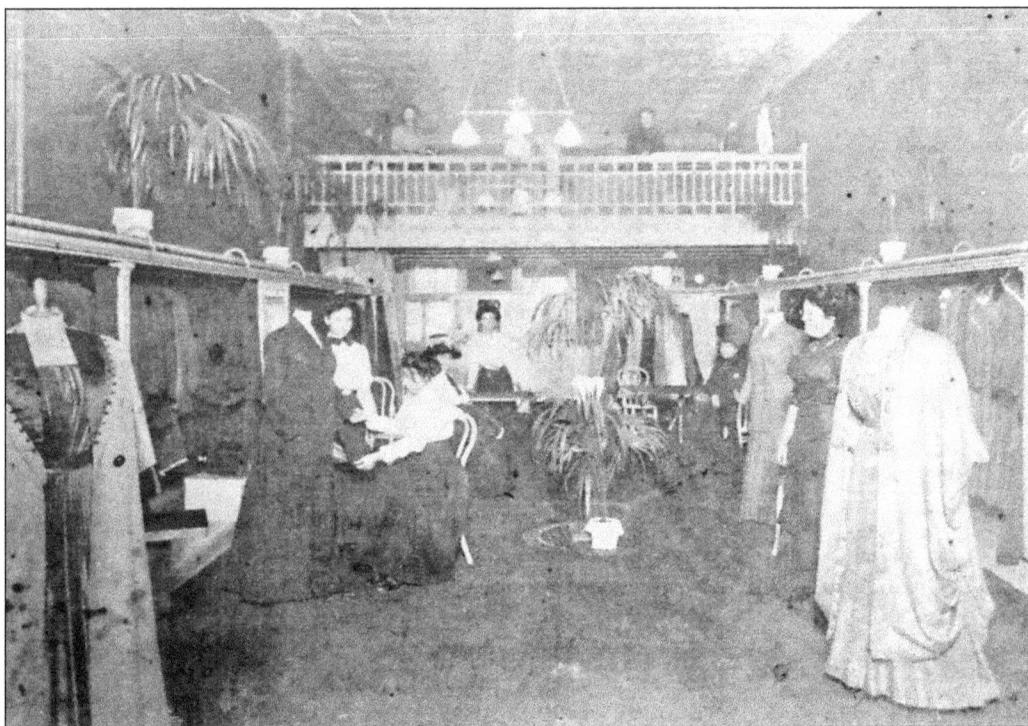

Mollie Bergang Wisbeg fits a dress for a patron of this dressmaker along Berry Avenue.

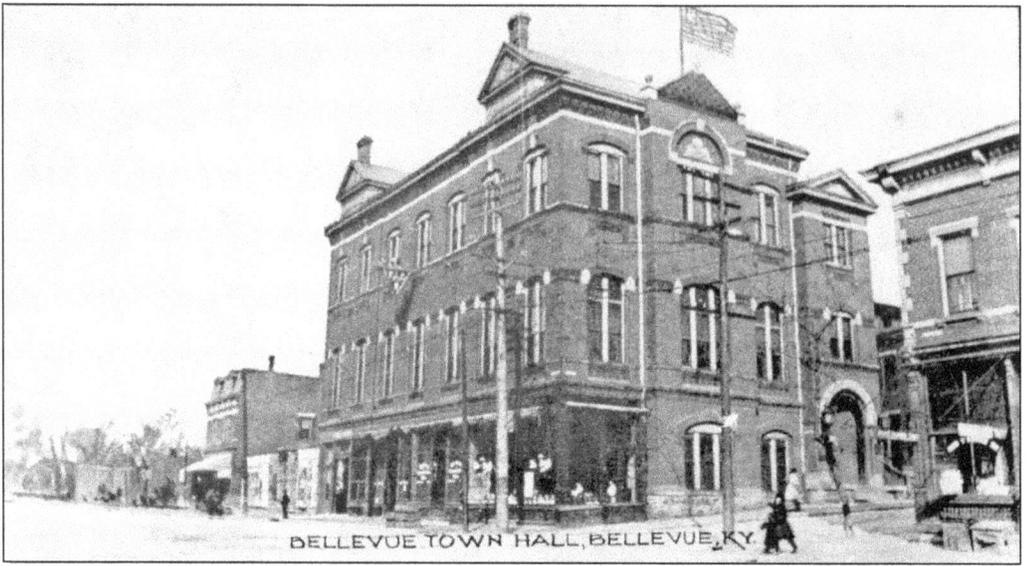

BELLEVUE TOWN HALL, BELLEVUE, KY.

Built in 1884 for Cincinnati businessman Julius Balke, Balke's Opera House was designed by Cincinnati architect George W. Rapp. The building housed the mayor's office and three storefronts on the first floor, an auditorium on the second, and lodge rooms on the third. "Balke's Hall" hosted theatrical productions, dancing classes, costume balls, and high-school commencements. By the early 20th century, the building housed city offices along with the police and fire departments. In 1924, the Bellevue Eagles bought and remodeled the building as a clubhouse. The Eagles vacated the building in 1962, and it was demolished two years later.

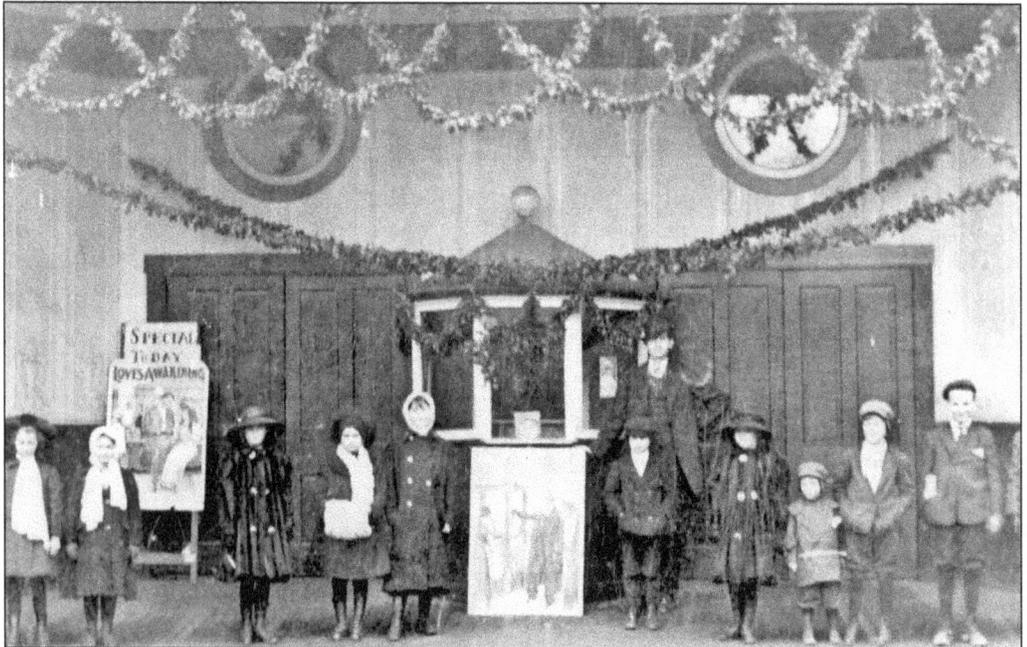

The latest movies were never far away in Bellevue. In 1910, the city's the first movie house opened on Fairfield Avenue. The movie playing was *Love's Awakening*, a silent, black-and-white film released on December 6, 1910.

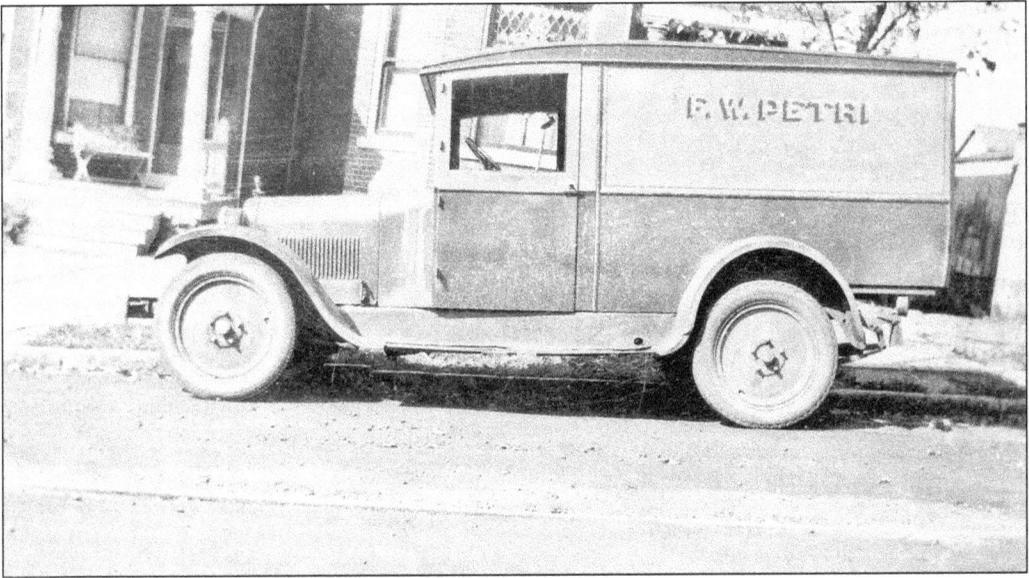

Bellevue's premier florist for nearly a century, F. W. Petri Florists, has always been located on Fairfield Avenue. Started by Fred W. Petri, the florist quickly became known for its outstanding floral decorations and the creativity of its arrangements.

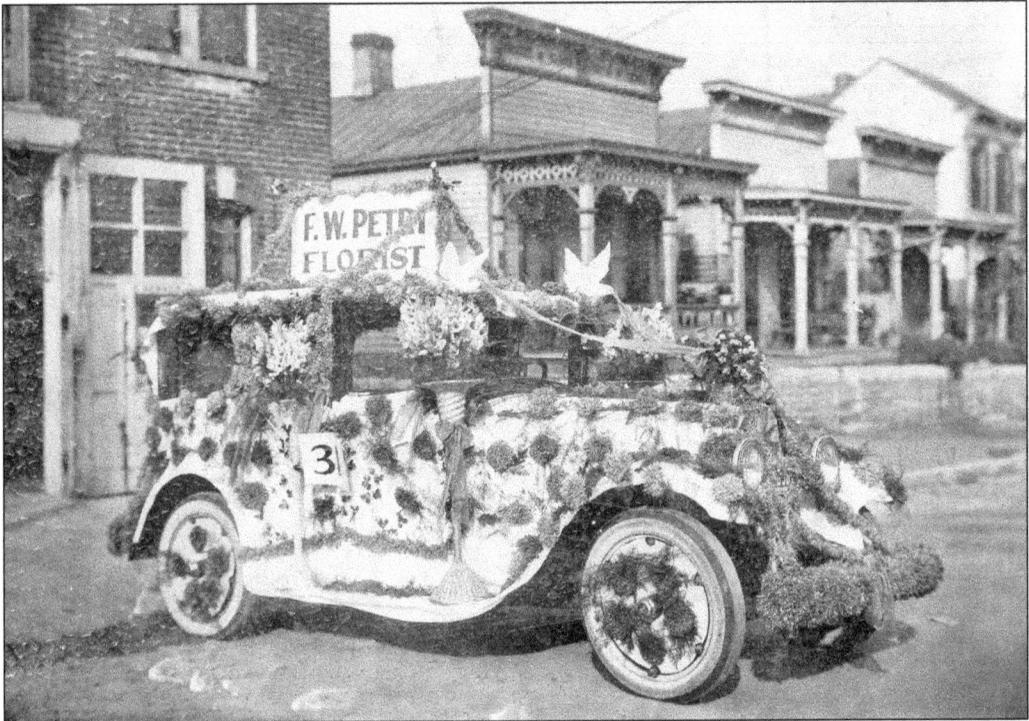

Over the years, F. W. Petri Florists developed a reputation for their elaborate floral arrangements. This car decorated for a parade drew increased attention to the Bellevue florist. Such elaborate decorations helped the Bellevue florist develop a reputation throughout Northern Kentucky.

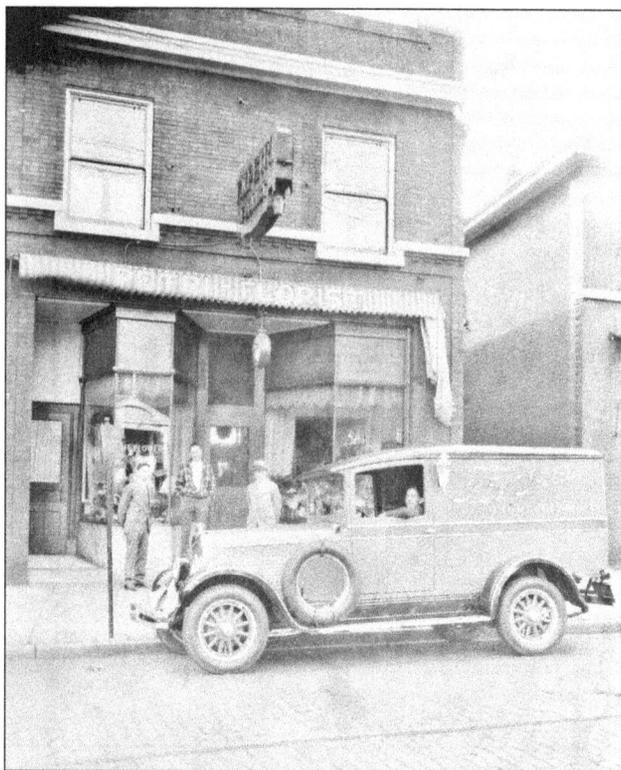

Founded in 1915 by Fred W. Petri, F. W. Petri Florists occupied this 1910 building at 236 Fairfield Avenue until they moved across the street in 1966. With this prime spot on the Avenue, the florist was able to become the most successful in town and still maintains a shop on Fairfield Avenue today.

In 1966, Petris Flowers (another of several names the business used) moved to this shop at 229 Fairfield Avenue from its original location across the street. Previously the building had been home to one of the many taverns that lined Fairfield Avenue.

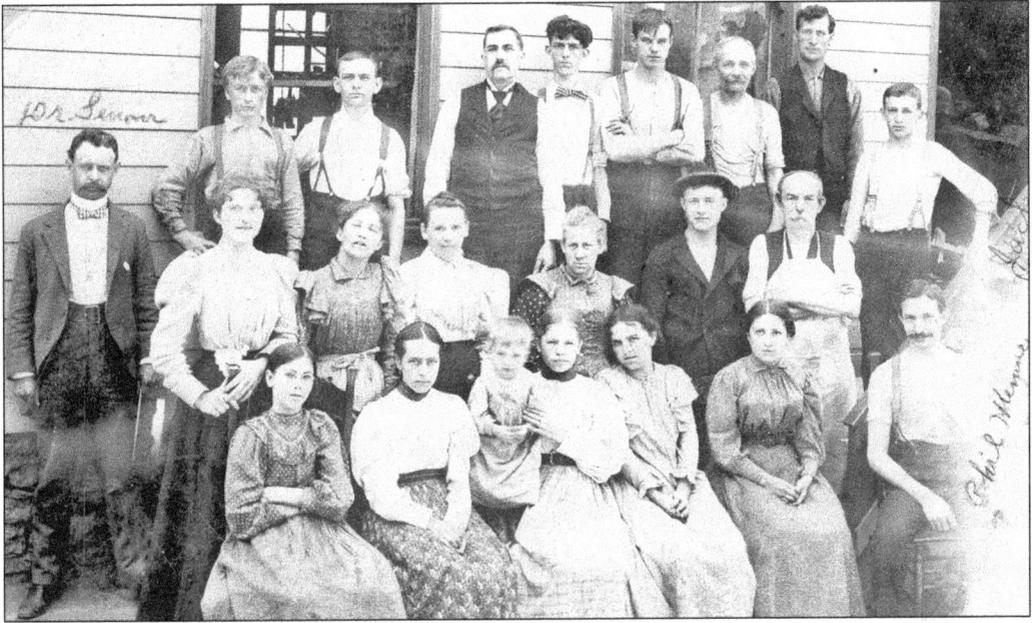

The employees of Dr. W. A. Senour's shoe factory pose for this picture in 1897. Located along the 400 block of Ward Avenue, the factory provided footwear to all parts of the Cincinnati–Northern Kentucky region. Always looking for cheaper labor, the Senour Shoe Factory regularly hired workers as young as 13. This practice quickly ended as child labor laws were passed. Dr. Senour, a prominent Bellevue doctor and businessman, had his office and home in a large Queen Anne–style house on Fairfield Avenue.

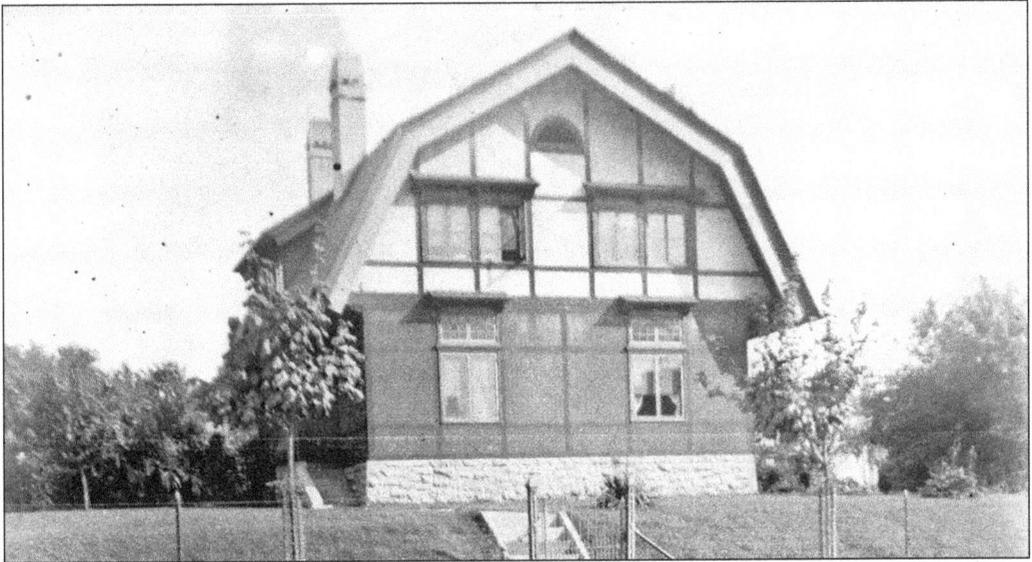

In 1885, this one-of-a-kind house was built on Fairfield Avenue. The home of Edward Johnston was designed by the Cincinnati architectural firm of Buddemeyer, Plympton, and Trowbridge. Built of brick and structural timber framing, it featured a stucco skin, casement windows, and slate gambrel roof. Lucien Plympton was a highly gifted architect fascinated with traditional Swiss architecture who popularized the chalet style in the Queen City. Johnston was a draftsman for the architects' office. Today the house is home to Councilman Vic Camm, also an architect.

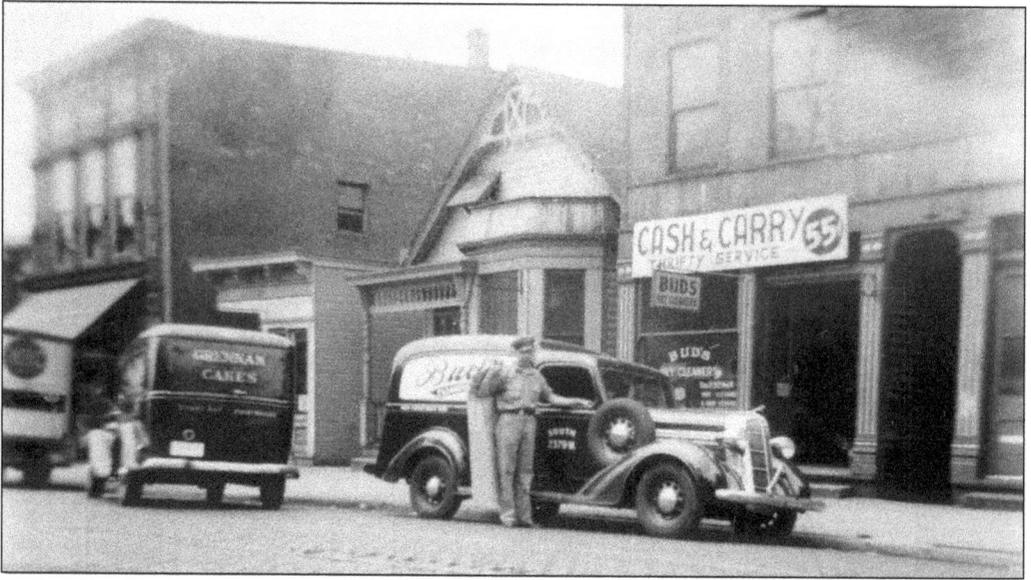

Bud, of Bud's Dry Cleaners, stands beside the delivery truck parked in front of his store on Fairfield Avenue in the 1940s. Bud's was the premier dry cleaner in town. Note the cobblestone streets and the track of the streetcar line that linked Bellevue and Dayton to Newport and Covington.

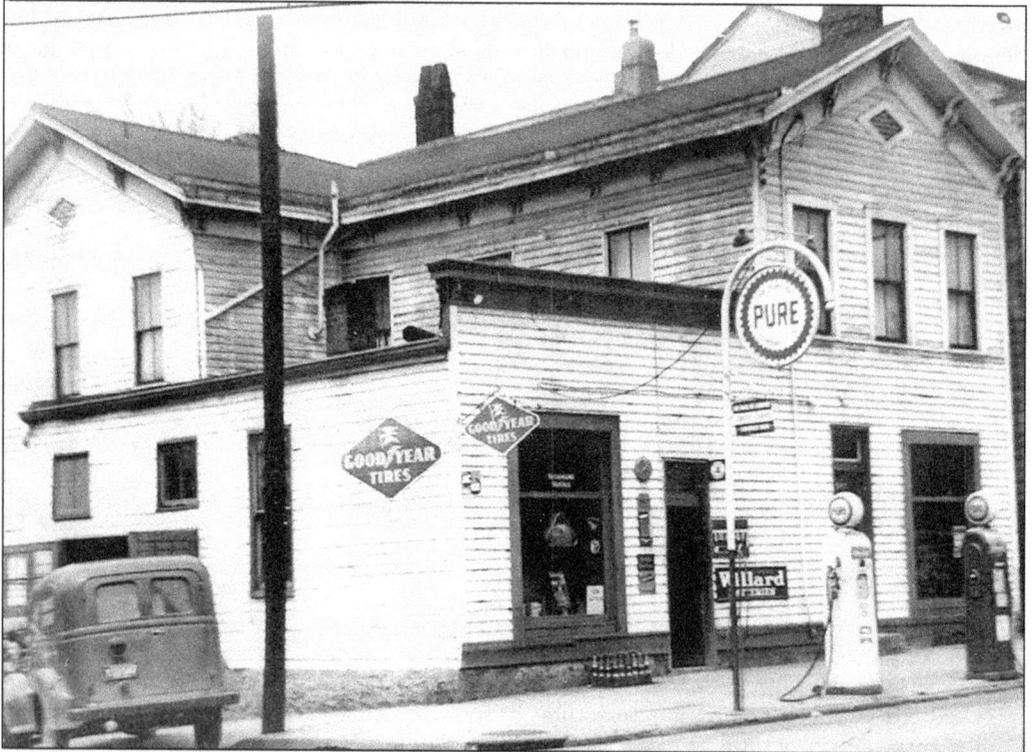

Ray's Service Station on Fairfield Avenue became a popular stop between Dayton and Newport in the 1940s for those looking for a refill. Owned by Ray Leurck, the station and house no longer exist.

116

The Bellevue Fire Department drives down Fairfield Avenue in its 1946 Buffalo fire truck during one of Bellevue's many parades. As one of Bellevue's main streets, Fairfield Avenue has played host to numerous parades and festivals to celebrate important events in the city. Just behind the truck on the left sits a 1940s Buick, parked in front of the Moose Lodge and Barney's Old Homestead Inn, a Bellevue landmark since the 1870s.

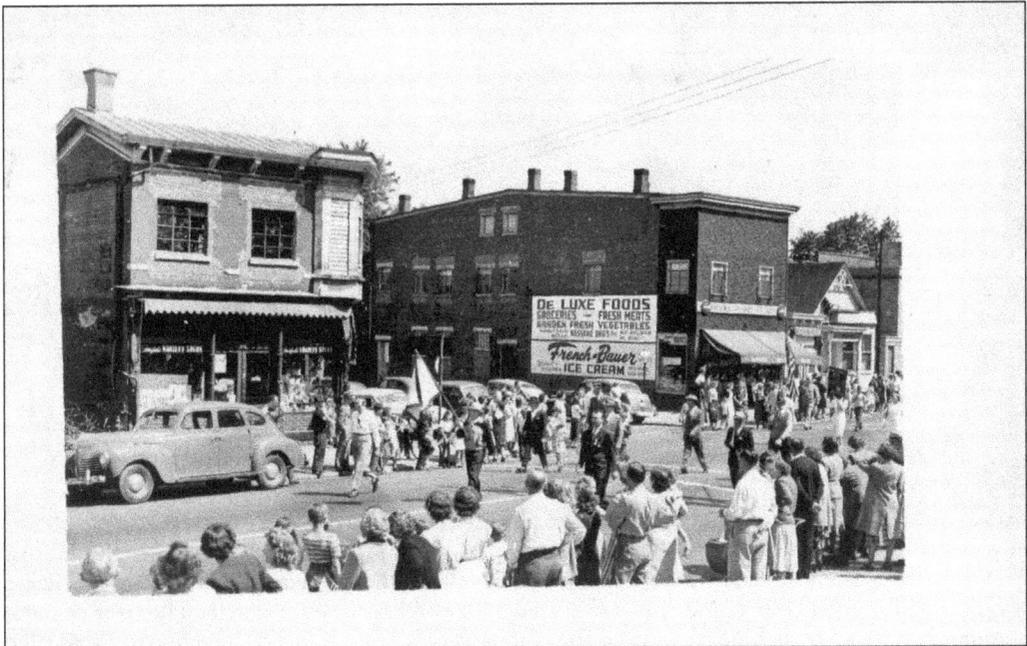

This July Fourth parade marches down Fairfield Avenue past Ward Avenue.

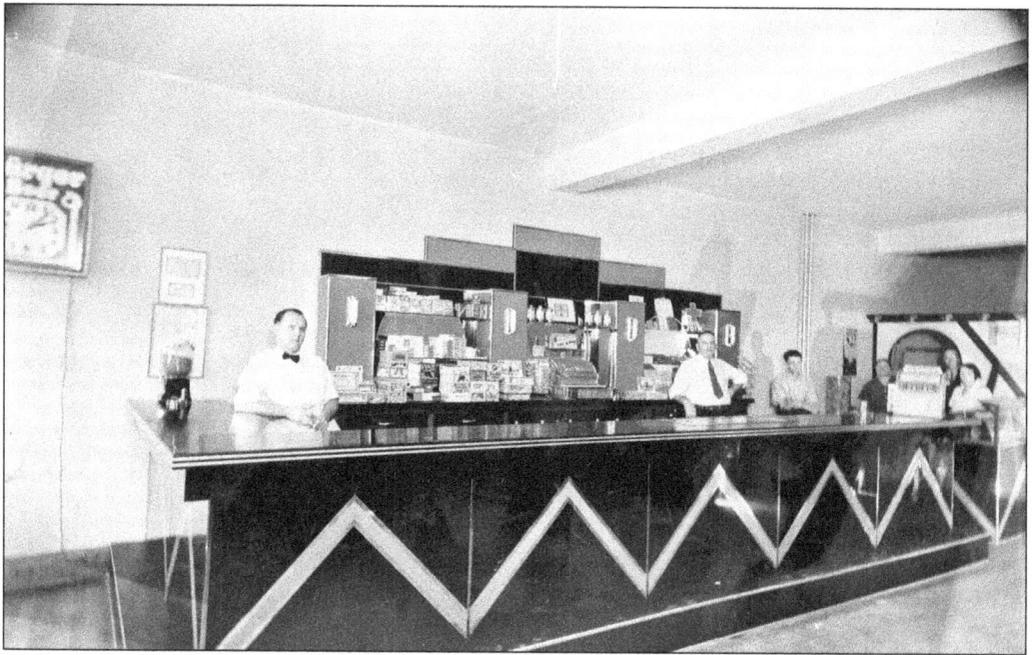

The Tay-Fair Café, named for its location near the intersection of Taylor and Fairfield, was long a popular lunch spot in Bellevue. The café was also a popular stop for a cold beer or a selection of tobacco products one might be searching for.

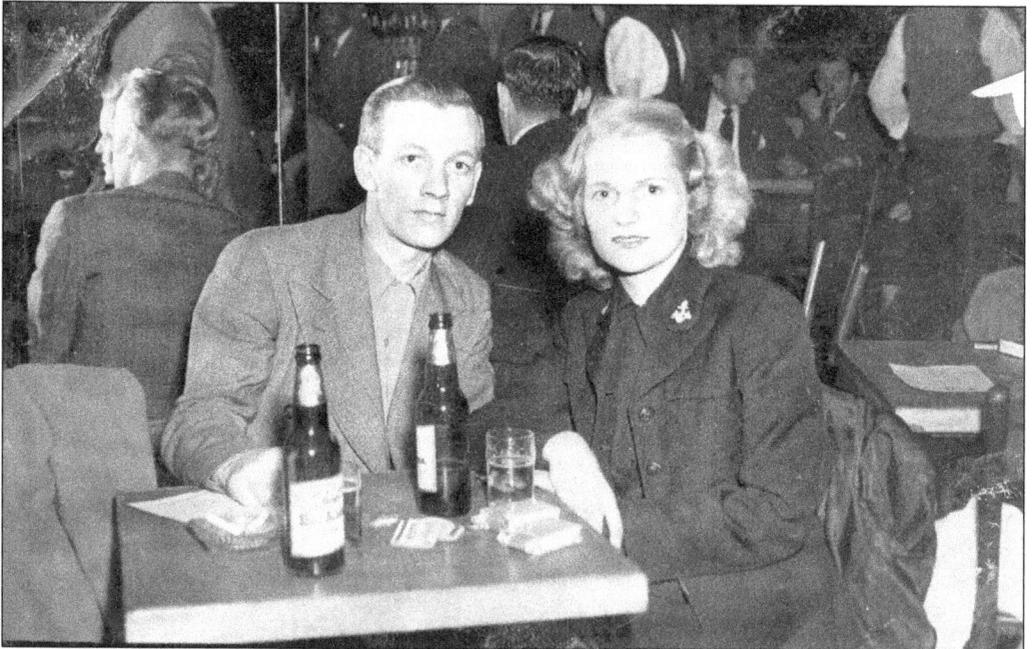

A young couple enjoys a few cold beers and cigarettes at one of Bellevue's popular nightclubs in 1939. The beer is Pabst Blue Ribbon, a main competitor of local beers like Wiedemann. Pabst was originally called Select, and the brewer tied a blue ribbon to each bottle. The beer became commonly referred to as Blue Ribbon, so the company officially changed the name to Pabst Blue Ribbon Beer. This photograph was recovered during a citywide cleanup project in 2005.

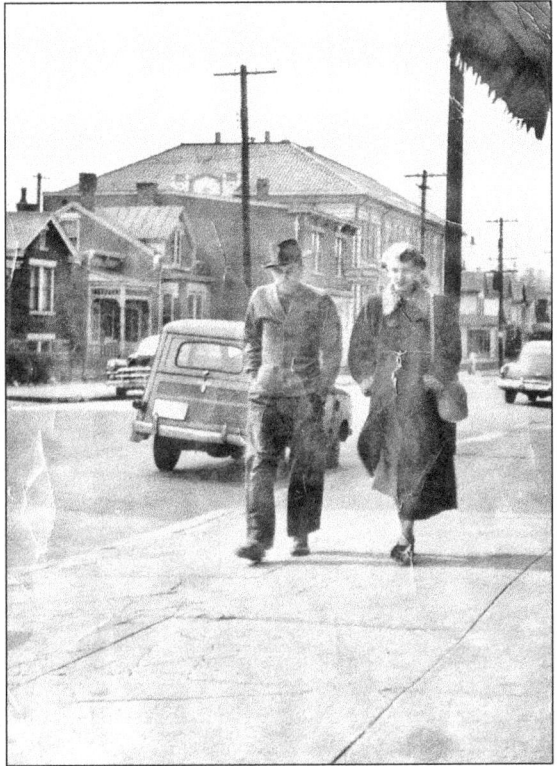

Bill Koehler and Jeannine Koehler Camm stroll down Taylor Avenue on a brisk afternoon in 1948. Taylor Avenue is still a prominent throughway for Bellevue and is home to many of the city's important buildings. Visible over their shoulders is one of the city's two catholic schools, St. Michelle (now Holy Trinity). The couple just strolled by a 1949–1950 Crosley station wagon. Cincinnatian Powel Crosely owned WLW radio, "the Nation's Station," and the Cincinnati Reds, but his tiny, fuel-efficient car was made in Richmond, Indiana.

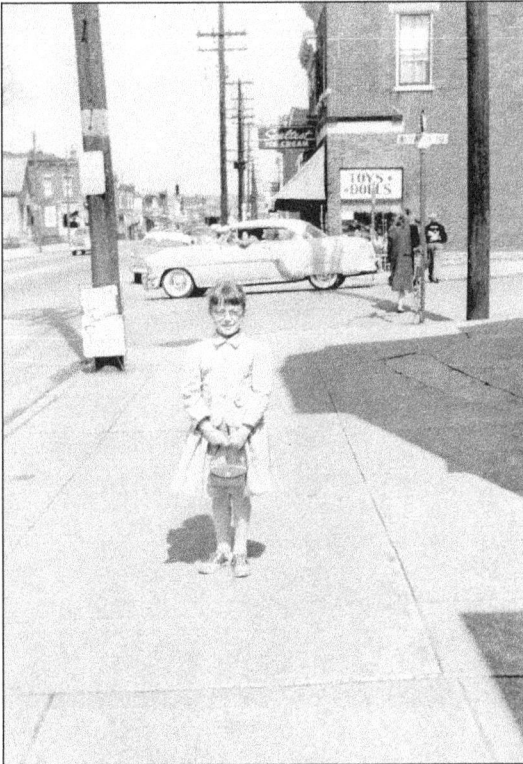

A little girl stops on the corner of Washington Avenue and Fairfield to take advantage of the fine shopping in the business district. Behind her, a 1954 Pontiac Chieftain Catalina comes down Washington Avenue. Note the Sealtest Ice Cream sign in the background. Sealtest was a regional dairy whose slogan was "Get the best, get Sealtest." They made door-to-door deliveries in dark green DIVCO trucks with red and cream trim.

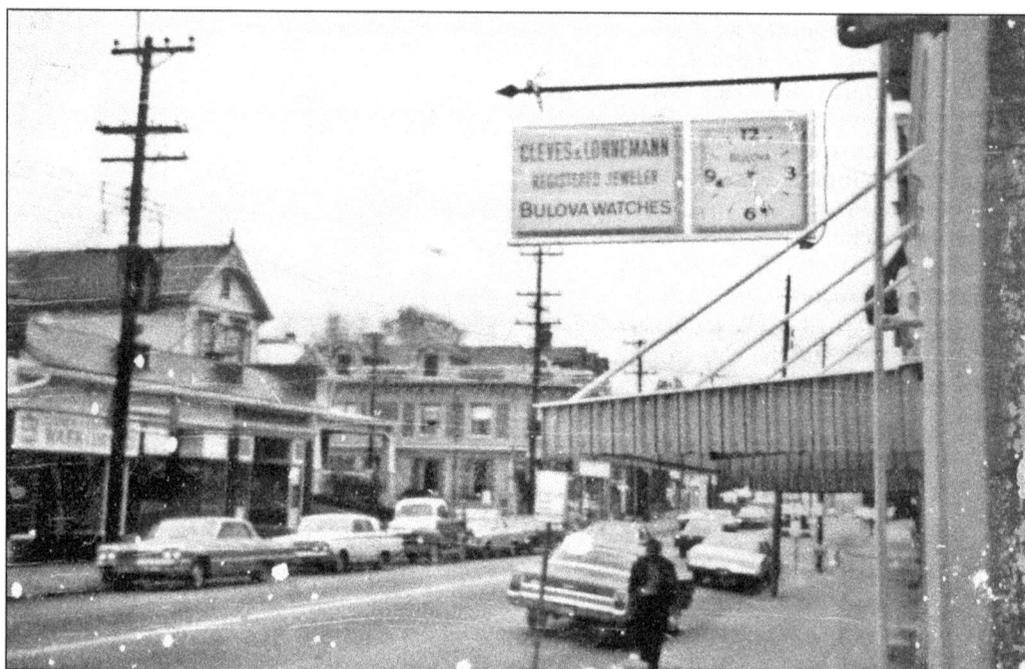

Cleves and Lonnemann Jewelers has been serving Bellevue from this location at 319 Fairfield Avenue since 1932. Built in the 1870s, this building housed a butcher and a plumber's shop before becoming a jewelry store. Cleves and Lonnemann has long been the first stop on Fairfield Avenue for the best jewelry in town.

Local business owner Ed Cleves (right) is pictured in 1960. Mr. Cleves owned Cleves and Lonnemann Jewelry Store for many years until turning it over to his son in the 1990s.

Seven

OVERCOMING ADVERSITY

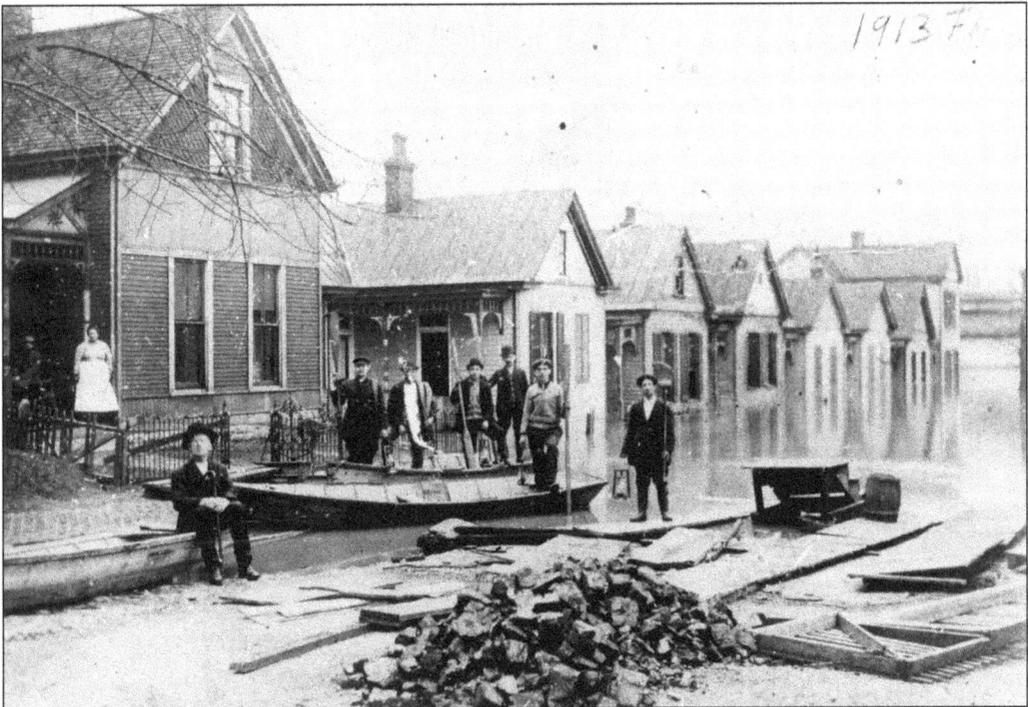

Much of Bellevue sat above the Ohio River's flood stage, but a few houses built in the lowlands were susceptible to flooding. These men clean up areas north of Fairfield Avenue on Front Street that were submerged during the 1913 flood. Flood waters did not reach much of this part of Bellevue again until the record flood of 1937.

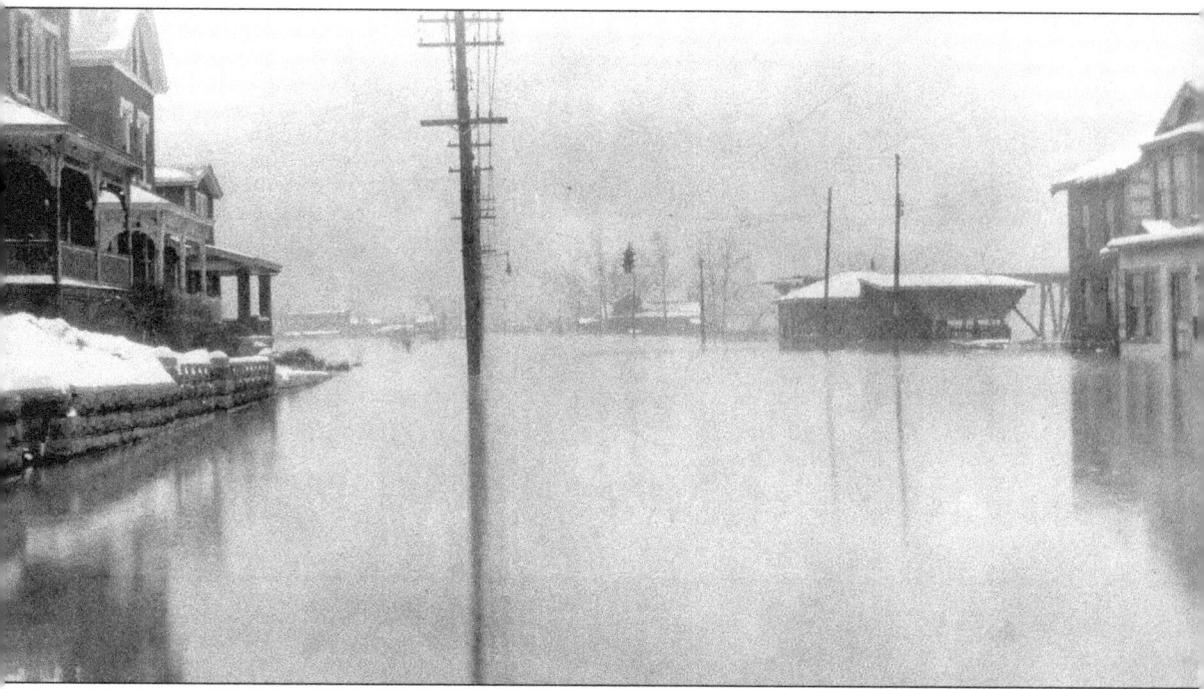

Looking west along Fairfield Avenue, the rising waters of the 1937 flood have swamped the city. The still-visible snow means that a few days of rising water remain before the crest of nearly 80 feet further complicates life for the residents of Fairfield Avenue and Bellevue.

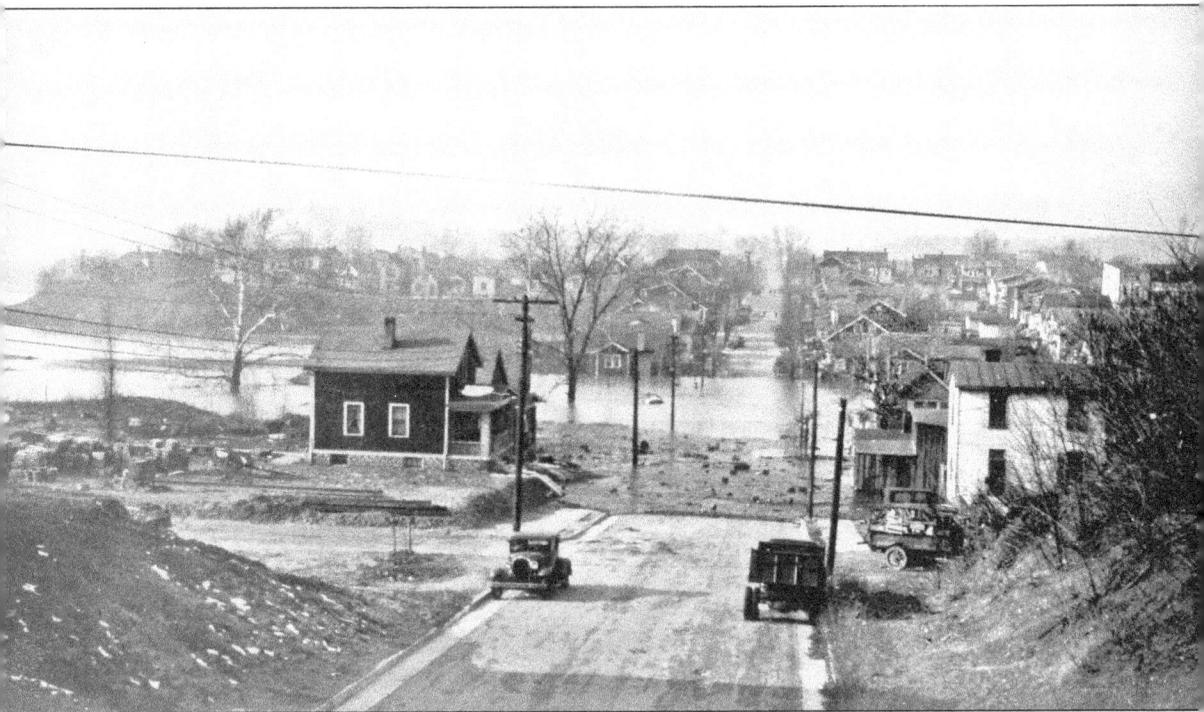

Looking North along Berry Avenue, homes thought to be clearly above the Ohio flood plain became victim to the rising water. Once the flood hit its peak at 79 feet, nearly all low-lying areas along the river in Cincinnati and Northern Kentucky were under water. This photo shows the damage as the waters began to recede.

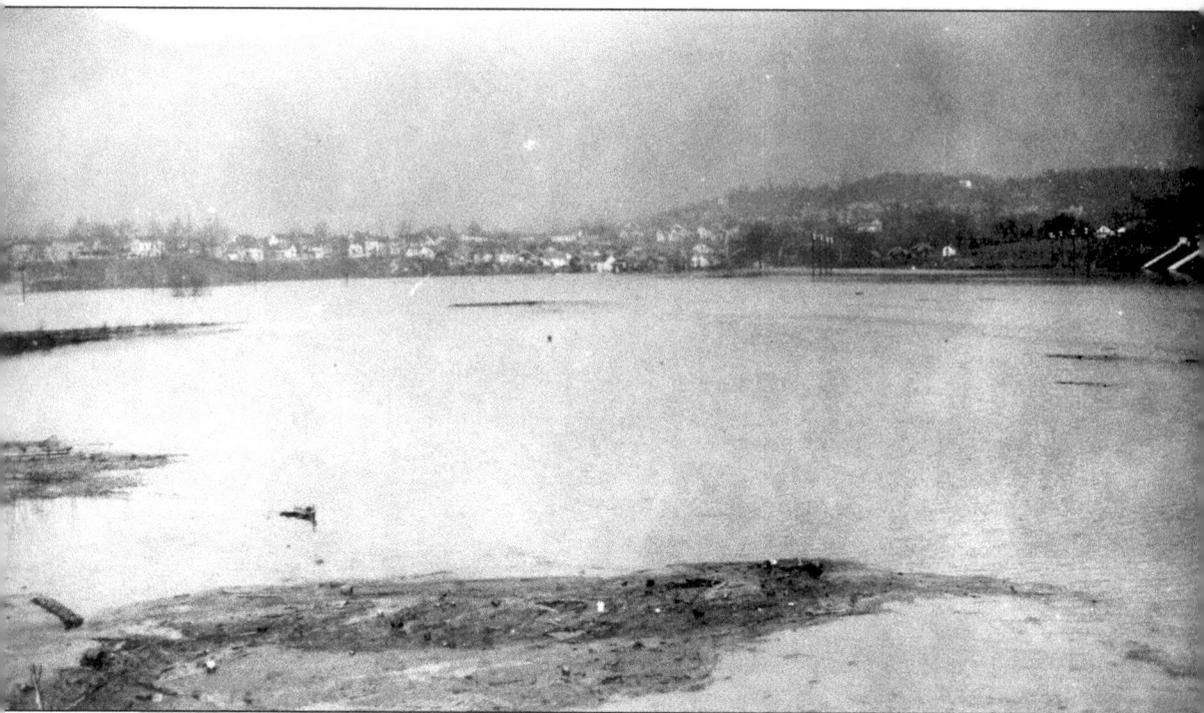

Looking toward the Sixth Street Fill, the extent of flood can be seen.

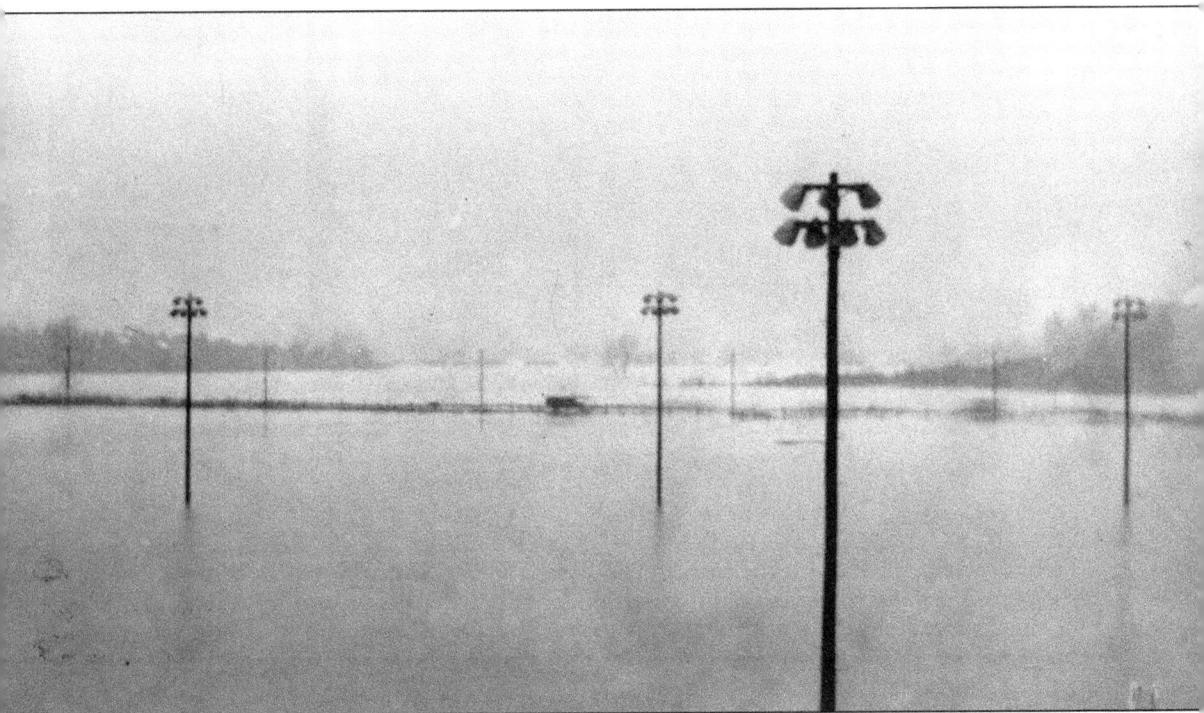

Gilligan Stadium, home to many of Bellevue's very successful amateur athletic teams, sits completely submerged leaving only the light poles visible. The stadium had just been constructed in 1936, one year before the flood. The stadium was named for Leo Gilligan, who served the Bellevue School System as a teacher, principal, and superintendent.

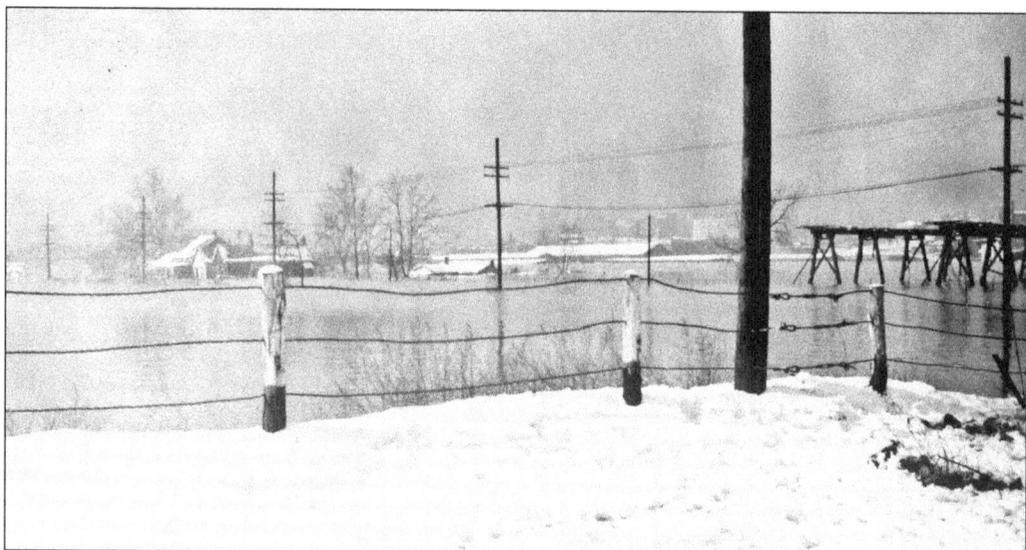

From a snow-covered hill at the corner of Ross and Patchen, Fairfield Avenue is seen completely submerged under the waters of the 1937 flood. Soon after this picture was taken, the house at the far left relented under the water's pressure and was added to the ever-growing list of properties lost to the great flood.

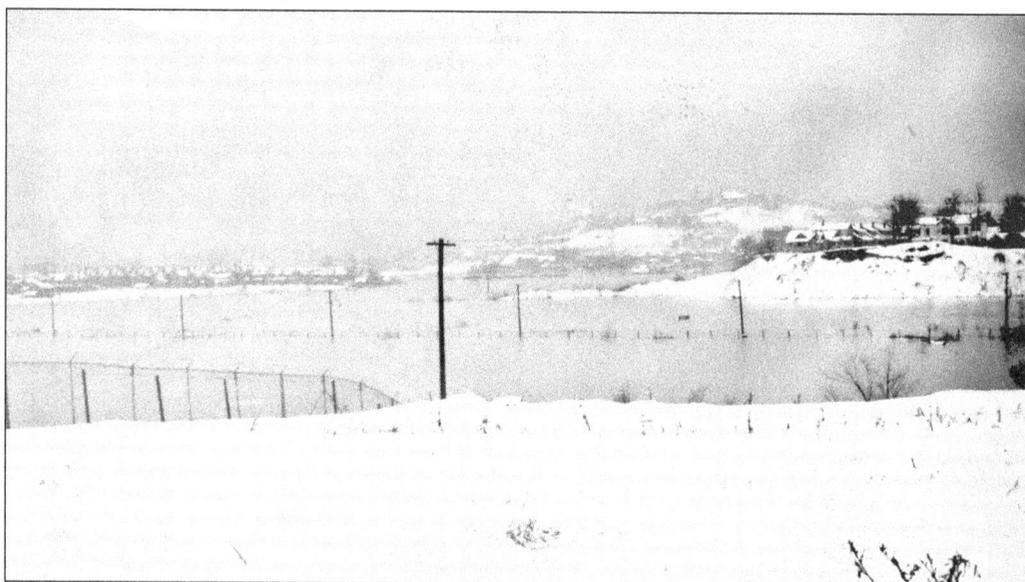

This picture was taken as the 1937 floodwaters rose. The fence in the middle of the valley was quickly covered as the floodwaters reached record heights. The homes on the hillside to the right of the photo are located along Clark Street.

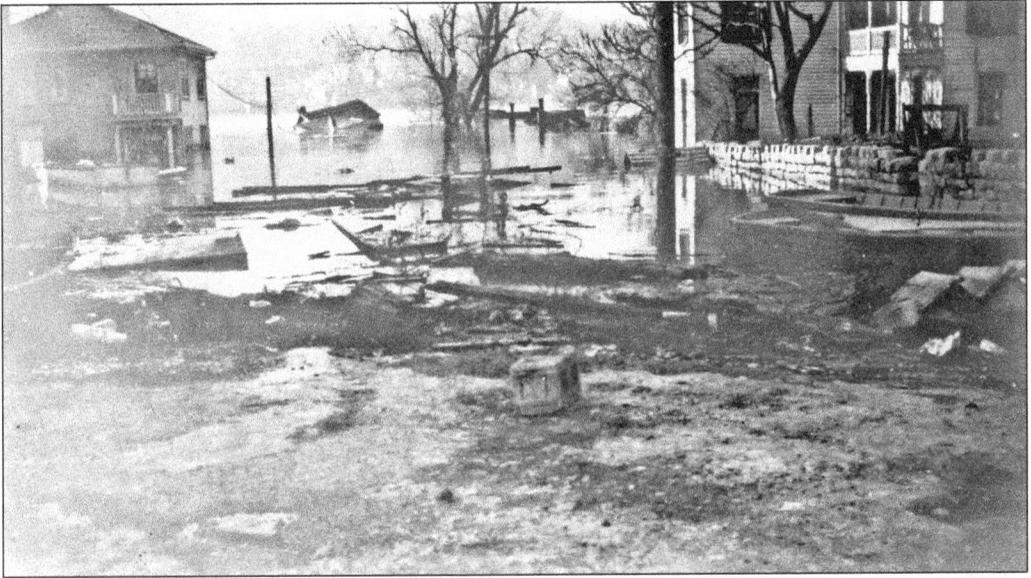

As the waters from the 1937 flood began to recede at Eden and Hallam Avenues, the damage becomes increasingly apparent. The remains of a house float by, and large amounts of debris begin to collect on the streets of Bellevue, setting up a long and arduous cleanup effort.

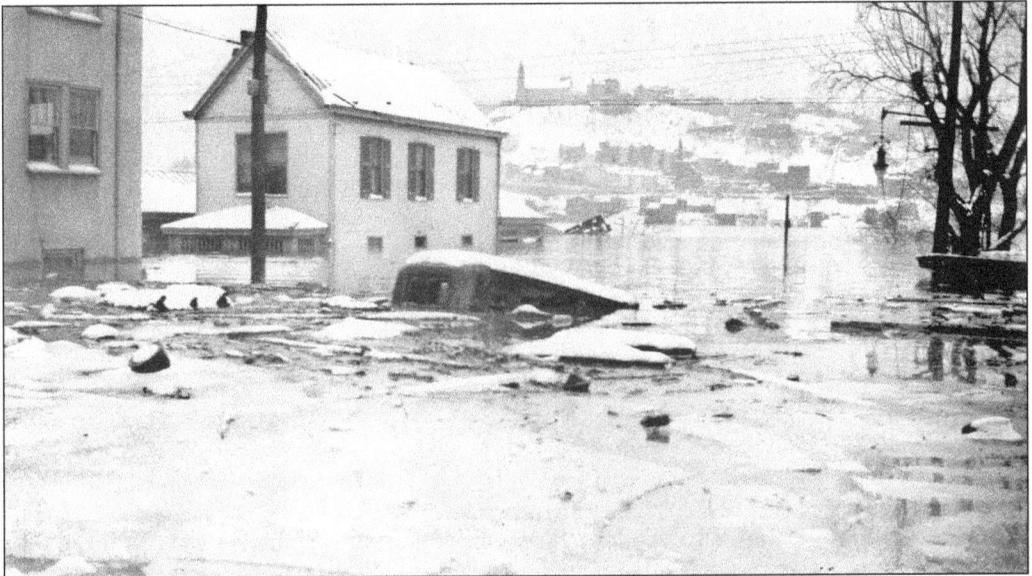

A truck floats by at the corner of Hallam and Eden just north of Fairfield Avenue in January 1937. The house in the middle of the picture was later washed away by the floodwaters. Mount Adams and Cincinnati are clearly visible across the water. Compounding the problem of the high water was the freezing temperatures.

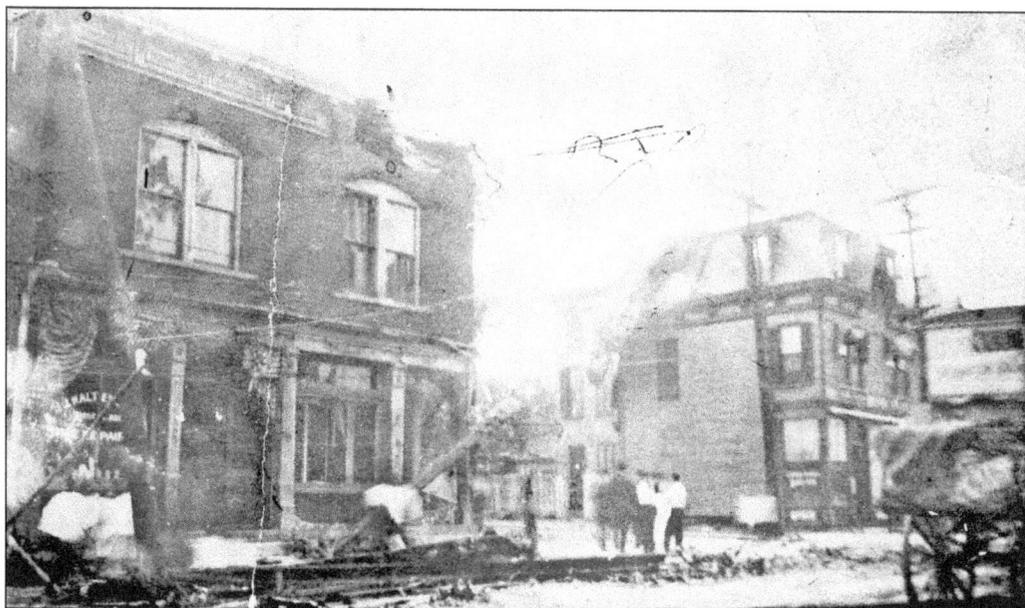

When the 1915 tornado came through town, devastation was not limited to Division Street and the steeple of Sacred Heart Church. Here at the corner of Foote and Fairfield Avenues, the tornado's destruction is apparent. Cleanup and rebuilding efforts took months, but finally there were no signs of damage and business along Fairfield Avenue returned to normal. On the back of this photograph are the handwritten words "Terrible twister—1915."

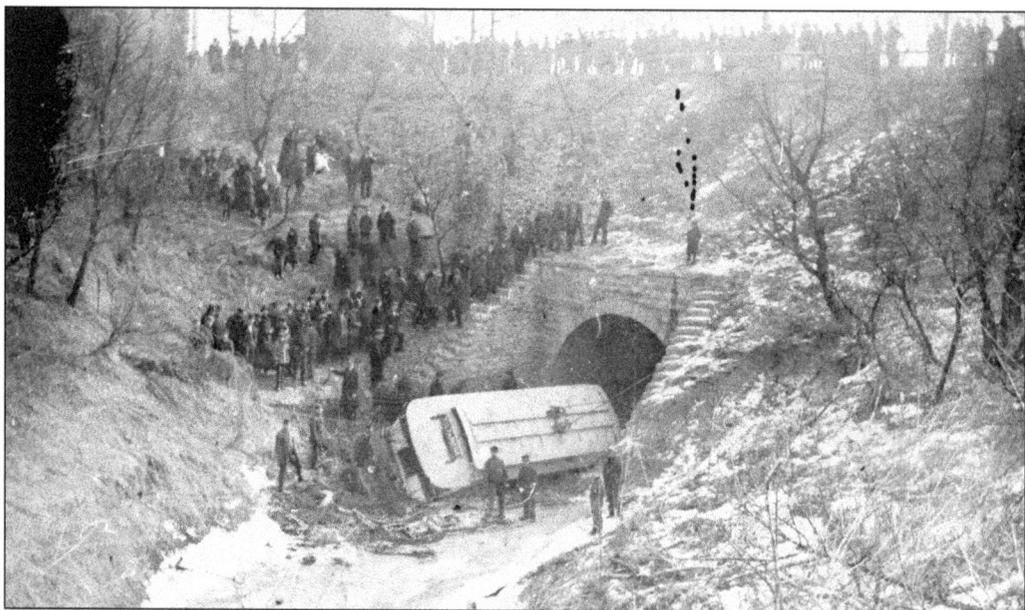

On February 15, 1901, the Bellevue–Dayton streetcar tumbled over the bridge at Mill Bottoms between Bellevue and Newport. The result of a broken axle, the accident launched the car and its 29 passengers into the ravine that was flooded just days earlier. Lewright Yeatts (motorman) and Sam Neal (conductor) had kept the car under the legal speed limit of 15 miles per hour before the accident, probably minimizing the tragedy. Mr. Yeatts and several passengers found themselves in the hospital, but luckily no one died.

Visit us at
arcadiapublishing.com